NO PLASTIC SLEEVES

LARRY VOLK
DANIELLE CURRIER

NO PLASTIC SLEEVES

PORTFOLIO AND
SELF-PROMOTION GUIDE FOR
PHOTOGRAPHERS AND DESIGNERS

SECOND EDITION

Focal Press
Taylor & Francis Group

NEW YORK AND LONDON

First published 2010 by Focal Press

This edition published 2015
by Focal Press
70 Blanchard Road, Suite 402, Burlington, MA 01803

and by Focal Press
2 Park Square, Milton Park, Abingdon, Oxon OX14 4RN

Focal Press is an imprint of the Taylor & Francis Group, an informa business

Notices
Knowledge and best practice in this field are constantly changing. As new research and experience broaden our understanding, changes in research methods, professional practices, or medical treatment may become necessary.

Practitioners and researchers must always rely on their own experience and knowledge in evaluating and using any information, methods, compounds, or experiments described herein. In using such information or methods they should be mindful of their own safety and the safety of others, including parties for whom they have a professional responsibility.

Product or corporate names may be trademarks or registered trademarks, and are used only for identification and explanation without intent to infringe.

Library of Congress Cataloging in Publication Data
Volk, Larry.
No plastic sleeves: portfolio and self-promotion guide
for photographers and designers
by Larry Volk and Danielle Currier. – Second edition.
 pages cm
 1. Photograph albums. 2. Art portfolios.
 3. Photography–Vocational guidance.
 I. Currier, Danielle. II. Title.
 TR501.V65 2014
 770.23'2–dc23 2014006721

ISBN: 978-0-415-71119-7 (hbk)
ISBN: 978-0-415-71118-0 (pbk)
ISBN: 978-1-315-88472-1 (ebk)

Typeset in Avenir and DIN
by Florence Production Ltd, Stoodleigh, Devon, UK
Printed and Bound in China by 1010 Printing International Ltd.

Bound to Create

You are a creator.

Whatever your form of expression — photography, filmmaking, animation, games, audio, media communication, web design, or theatre — you simply want to create without limitation. Bound by nothing except your own creativity and determination.

Focal Press can help.

For over 75 years Focal has published books that support your creative goals. Our founder, Andor Kraszna-Krausz, established Focal in 1938 so you could have access to leading-edge expert knowledge, techniques, and tools that allow you to create without constraint. We strive to create exceptional, engaging, and practical content that helps you master your passion.

Focal Press and you.

Bound to create.

We'd love to hear how we've helped
you create. Share your experience:
www.focalpress.com/boundtocreate

Focal Press
Taylor & Francis Group

To H. H. with love and appreciation for all of your support.

To the artists in my community, who over many years have shared their ideas, and been supportive friends and inspiring colleagues.

—L. V.

To P. C., my mom, and the other academic in the family—thanks for all the inspiration.

To C. P., my better half—thanks for all the love, support, and belief in me.

—D. C.

CONTENTS

For more information, including additional portfolios, interviews, resources, tutorials and articles please visit the companion website at
WWW.NOPLASTICSLEEVES.COM

Thank you to all the creative professionals and students for your generous contributions.

We know your work will inspire the readers of this book.

A special thank you and acknowledgment to Anne Pelikan for her consultation, demonstrations, and input in regard to the book construction photographs and text.

ACKNOWLEDGMENTS

Authors' Note

The process that we have described in this book has evolved over many years through our experiences as educators and professionals in the creative industries. This process has ultimately developed into a system that addresses all facets of the portfolio package. Each step has been carefully planned, organized, and simplified in order to maximize the potential of your complete portfolio package. This book will guide you through a process of conceptualizing, designing, and developing all the interconnected pieces you will need. Professional and student work, diagrams, illustrations, and step-by-step visual guides will provide examples of and demonstrate key concepts, principles, and techniques.

This 2nd edition features many new outstanding examples of portfolios and promotions both online and in print form. Included are additional international examples and a more even balance of photographic and design focused portfolios and promotions. Several examples from illustrators and artists are also included.

The 2nd edition includes a completely revised chapter for "Step 6: Online Portfolios & Blogs." This chapter focuses on current user experience design strategies, functionality, technology, and delivery methods specific to online portfolios, blogs, and your online presence. Several strategies are discussed for effectively reaching and meeting the needs of your target audience. Options from custom websites to more "out-of-the-box" solutions are discussed. The chapter also features all new examples of online portfolios and blogs, many of which are accompanied by quotes from the individual photographers and/or designers themselves.

Much of "Step 7: Promotional Materials" is updated with a greater focus on online marketing and the utilization of blogs and social media to increase your visibility and reach. Printed promotions are also discussed with many new examples featured. "Step 2: Branding" also includes an expanded discussion of brand and brand identity.

FORM FOLLOWS FUNCTION—THAT HAS BEEN MISUNDERSTOOD. Form and function should be one, joined in a spiritual union.

FRANK LLOYD WRIGHT

Have you ever heard the phrase "form follows function"? American sculptor Horatio Greenough is credited with the phrase, but it was the American architect Louis Sullivan who made it famous. The phrase became the guiding principle of modernist architects and industrial designers during the 20th century. It means that the structure and appearance of a thing should reflect and support what its purpose is. Let's examine the purposes of your portfolio. Your portfolio of work is the evidence of your experience, knowledge, skills, creativity, innovation, and aesthetic and technical capabilities. In essence, it is the culmination of who you are as a creative professional, and can even indicate where your future interests and passions lie. It is a large part of your identity as a creative professional and will be used heavily to market yourself to potential employers and clients. Therefore, your portfolio, both in print and digital form, should reflect and support your specific goals as a unique creative professional.

Types of Portfolios

In the creative industries a *portfolio* usually refers to an edited collection of visual work that comprises separate pieces and projects, representing both range and depth within a particular field. Typically, this collection reflects the best a company or individual has to offer.

There is also a portfolio that is referred to as a "body of work." This describes the collection of an artist, often unedited and presented in its entirety. Sometimes a "body of work" refers to a specific series, developed around a central theme or defined within a particular time period. Such a collection is often edited when exhibited or published in book or website form. Many artists create such collections, often serving as a portfolio of sorts, since they are intended for marketing and promotional purposes. In fact, most art and design students create a "body of work" as their senior project, including many interrelated pieces that are developed over several months.

What are the goals and purposes of your portfolio? While the work in your portfolio is obviously a very essential part of your ability to market yourself and should be considered carefully, you should not stop there. Your comprehensive portfolio package has the potential to be so much more.

- The intention of putting together a portfolio is to present yourself as having a visual character, to differentiate yourself from the average creative professional, and make yourself stand out, supported by your own unique creative vision and the work you have done to prove yourself.

- Your portfolio package should be considered as a whole—from the first glimpse of your book's cover, to the work included inside, to your website and related professional and promotional materials. All of these materials are essential to marketing and establishing yourself as a creative professional.

- Your portfolio is evidence of your experience, knowledge, skills, creativity, innovation, and aesthetic and technical capabilities. These should be reflected by the portfolio's overarching design concept and backed up by the project work you choose to present.

- You should consider your portfolio not simply as a container for your work, but as a creative statement in and of itself that reflects the value you place on your work and craft. In the creative industries, our goal is very often to make work that captivates, engages, and communicates a point of view. What does it say if a creative professional's portfolio does none of these?

- Ultimately, the goal is to get you the job you want or the types of clients for whom you want to work. You can use your portfolio design as an opportunity to express and characterize the kind of work you want to do in the future.

- A comprehensive portfolio is finally about self, with the end goal of promoting and positioning yourself within your industry.

The Comprehensive Package

While your portfolio book is an essential part of your ability to market yourself, it is not the only piece. As part of a comprehensive portfolio package, you will also need to include an online presence, a resume, a cover letter, and perhaps even a business card and mailers such as postcards or brochures. A resume, cover letter, and online portfolio or mailers will function as the first contact and impression you make. These items will work to get your "foot in the door," so to speak.

Since your portfolio book will be built and designed by you, it will most likely be limited to one or two copies. It will be the book you mail to a limited number of select potential employers or clients and/or the book you bring with you to an interview. Along with your interviewing skills, your book must totally impress. Together, all these materials will ultimately be used to establish and secure working relationships with potential employers and clients. In order to do so, your portfolio package needs to function as a whole, with unifying visual elements that integrate the separate, but related pieces—all establishing and reinforcing a consistent, positive message about you.

Brands and Concepts

As previously stated, your portfolio book needs to function in some really important ways. For one, it needs to get you noticed, grab someone's attention, and distinguish you from "the crowd." It needs to communicate your unique talents and experiences in a positive and memorable way. To do this, you will need to develop a *brand statement* for yourself, capitalizing on your unique abilities and creative vision. You will then need to develop an *overarching concept that expresses this brand* through specific visual and verbal means. Some of you may even develop a subsequent *brand identity* that will inform the visual and verbal direction of all of your portfolio materials.

Your message will shape and influence how potential employers and clients perceive and remember you. Distinguishing yourself from hundreds of other similar candidates through a distinct brand concept will provide you with a vital competitive edge.

Therefore, it is important that your portfolio book is not simply a container for your work, but a well-thought-out and well-crafted creative statement, in and of itself. Creating your own unique book, related website, and supporting materials will demonstrate your commitment and dedication to your profession. This is especially true in our competitive creative industries where creative professionals distinguish themselves by taking the initiative to make sure that they show their very best right from the start. The first part of this book will guide you through a number of steps in order to achieve this very important first goal.

The Book

Driven by your brand statement and subsequent conceptual ideas, the two main design goals of your portfolio book can be thought of as interrelated structural parts. Namely, there is the exterior, or front and back cover design, and the interior page layout. While the exterior and interior of a book are certainly related and need to function together as a whole, they do serve different purposes, and separately, each addresses an important function of the book. The front and back cover design addresses the first goal by drawing attention to the book itself and by communicating, through visual and verbal elements, the nature of the content in the book—in this case, who you are as a creative professional.

Once you've piqued someone's interest with the cover design, the interior layout of your book communicates the body of the book—its content. In this case, this is a presentation of your work and related experiences. As the very first step in our process, you will need to take some time to evaluate and edit just what to include.

Your portfolio book and related website need to function by clearly and effectively presenting your work. To do so, the image of the work itself must be the focal point within the composition of each page. Information about the work and any other related visual elements should be secondary. In a visual industry, showcasing and showing off your work is ultimately what will get you the job! As part of our process, we will guide you through the organization and layout of elements within the layout of a page (both print and web based), including image relationships and typographic and compositional issues.

Visual elements, as established by your brand, will be prominent in your cover design and continue to a lesser degree into the interior layout of the book. This is done so that the exterior and interior parts don't seem like separate entities, but are visually related, creating a cohesive experience. Such visual elements could simply be the consistency of a typeface and color that carries over from the cover to the interior pages.

Book Construction

The next step in our process is to construct the actual book. We will guide you through a step-by-step process for creating the structure and form of your portfolio book. The form is, of course, driven by the functions of the book that we have already discussed. Thus, we will show you how to construct a book that can be customized so that it is unique to you, and can easily be updated. In addition, the craftsmanship of your portfolio book is very important as part of your professional presentation. Several tricks and tips will help ensure
that you create a well-crafted, quality book presentation.

The Online Presence

Critical to the career of any creative professional is an online presence and for some even a blog. Having established a brand statement and related design concept for your portfolio book, you now need to transform and extend this to your online presence. Consistency of design and visual statement is key. There are numerous decisions to be made about the function and purpose of your web presence, as well as challenges in bringing your visual identity and work into an online form. Step 6 will help you sort through the key issues as well as understand the key design concerns when developing your portfolio
for the web.

Marketing

Your portfolio will only serve you if it is seen. You need to develop marketing materials as well as other ancillary materials to support your book and website. As always, continuity with the rest of your portfolio package is a must. There are, however, many routes to take with mailers, social media, electronic mailings, leave-behind fliers, and business cards. In this part of the book, we walk through the considerations and possibilities of marketing, marketing materials, and resumes, as well as contacts and interviews.

Our Process

For those of you who encounter this book having already started this process in some form, the chapters are designed to allow you to enter the process at any point, to review, revise, and redesign if necessary. For those of you who are just starting this process, it is important to follow each step in the order that we have outlined, as each step informs the next. Since the creative industries are constantly evolving, you will most likely need to update your portfolio package several times throughout your professional career. You may even want to modify or change your brand statement at some point. Politicians and pop stars remodel their images all the time in order to stay current with the times and sway popular opinion. As long as the work in your portfolio reflects your assertions about yourself and your work, you can do the same. Once you have completed the process at least once,
it will be easy to go back at any time and rework your portfolio.

Note: Resources and information on all topics and material can be found online at *www.noplasticsleeves.com*. Visit the website regularly for updates, new resources, and to submit your own portfolio or promotional work for a chance to be featured.

A DESIGNER KNOWS HE HAS ACHIEVED PERFECTION,
not when there is nothing left to add, but when
there is nothing left to take away.

ANTOINE DE SAINT-EXUPERY
Writer

EVALUATE & EDIT

This book is designed and structured to allow readers to move to any chapter and apply that aspect of the portfolio process to their work. For those who have never made and distributed a portfolio, the concerns addressed in this first chapter are essential to all of the design, editing, and construction decisions that follow. For those who have previously made a portfolio, what we ask you to consider in this first chapter can be used to evaluate your existing portfolio and guide you through changes you may need to make.

For those just starting out the process may be different, and in fact, this may be the hardest point in the process. It is at this point that you have to access not only your interests professionally, but you also have to take a hard look at your body of work and determine (a) if it is up to standard, and (b) whether it is relevant to the goal or target you have defined for yourself.

For individuals with an established career you may want to review and possibly redefine your target audience and work interest. Has this shifted, or changed? Can you articulate more clearly the kind of work and audience for your portfolio?

In this chapter: you will establish and define the goals for your portfolio and ultimately for your career. Once established, this then determines how you *brand* yourself. You need to begin by accessing where you are and where you want to go. What follows are some suggestions for considering your work and some exercises to help you get feedback and put things into perspective.

What Constitutes an Effective Portfolio?

By defining yourself—creating a brand, which then gets expressed through a visual design—you will take your work beyond a sampling of skills and capabilities. In this sense, it should capture not only your abilities, but also your attitudes and personality. By extending your visual identity to all the pieces in your comprehensive portfolio you can establish this message clearly and consistently, ensuring that your portfolio will stand out and be seen. Some of these aspects will vary with the individual and the goal of the portfolio. The portfolio, however, should function in the same manner as any piece of work you produce as a visual creative. It should be concise, effective, communicate an overarching concept, and hold the viewer's attention long enough to convey your message.

Evaluate, Edit, and Define

The most powerful way you can communicate your unique identity— your strengths and abilities—is through examples of your work. This is, of course, the heart of your portfolio. You need to make sure that every piece included in your portfolio is an example of your very best. That means that you should take the time to evaluate each piece and rework projects if necessary.

What constitutes an editing and evaluation process when you are examining your entire body of work? This differs from editing an individual piece of work. It is important at this very early stage to take a larger view that moves beyond considering individual pieces of work (or projects) . You should assess the sum total of the work that comprises your portfolio and assess how it fits into your intentions as a creative and career artist or designer.

Before you begin looking at the work itself there are key questions that need to be asked. To begin with, you need to make an assessment of your work as it stands, as well as consider your intentions for your career. We start by asking some basic questions. We also have some methods to spark your ideas and help you in evaluating and considering your work.

Who is your audience? How would you characterize where you want to end up? In order for you to create an effective brand statement and subsequent visual identity you need to first know what you want it to say. Who is the "client" for this portfolio?

For the Photographer

The photography market is a widely varied environment and you need to consider where you want to place yourself. Are you showing your work to editorial clients who might need to see some versatility? Are you targeting art buyers who might be looking for a cogent vision to apply to a specific account or campaign? If you have different bodies of work that represent different potential markets or subjects, you need to start by defining them.

For the Designer

The career goals of a designer can be somewhat different from that of a photographer. Designers are more often applying for a full-time position at an agency or firm. If you are already working in the industry, you may want to think about how your work can reflect your next intended career move. Are you presenting this work to creative directors who need to understand your abilities from the perspective of a particular kind of work (advertising, brand, publishing, web, etc)? As a designer, do you need to show concept development because you want to be more than a production designer?

What is your area (or areas) of practice or specialty? How would you define your work? Does it fit into a particular category in terms of professional practice? Is there more than one category?

Visual character or visual style: What characteristics does your work communicate? Describe your work and its approach and style.

What skills and capabilities are featured in your work? Is there an emphasis on particular kinds of work or is your work more of a general representation? Are there examples that are out of character or unrelated to your intended audience and goals? Do you have process-based examples? Should these be included?

What is the standard for the work? Do the examples meet your criteria for concept, execution, coherence, and consistency?

Note: Rework!

You may have work that is worthy of your portfolio, but needs to be adjusted, improved, and refined. It is never too late to do this, especially if you recognize changes that need to be made after having had some time away from a project or assignment. Never let a subpar piece of work slip in. If someone reviewing your work questions a project, then you need to address this, or at the very least confirm with another set of eyes what might need changes.

Perhaps many of your portfolio pieces come from college assignments or client work which, although strong, may not necessarily be the best representatives of the type of work you want to pursue. You may want to consider eliminating work that you feel deviates from your intended goals or audience and create additional portfolio pieces that take you in the direction you want to go.

How to Start: Describe Yourself as a Creative

Start by writing down a list of adjectives and adverbs that describe you and your creative self. Begin by looking inward for these qualities. Describe your personality, your work ethic, your sense of style, your strengths, your attitudes, and the kind of work you enjoy making. Consider how best to position yourself given the kind of work you've done and the kind of work you want to do. What are your unique talents, conceptual abilities, and skills?

Exercise: Reverse View/Reverse Roles

View yourself as a new client who you are trying to access. You are being asked to make a branding and identity piece that features the work that this client produces. What are the questions you would ask if you were hired to design or photograph for yourself?

Help: Get Feedback

You should solicit as much feedback about your work as possible. Seek out the opinions of industry professionals, professors, clients, and peers. In addition, industry associations, such as AIGA (the professional association for design) and American Society of Media Photographers (ASMP), often organize professional portfolio reviews whereby you can receive feedback from a variety of professionals in your field. Ask for someone's honest opinion; constructive criticism is more valuable than simple praise. Ask specifically what could be improved. Remember that nothing is ever perfect and you should strive to learn and grow. As always, you should consider feedback carefully and make up your own mind about whether or not the opinion of someone else is valid and applicable to your project goals.

How much work should a portfolio book contain? At this stage of the process, you probably will have a selection of works that you feel will be suited to your portfolio. As you develop your brand and visual identity, this may shift and you may add or eliminate works. Initially, you may want to hold work for consideration until you are clearer about the direction the portfolio is taking.

While the intended audience and goals for the portfolio can determine the scope and content of the projects, there is still a question of quantity. There is not a set standard, however. You want to consider both what is practical and what is most effective in reaching the viewer of your work. For a student just graduating from school, the average is 8–15 well-developed pieces. Photographers should show cogent consistent groups or series of images. Designers, as well as photographers, should show work that presents capabilities, range, and some aspect of your voice and vision. A designer may include process-related materials that reflect concept development, sketches, and comps. See Step 4 regarding image sequence and considerations for how much work to include.

A well-thought-out portfolio should tell a story about you. It should be a journey that displays your talent, thinking, and abilities and it should have a beginning, middle, and end. Lead with a particularly strong piece in order to make a solid first impression. But also end with a strong piece, as this may leave a more lasting impression than the first. Imagine someone going through your book. What is the journey on which you want to take the viewer? Imagine that you are there with them and they are flipping through your book and asking you questions about you and your work. What kinds of questions do you want them to ask? What pieces do you want them to spend more time on? What pieces do you want to emphasize, or are particularly proud of? Designers, as mentioned, can also show projects at multiple stages— concept, sketching, design mock-ups, finished piece.

At this stage, you are trying to get to a set of works that can help you formulate your brand statement. You are assessing your work to see if it is suitable to your goals and to aid you in developing a concept and visual identity that can be characterized by your work and through your work. See Step 4, Editing and Sequencing, for more on editing and sequencing your work.

Here are three guidelines:

Concise: What are the fewest number of pieces that effectively convey everything you wish to suggest about yourself as a designer/ photographer? Can you create the most concise statement? In fact, this might be a starting point. You need to bear in mind that if you have too many pieces, the impact of individual works can get lost. As the viewer of your portfolio looks through it, an impression can be built cumulatively. Once you establish this, you don't need to go any further.

Convincing: What quantity will demonstrate that you are capable of the scope of work and production required for your intended goal? What will show a viewer definitively that you have the goods and chops to do the job?

Clear: Show too many pieces and the viewer will lose the thread about you. The pieces will get lost in the breadth of the portfolio. You want the viewer to be seeing a statement that builds on itself. If it gets too lengthy, he or she will not be able to tie everything together, nor does it show your ability as a developer of tight concepts.

How to Sort Your Work

To start, take out any pieces that appear to be redundant, or offer essentially the same idea, demonstration, or method. If they simply repeat something that is already well presented, you should consider removing them.

Can the portfolio work without a piece? Having made an edit of your work, consider taking out a piece or two. Can the portfolio function without them? If so, they don't need to be there. Continue this process until you can't remove any more pieces without making the portfolio appear fragmented, or incomplete.

Having done this first step, the next chapter will take you beyond sorting and organizing the work; you have to begin the process of "branding yourself." You will further examine what you offer as an individual visual creative and will revisit some of the questions raised in this chapter, but with greater focus on characterizing yourself further. In this way you will distinguish who you are and your qualities as a creative, leading to the development of an identifiable "brand."

SIMPLY DO GOOD WORK.
UNDERSTAND THAT THE ULTIMATE VALUE OF YOUR WORK IS TRUTH, WHICH IMPLIES A SENSIBILITY OF TRANSPARENCY AND CLARITY.

RICHARD GREFÉ
Executive Director, AIGA

Q&A: Interview with Mary Virginia Swanson, Marketing Consultant and Educator (© 2013, Mary Virginia Swanson)

As a consultant to photographers who are trying to extend their work and build their careers, how important is a printed portfolio versus an online portfolio?

While many designers tell me they make the decision to work with a photographer from reviewing their website, their client may well require showing a proper print portfolio prior to any decisions. I believe one must have both available, each different from the other, designed to be effective in their respective viewing context.

What do you recommend that a photographer have as part of a comprehensive package of his or her work?

First and foremost: great work! Second: A clear brand identity that appears consistently through every element in every format. Print: identity components, mailer, portfolio. Online: website, e-mailers, and possibly e-newsletter.

What makes for a good portfolio? Should it have an overall vision, concept, or a visual identity beyond an edit or series of strong images? Do you make distinctions between what is presented in an online portfolio and what is seen in a printed portfolio?

It is generally true that within smaller markets one must have a broad technical and creative "toolkit," to secure the diverse range of commissioned work one town or city has to offer. I would demonstrate the ability to tell a story through your images, in multiple presentation formats. When competing in a larger market, with a broader range of clients and needs, specializing will help you to rise above the pack. If you are a specialist, present your strengths. Whatever your strengths, broad capabilities, or distinct style/technique, every single image you show must be memorable.

In today's business environment it is rare that you have the opportunity to show your printed portfolio in person. Your online portfolio most often serves as the introduction to you and your work; it should provide a strong "first impression" that in a clear, organized manner informs the viewer about your capabilities and overall conveys value.

How much work do you like to see?

Less is more. It is better to show 10 outstanding photos instead of 20 with some that should not have been included. You can always tell when it was a stretch to grow a portfolio up to 20 images, and when I see portfolios with 25, 30, even 35, I'm editing it in my mind as I'm viewing it … not a great first impression to make.

How important is the brand or overall visual identity of the portfolio package (including book, online portfolio, blog, resume, business card, etc.)?

Essential. First, great work, second, great graphic identity that is present through all platforms you are engaging: print, web, blog, and social media. One that reflects the attributes of YOU and your brand. Successful brand graphics are the result of an inquiry—about you, your strengths, the message you want clients to know about you before they commission you. Is the feeling you want to convey young, hip and modern—"of the moment" and fun to work with? Do you want to appear classic, confident—a solid brand, someone who always delivers? Does a graphic logo add to their understanding, or is your name with type/color treatment a stronger, more memorable element? I always encourage engaging professional help with branding, to ensure your message will help you achieve your goals, or at the very least, study the advice of branding masters.

Do you have any advice for students or recent grads who are just starting out in the industry/their careers?

Put yourself in a professional situation where you will be constantly learning, where you will overhear the language of your industry, and thus gain a more realistic overview of doing business in today's economy. Stay current with technology and with trends. Read your industry trade publications, and attend lectures and trade shows. Don't ever stop pushing yourself to create new work, whether the commissions are coming your way or not. It is your personal work that will be the backbone of your creative skills for your clients.

Q&A: Interview with Richard Grefé, Executive Director, AIGA

Richard Grefé is the executive director of AIGA, the oldest and largest professional association for design in the United States. Prior to joining AIGA in 1995, Mr. Grefé crafted books at Stinehour Press, spent several years in intelligence work in Asia, reported from the Bronx County Courthouse for the Associated Press, wrote for *Time* magazine, and managed the association responsible for strategic planning and legislative advocacy for public television. Mr. Grefé earned a B.A. from Dartmouth College and an M.B.A. from Stanford Graduate School of Business.

How important do you feel an online and/or print portfolio is in securing a creative position in the design industry?

There are probably four attributes that every student or young designer needs to convey in pursuing a job: breadth of knowledge, because design is now about content and context, as well as form; attitude, in terms of being curious, willing, and committed to creating effective communications for very specific audiences; the ability to give form to ideas; and an ability to divine clear objectives from a client's brief and to serve those objectives. The last two are well represented in a portfolio that includes an articulation of a business problem, a proposed solution, and a discussion of the approach the designer used to address the problem. This can be accomplished in either digital or print form.

How important do you think a brand or overall visual identity is in the success of a portfolio design?

To the extent that a portfolio is a means of demonstrating the talent of an individual in branding herself, a well-conceived approach to a portfolio is smart, so long as it is not too contrived (in which case it can draw attention away from the work).

Where do you think current trends in design are leading?

Design can be a major contributor to creating value in the knowledge economy. However, it will depend on communication design being conceived as communicating with form, content in context over time. This means that designers must be conceptual, strategic, and multidimensional. They must be able to work across media seamlessly in finding ways to succeed in communicating on the part of their clients. And, increasingly, they must find ways to tune their sense of empathy to other cultures, for the design economy will be a global enterprise in which different cultures will be a critical element of understanding audiences.

Do you have any advice for design students or recent grads trying to break into the industry?

Simply do good work. Understand that the ultimate value of your work is truth, which implies a sensibility of transparency and clarity. If jobs are difficult in the private sector, find ways to help in areas of social engagement; it will be rewarding and give you an opportunity to demonstrate what you can do to change the human condition. Be patient, remain passionate, and even difficult times will pass.

Q&A: Interview with Joe Quackenbush, Associate Professor of Design at Massachusetts College of Art and Design

Joe Quackenbush is an associate professor of design at Massachusetts College of Art and Design in Boston. He has an M.F.A. in graphic design from the Rhode Island School of Design and a B.A. in English from Oakland University in Rochester, MI. He is president of Jam Design Inc., an interactive and print design studio based in Boston. Professor Quackenbush has also taught courses at the Rhode Island School of Design, The University of Hartford School of Art, and Clark University. He co-organized the 2008 AIGA design education conference entitled "Massaging Media 2: Graphic Design in the Age of Dynamic Media."

Do you teach a portfolio or promotional materials type of course? What's the course name? What level is it geared toward? Is it a required course?

I do not currently teach a portfolio class. However, I work regularly in helping my students to develop and learn how to present a project as a potential portfolio piece, particularly in interactive classes where the final product is really a small part of the overall process that the students need to convey. We do have a required portfolio class (titled simply "Portfolio"), which is the final senior studio course in our program, offered only in the spring.

What do you think makes for an outstanding portfolio?

- A diversity of projects that include drawing, motion and interactive work, and multiple print pieces that include branding, identity, systems, and expressive projects.

- Lots of process work, preferably in a form that shows the progression of a concept from rough initial sketches to final polished form. I feel strongly that there is too much emphasis on final product and not nearly enough emphasis on a student's process.

- Evidence of collaborative work with other graphic designers and students or business executives from diverse fields.

- Evidence of real-world client work, even if it was conducted during a class.

How important do you feel a print and/or online portfolio is in securing a job in the industry?

Based on everything we hear from the industry and what recent alumni relate, an online or digital portfolio, such as a PDF, is absolutely essential. The days of large boxes custom designed to hold eight or nine projects simply is not practical anymore. We hear repeatedly that books are an increasingly requested form of portfolio presentation.

How important is the brand or overall visual identity of the portfolio package (including book, website, resume, business card, etc.)?

Essential. Graphic designers are in the business of presentation and persuasion. A coherent identity among all facets of a portfolio should be baseline expectation.

In general, how many pieces of work do you think a student should include in his or her portfolio?

For a PDF, book, or web portfolio, I recommend students have between 10 and 12 projects.

Do you have any advice for a student currently working on his or her portfolio and/or promotional materials?

- Work with all your instructors, not just your portfolio instructors, to develop your portfolio.

- Try to work with a writer or editor to make sure your resume and any text you may be writing to support your portfolio is crisp, clear, and free of grammatical errors.

- For interactive projects, make sure to explain the entire process of developing the project clearly. Too often students simply show a click-thru prototype and fail to discuss the research and analysis that helped shape the final project.

INDIVIDUALS, COMMUNITIES, AND ORGANIZATIONS EXPRESS
THEIR INDIVIDUALITY THROUGH IDENTITY.[1]

ALINA WHEELER
Author, *Designing Brand Identity*

BRANDING

The primary function of your portfolio is to present a collection of your best work in order to communicate your experiences and capabilities, in hope of securing a position or client. While this purpose cannot be forgotten, your portfolio can also be taken much further. It can become a quintessential marketing piece in and of itself. In doing so, it has the potential to make a more impactful and memorable impression on its intended audience. Your ability to develop ideas and market yourself is not only relevant to working in the creative industries, but it can provide a much-needed advantage in such a competitive field. This is especially important for students and recent grads who have not yet had as many opportunities to distinguish themselves in their careers.

In this chapter, the process of defining and developing a brand will be outlined as related to the development of your portfolio. This chapter will address the following issues:

How do you move from an assortment of work to a clear and concise brand statement?

How do you utilize a process of self-discovery to create a brand statement that can be used as a touchstone in the creation of your entire portfolio package?

First, consider where you are in this process. If you:

- *Already have a clear concept or idea for the direction of your portfolio:* Use this chapter to reflect and evaluate this idea as it represents and positions you within your field. Developing a brand statement can't hurt—the clearer you are about how to position yourself within the industry, the better you'll be able to do just that. **Keep in mind (especially for those of you who do not have a design background) that you can develop a brand statement without developing a corresponding brand identity.**

- *Already have a brand and corresponding brand identity:* Use this chapter to reevaluate it. It may be time to analyze your current brand's strengths and weaknesses, refreshing or changing it if need be.

- *Don't know what to say and/or how to say it:* Use this chapter to begin a process of self-discovery, defining and shaping your brand position. The work in your portfolio may not be enough to take you where you want to go. While it's difficult to define something, let alone oneself, in the long run it will help you to have a statement that you can use as a touching point in the development of your portfolio design.

A brand is an attitude. It is a symbolic statement comprised of descriptive qualities that aim to express the heart and soul of an individual, company, or product. These qualities are typically defined by a set of *brand attributes*—a list of descriptive words and phrases that have the power to describe style, tone, and personality; establish connections and associations; and shape emotional reactions. Brands attempt to project certain expectations and promises in the hopes of establishing an emotional and intellectual connection with their target audience. Truly successful brands are able to deliver on those promises through the value that the individual or company provides. Such brands express and establish a specific attitude that is identifiable throughout their particular market.

Think about the clothes you wear, the music you like, and the products you buy. Among all of these things you have choices you make based on certain attitudes and qualities that appeal to you. In some ways, these things even go so far as to define aspects of who you are and the broader culture that you belong to. The most successful brands often become timeless icons of culture—think VW, Coca-Cola, MTV and Apple.

A strong brand should:

- *Differentiate:* Stand out from your competition.

- *Be authentic:* Communicate a message that is relevant and meaningful to your intended target audience.

- *Be memorable:* Consistently communicate a clear and concise message.

- *Versatile:* Hold up across medium and forms.

A brand is the sum of the good, the bad, the ugly, and the off-strategy. It is defined by your best product as well as your worst product. It is defined by award-winning advertising as well as by the god-awful ads that have somehow slipped through the cracks, got approved, and, not surprisingly, sank into oblivion. ... Brands are sponges for content, for images, for fleeting feelings. They become psychological concepts held in the minds of the public, where they may stay forever. As such you can't entirely control a brand. At best; you only guide and influence it.[2]

— Scott Bedbury, Author, *A Brand New World*

This means that everything you use to represent yourself will in some way define you—the work in your portfolio, the design and craft of your portfolio, how you conduct yourself on an interview, your resume, your website, and even how you compose an email.

Research and Analysis

- Find out about your target audience: What are they looking for?

- Find out about your competition: Who are you up against?

- Analyze your current brand's strength and weaknesses (if you already have one).

YOU NOW HAVE TO DECIDE WHAT 'IMAGE' YOU WANT FOR YOUR BRAND.
Image means personality.[3]

DAVID OGILVY
Author, *Ogilvy on Advertising*

Defining Your Own Brand Attributes

A good place to start thinking about your own brand statement is by reflecting about the work you've done, the person you are, and the creative professional you want to be. In order to do this, there are some key questions that you should ask yourself. Write down the answers that you come up with. Trust yourself and listen to your intuition throughout this process. You should also think about getting the opinions of others whom you trust. Ask faculty, clients, fellow designers, photographers, artists, etc., how they would characterize the work you do and the creative person they perceive you to be. Ultimately, you want to focus in on descriptive key words—adjectives and adverbs that can begin to define your brand statement.

Reflect on Your Work

Ask yourself some key questions:

- What kind of work do you like to do?

- What kind of work do you do best?

- Was there a particular project that you really enjoyed working on?

- How would you define your talents and skill set?

- How would you describe the styles, forms, and concepts with which you prefer to work?

- How would others describe your talents and the work you do? (If you don't know, ask.)

- What does your body of work say about you?

- Is there something missing from your body of work that you think you need?

Reflect on Yourself and Interests

Ask yourself some key questions:

- How would you describe yourself as a creative professional?

- How would you describe yourself in general—your personality, work ethic, beliefs, etc.?

- How would others describe you? (If you don't know, ask.)

- Are these qualities communicated through any of the pieces you've worked on?

- What do you have to offer a company or client?

- What types of experiences engage you?

- What do you find most interesting about the world around you?

- What do you find most interesting about photography, art, and/or design?

- Whose work influences, attracts, and inspires you? Why?

Reflect on Your Future

Ask yourself some key questions:

- What kind of work do you want to do?

- What kind of creative do you want to be?

- Are you doing the kinds of things now that you want to be doing in the future?

- If not, how can you position yourself to get to where you want to be?

- What kind of company or client do you want to work for?

- What kind of company would fit your lifestyle? Are there compromises you are willing or not willing to make (travel, moving to a different location, long hours, etc.)?

- Where do you see yourself in one, two, or five years?

- Is there someone in the field who you admire? Would want to emulate? Why? How did they get to where they are?

This is your opportunity to invent yourself for the first time, or reinvent yourself all over again. Think about where you'd like to be two years from now. How about five or ten years? People change jobs and even careers often throughout their lifetime. Now is the time to think about what you want out of your career.

By defining what you show based on what you truly are and what you want to do, you create a self-selection process: you are *not* for everyone. You are *different*. Be courageous enough to show that you see in a way no one else does.[4]

— Doug Menuez, Photographer

There are many different places where one can find sources of inspiration. Keep in mind that you can't create in a vacuum. Find what will help get your creative juices flowing.

Looking Outward

Try looking outside of yourself for things that inspire and appeal to you. Go to museums and galleries; browse the shelves at libraries and bookstores; flip through industry magazines and online portfolios. Look at the work that other people have made and ask yourself whether or not you want to create similar work. If so, try to define what you are looking at or experiencing. Try to figure out what characteristics define a particular piece that you are drawn to. What makes it stand out? What makes it meaningful to you? What does it communicate about the artist who made it? Try to be conscious of the various visual things that you are drawn to: patterns, signs, graphics, images, films, typefaces, or anything else to which you feel a connection. You should take some time to explore the things around you.

Genres and Styles

While there are many places from which to draw inspiration, an easy place to start is with a "history of" anthology or "style" book. These types of books explore numerous genres throughout the history of a particular discipline. You'll find artists who have explored any number of concepts, styles, and techniques. You may find that you are drawn to the postmodern, deconstructed typographic styles of *Ray Gun* and *Fuse* in the 1990s; or the vibrant psychedelic posters of the 1960s; or the sardonic images of a 1930s photomontage. Perhaps you will connect with the clean, clear "objective" design of the Swiss Typographic style or the expressive illustrations of Push Pin Studios. Perhaps you will be drawn to American modernism and the abstract, symbolic graphics of Paul Rand, Lester Beall, and Saul Bass. Maybe still, a painting will inspire you, or a landscape, photograph, texture, or pattern.

Photographers should look to both photo history as well as contemporary approaches found in commercial photographic production. Perhaps your work is more in keeping with the late 20th-century study of typologies coming out of German photography or you like the freewheeling framing of Garry Winogrand. Look to fashion photography, which has always repurposed historical forms such as: reportage, early color, alternative process, Polaroid, snapshot aesthetics, and plastic or alternative cameras.

Explore a variety of mediums and forms in your search for inspiration. If a particular genre or artist inspires you, try to determine what it is about their work that you find so appealing. Think about how this is or is not reflected in your own work and the type of work you want to do. Does a particular design style match up with how you define yourself and your work? Will referencing it help communicate your unique qualities as a creative individual?

Process

Keep a sketchbook of inspiration as you search and explore. This process may take some time. If the end result is to be meaningful, it is important that you define a brand that is reflective of your own unique vision, talents, abilities, and personality. In the end, you should feel confident about your own creative identity.

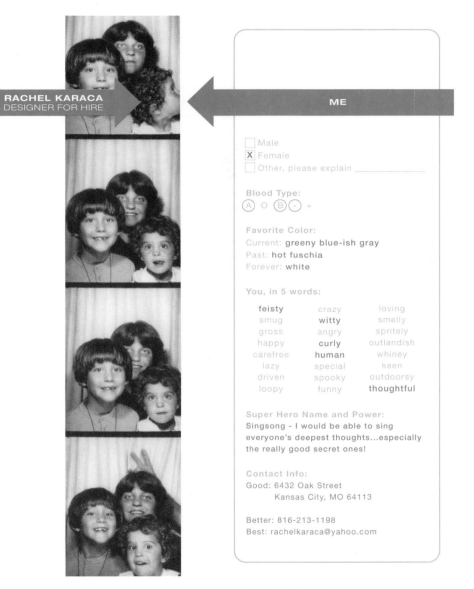

RACHEL KARACA
DESIGNER FOR HIRE

ME

☐ Male
☒ Female
☐ Other, please explain _____

Blood Type:
Ⓐ ○ Ⓑ ⊖ +

Favorite Color:
Current: **greeny blue-ish gray**
Past: **hot fuschia**
Forever: **white**

You, in 5 words:

feisty	crazy	loving
smug	**witty**	smelly
gross	angry	spritely
happy	**curly**	outlandish
carefree	**human**	whiney
lazy	special	keen
driven	spooky	outdoorsy
loopy	funny	**thoughtful**

Super Hero Name and Power:
Singsong - I would be able to sing
everyone's deepest thoughts...especially
the really good secret ones!

Contact Info:
Good: 6432 Oak Street
 Kansas City, MO 64113

Better: 816-213-1198
Best: rachelkaraca@yahoo.com

RACHEL KARACA, STUDENT PORTFOLIO, University of Kansas.

How to Identify Key Brand Attributes

However you come to determine your brand qualities, you will want to narrow down your list and focus on about three to five descriptive words. Choose qualities that best represent your unique capabilities and attitudes. Think about how you would envision translating these qualities into a more tangible "look and feel." Try to choose brand qualities that will lend themselves to creating a more **focused, positive,** and **memorable** impression that distinguishes you.

Words like witty, vintage, bold, intense, organized, daring, confident, imaginative, reflective, quirky, experimental, retro, edgy, outgoing, enthusiastic, focused, classic, raw, poetic, creative, playful, and wacky, are some choices you could use to describe your style.

A light-hearted and fun concept, this piece plays with the idea of identity. The design expresses Rachel's personality not only through the concept itself, but also through the copy and visuals used to support it. This unique concept and form is sure to stand out and be memorable. Indeed, it got her a job at Hallmark Cards.

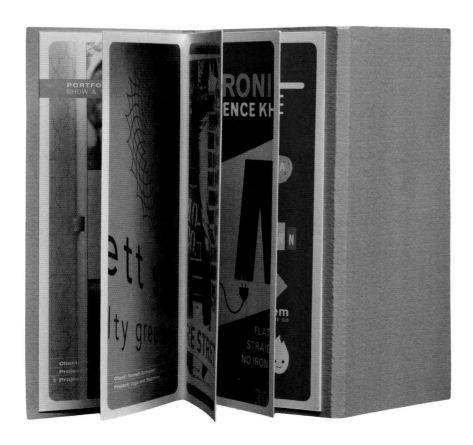

This little resume book is what I mailed to Hallmark Cards to get the position I currently (as of May 2008) hold as an associate art director for Shoebox, the humor division. I had to do something unexpected because they get over a thousand resumes a year. And the size was a result of wanting the piece to feel intimate and personal.

— Rachel Karaca

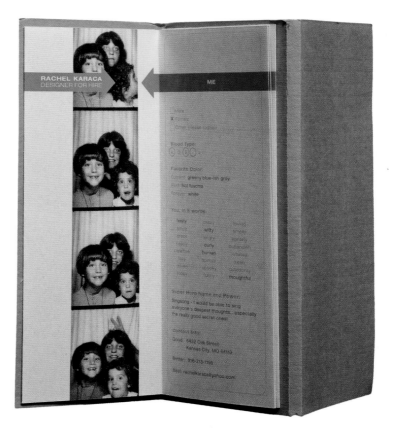

Brand Statements

A brand statement (sometimes known as a brand position) is a single statement that communicates quickly and succinctly the core values of an individual or company as they relate to its strategic positioning within a particular industry.

Personal brand statement: A single sentence that strategically promotes who you are, what you stand for, and what you're best at. It is a difficult process to develop such a statement as it challenges you to focus on your strongest positive attributes and then have the confidence to state them clearly and concisely. Be forward-thinking—take a stand, focus your message, and set yourself apart. A targeted message is guaranteed to make you more visible and memorable.

Don't worry about including *all* your talents and skills in this statement. You shouldn't include everything you can think of—this will only water down your message. Besides, there is a baseline level of skills and experience that should be true of most people in your industry. Such expectations should be demonstrated through the actual work in your portfolio. Your brand and subsequent portfolio design should, however, go above and beyond a generic description and focus on what makes you special. It's better to be targeted
and have something more unique to say than to be too generalized and like everyone else.

Your brand statement will be used as a guide, a touchstone, in the expression of your portfolio concept and design. A personal brand statement can also provide the basis for the development of a visual identity if you decide to create one.

Sample statement:

I am a [state professional title (photographer, graphic designer, illustrator, etc.)] **with strong** (amazing, leading, etc.) **skills in** [list core skills] **who is** [list brand attributes (qualities)].

Exercise: Brand Book

Need help? Think about your brand like you're telling a story about it—one that captures the essence of who you are as a creative professional. In advertising, most brands have a "brand book" that tells their story. Check out our website for resources.

A brand book is the story and personification of a brand—its ethos. It answers the questions: What does a brand sound like? Feel like? Look like? What's its purpose? Its mission? How is it different from its competitors? What's its unique personality and characteristics? How does it think and perceive the world? How does the world perceive it? Through visual elements and copy a brand book tells its story—written in the first-person narrative form as if the brand (or company it is representing) is speaking.

— Christine Pillsbury, VP, Group Director, Creative & UX, BEAM Interactive and Relationship Marketing

Brand Concepts

Often when you think of brand you automatically think of a logo. But you don't necessarily need one to communicate your brand and develop a concept and design approach for your portfolio (discussed in more detail in the next chapter). A brand concept tells a story that brings your brand to life in a tangible way, creating a context to view you and your work. And for those that do have one, it can extend the meaning and message of a brand identity. Thus creating an overall brand experience. The following are examples of brand communicated through symbolic visual and verbal references to personality, an idea, and/or a particular subject matter. Such references can be made through the use of symbols, iconography, imagery, forms, material choices, typography, color, and design elements that work alone or in combination to communicate a desired meaning. For any brand message to appear authentic it must resonate with how you present yourself and the work in your portfolio.

Food photographer, Reena Newman's portfolio book cover references a picnic with its red-and-white checkered tablecloth pattern. It's significant that she chose this type of tablecloth as her reference and not something more formal like a white linen tablecloth. This tells you a lot about the type of person and shooter she is. So, in this example, the "brand" is defined by visual symbolism that communicates subject matter and personality. Sticking with a similar theme, her logomark is reminiscent of a cattle stamp.

My favorite thing about the look of my portfolio (aside from the tablecloth/picnic reference—which I love!) is the reaction I get when people first pull it out of its case. It's playful and I feel like it reflects my personality before you even meet me. It seems to bring a smile to people's faces and gets the conversation flowing before they've seen any of my photographs. I'd say that that's a pretty great way to introduce myself, especially if I'm not there with my portfolio.

Having people know who you are and be able to identify your work as yours is hugely important. As a shooter trying to get out there and be recognized for what I do, so far, introducing myself as somewhat of a "specialist" has definitely been working to my benefit. I think that as I begin to establish myself as a name, I will be able to show people my range as I go.

— Reena Newman, Photographer

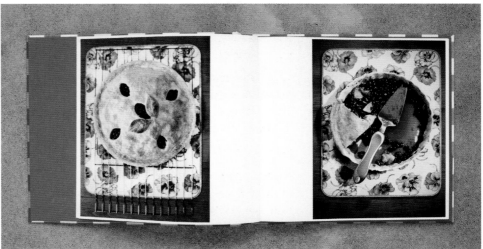

REENA NEWMAN, PORTFOLIO BOOK, Toronto, Canada.

MATTHEW BARNES, PROMOTIONAL MATERIALS, Toronto, Ontario.

Trends

When thinking about your brand, consider that certain industries tend to align themselves with certain attitudes and trends. Think about what's popular for the moment—like "modern," "minimalist" or "classic." Look to industry leaders, organizations, and publications to find articles and visual examples of what is being called the "latest and greatest." Consider trends not only from the market you are currently in, but also trends evident in the industry that you want to break into. Ask yourself—what concepts, visual forms, or attitudes are being represented? Then consider if you are already aligned with these or even if you want to be.

Matt is a shooter who focuses greatly on music, and
my concept was to make him the rock star.
— Clay Rochemont, Rochemont Reps

SOLVITA MARRIOTT, STUDENT PORTFOLIO,
Tyler School of Art.

Solvita's portfolio concept emphasizes her creative process and the things that inspire her. Her book design makes reference to a Victorian-style book aesthetic, making associations to the value and respect afforded such a book of that era. The craftsmanship of this book is exquisite. A subtle faux foxing technique further affords the piece a more antique look.

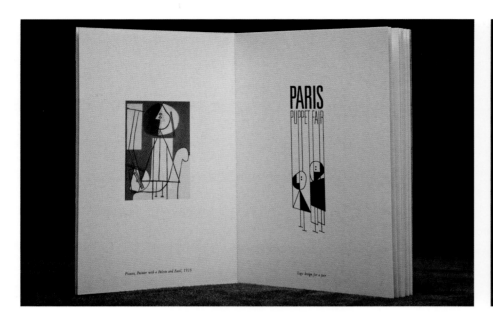

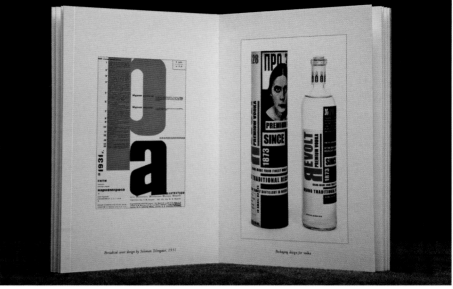

While working on ideas for my portfolio book I was looking for a common thread that would bring together my different projects. I noticed that many of my solutions were rooted in history, inspired by a certain art movement, or referenced an image I had seen somewhere while researching for my projects. I decided to make this the theme for my portfolio book. I selected and compared my projects (that had the most obvious inspiration) to the historical reference or original image that influenced the end product. I wanted the viewer to feel the special connection to the history and tradition that inspired my designs.

— Solvita Marriott

Q&A: Interview with Will Bryant, Recent B.F.A. Graduate, Mississippi State University, Mississippi State, MS

Will Bryant makes stuff as a freelance creative at the shared studio space *Public School* in Austin, TX. Will is primarily an illustrator and artist, but also enjoys identity and print design. He graduated from Mississippi State University in 2008 with a B.F.A. in graphic design. Check out his website at *www.will-bryant.com/*.

Were you a student when you created this piece? Was it created in response to a course assignment?

Yes, my final semester of undergrad (December 2008) at Mississippi State University. As an existing senior graphic design student at MSU we are required to create a self-promo. Typically, these are difficult and expensive to reproduce.

How did you arrive at the idea or concept for your piece? What do you think it communicates about you?

I wanted to create something I could easily reproduce in order to distribute to more people. My inspiration came from Frank Chimero's "The Small Print" book. He was very helpful (always is)!

I think it definitely showcases my personality and infatuation with hand lettering, bright colors, and light-hearted content.

Did you target a particular area of the market or industry with this approach?

Yes and no. It definitely showcases my illustration work more than design, so I'm planning on self-publishing another book to showcase that aspect of my skills.

What was the most challenging part about creating this piece?

The hardest part was definitely laying it all out. I didn't take the time to really edit myself or construct a systematic way of ordering the book, which I will definitely do in the future.

Who have you sent it out to? How did you send it? What did you follow up with (call, email, etc.)?

I've sent my portfolio to WK12, Decoder Ring, John of Advice to Sink in Slowly, Chris of Gorilla vs. Bear, and Domy Books. I just mailed it in a standard envelope and included a print among other brightly colored collateral (buttons and moo cards).

I've definitely followed up with email for the most part. I've visited the fine folks at Decoder Ring, and I would say meeting in person is the best.

What was the response?

Generally it has been very pleasant. Most people are genuinely impressed and it has sparked an interest to use Lulu for their own projects. On the other hand, I haven't landed a full-time job from this book. It is getting recognition and selling well ... so high five!

Do you have any advice for a student currently working on his or her portfolio and/or other promotional materials?

Definitely try to showcase both your work and your personality. Depending on what you're wanting to do in a creative field, that resume of yours can be secondary to the creation of your portfolio. Having it as a separate piece that just slips in something has been really nice. I've been able to show my book and then just leave behind a resume.

WILL BRYANT, STUDENT PORTFOLIO, Mississippi State University (page 26).

I MADE THIS FOR YOU

by Will Bryant

Design must seduce, shape, and perhaps more importantly, evoke an emotional response.

— April Greiman, Influential Designer

While brands speak to the mind and heart, the brand identity is tangible and appeals to the senses. Identity supports, expresses, communicates, synthesizes and visualizes the brand.[5]

— Alina Wheeler, Author, *Designing Brand Identity*

Once you have created a brand statement, you can begin to think about the visual and verbal properties that will best communicate your message. For some of you, that may develop into a brand identity.

A *brand identity* consists of both visual and verbal properties that work together to create a tangible representation of the qualities outlined by the brand. The best brand identities are **memorable**, **authentic,** and **differentiate** themselves from their competition. They assert the brand attitude with confidence and enthusiasm.

Do You Need A Brand Identity?

The following discusses the traditional components of a brand identity. Depending on your specific discipline and level of expertise, some of these aspects may not be appropriate to your needs.

For an independent photographer and designer, a professional brand identity, including a logo, is pretty much a must have. It's necessary if you're going to come across as a professional who takes their business seriously. It's also a good way to cohesively and consistently tie all of your promotional and marketing materials together. For those who are not designers themselves, it's recommended that you work with a designer to establish a professional brand identity system. A brand identity can stand on its own or coexist within a larger brand concept as applied to your portfolio and/or promotional materials.

For photography and art students, as well as many design students, a formal brand identity will not be appropriate. In this case it's not necessary to create a "company" name or personal logo. Instead, a simple yet effectively designed typographic treatment for your name is sufficient. The development of a brand identity and one that works effectively across medium is a difficult thing to do. A less than impressive one won't represent anyone well, even a student. Many professionals are even turned off by a student's attempt at a "logo" for themselves.

Instead, to show some personality and create a meaningful context for one's work, most students should focus on the development of a brand concept and subsequent design approach for their portfolio book, online portfolio and additional promotional materials. Typography, color palette, iconography, and other design elements as related to one's brand concept can work well to establish a consistent visual look across materials without the need for a more traditional brand identity and logo.

There are exceptions, however, for those students who have the chops to take their brand to the next level and have the work and promotional materials to warrant the creation of a formal brand identity system.

Verbal Components

The most prominent verbal components of a brand identity typically include name and tagline. However, all copy written for advertising concepts and marketing purposes contributes to a brand message. Such copy communicates a specific *tone of voice* and *attitude* relevant to the brand. Keep in mind that a message is only ever as good as its delivery. While you probably don't need a company name or tagline (your own name will suffice) you should think about differentiating yourself with some engaging copy—perhaps simply as the title of your book.

The following examples (taken from portfolio and promotional pieces in this book) demonstrate effective copy; that is, the title is an integral part of the portfolio's brand and concept and works well to differentiate the book.

- *Body of Work* (used as a pun) by Jessica Hische
- *Blood Makes the Grass Grow* by Anthony Georgis
- *I Made This* by Will Bryant
- *A Little Book of Inspirations* by Solvita Marriot

Visual Components

A brand identity is the distillation of a brand message. In its simplest visual form, it includes a logo as an identifying, symbolic mark, a color palette consisting of 1–3 colors and 1–2 selected typefaces to be used consistently across materials.

A visual identity system, however, includes all of the visual aspects that contribute to the overall brand message. In addition, this can include signage, icons, material choices, imagery, audio, and even motion— basically all the aspects of design used for promotional and marketing materials. All of these aspects should work together to support the brand as a whole.

For a visual identity to be successful it must do four things.

1. It must be *distinct* enough to stand out from the crowd—it must get you noticed. A successful visual identity should be unique enough to grab someone's attention and also hold his or her interest.

2. It must be *meaningful*. A visual identity should communicate something that is real. Like an overall brand identity, it projects an expectation that in order to be successful must be realized by the person or thing to which it is referring. In other words, the work in your portfolio should back up the attitudes and qualities expressed through your visual identity.

3. It must be *memorable*. To do this, the visual identity needs to be applied consistently to all aspects of the comprehensive portfolio. If someone were to view your portfolio book, website, or even business card for just a minute, it should be recognizable as yours.

4. It must be *versatile*. A brand identity, especially a logo must work well across medium and varying scale. It should look good on your portfolio book, letterhead, website, postcards, T-shirt, blog, etc. Your brand identity should be consistently applied to all your portfolio and promotional materials—connecting and reinforcing your brand.

Style Guide

A brand identity is typically defined in a document called a *style guide*. This document is used as a reference for all aspects of a brand's marketing materials. A style guide is often very specific about how visual and verbal components of the brand should be used. It can include directions regarding logo and image placement, color palette, size and proportions, image stylization, grid systems, materials, typographic systems, and even types of media to be used. All of these aspects are meant to work together to establish a distinct and consistent brand style. This same strategy can be applied, more or less, to the creation of your comprehensive portfolio. In the next chapter you will explore applying your brand identity to your portfolio book's front and back cover design.

Logos & Brand Identity

Many brand identities begin with a logo. Influential designer Milton Glaser said, "A logo is the point of entry to the brand."

There are two types of logos. A *logotype* is a visualization of the name of a company or person. A *logomark* is a symbol—abstract or pictorial—that symbolically represents a person or company. Sometimes both are used. Either way, logos can build awareness if used consistently.

A logo is created through the selection, manipulation, and visual simplification of formal properties belonging to shape, image, color, type, and word (like that of someone's name or pseudonym). It should be memorable and distinctive in the combination of those properties as well as in the meaning it evokes. Logos can be more or less specific to certain associations. Those logos that do not communicate specific stylistic and/or cultural references can have a broader, more versatile range across bodies of work or stylistic approaches. In which case, elements such as color, typeface, form, and material choices can be used to connect to broader symbolic or aesthetic associations.

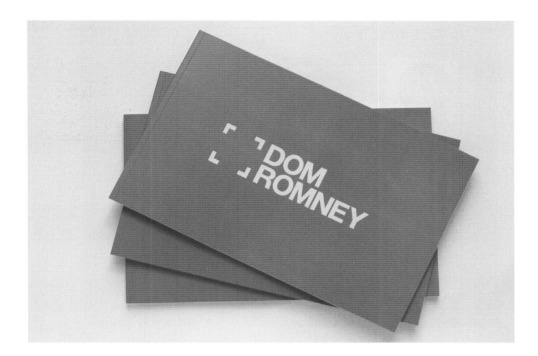

Dom Romney's brand identity includes both a logomark and logotype. The use of red along with his logo communicates a bold, modern, professional look. The symbol of a viewfinder references a camera and "seeing" without being so literal and of course speaks to the type of work Dom does.

DOM ROMNEY, WONDERFUL MACHINE, PORTFOLIO BOOK & IDENTITY, Newport, UK.

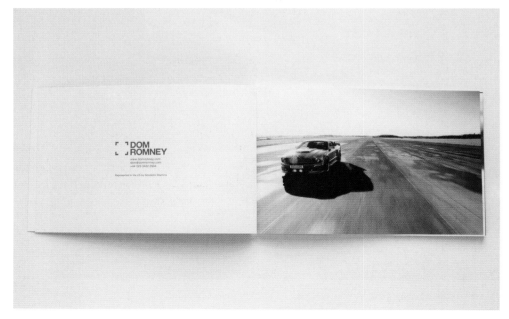

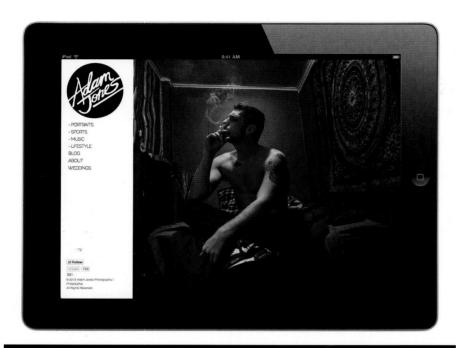

A brand identity, especially a logo, can be associated with a particular design, artistic, or cultural *style*. Doing so creates certain visual associations to you and your work. It can be used to express brand personality through specific characteristics associated with particular colors, shapes, ornamentation, and/or typography. To be effective, these visual references must be recognized and understood by their audience. Referencing characteristics with specific stylistic associations may limit the range and shelf life of a portfolio. However, it often leaves an impression and can make a more memorable connection (because of its specific associations) with your target audience. Again, make sure such references are authentic and meaningful to who you are and the type of work you do or it'll fall flat.

Photographer, Adam Jones' logo draws its inspiration from the skate and surf brands he grew up with. Kevin Fenton, the logo's designer explains, "The vibe I was going for with this logo was kind of an old school skate/surf feel. I wanted to try and stay away from incorporating a camera into the logo, and just do a simple typographic treatment that would help him stand out from other photographers in the industry. So I felt that this was a good simple way to represent Adam and the amazing work he does."

ADAM JONES, PORTFOLIO & IDENTITY, West Chester, PA.

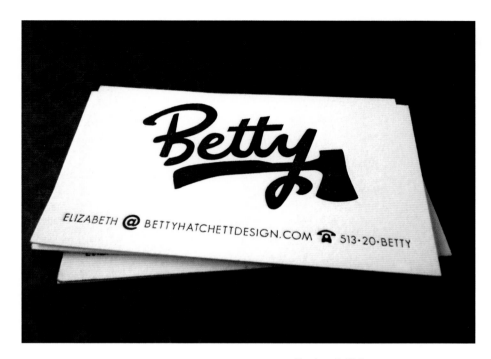

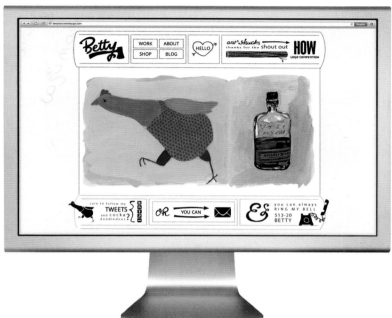

BETTY HATCHETT, IDENTITY & WEBSITE, Cincinnati, Ohio.

In this logo for designer Betty Hatchet, her last name takes the shape of a "hatchet"—a witty and playful visual pun that's memorable and stands out. She has designed additional icons and graphics for her website in a similar manner—extending the elements of her brand identity and creating a strong visual identity system.

Q&A: Interview with Christine Pillsbury, VP, Group Director, Creative & UX, BEAM Interactive & Relationship Marketing

Christine Pillsbury is a creative director at BEAM Interactive & Relationship Marketing in Boston. She has held previous positions at Mullen, U.S. Interactive, and Ogilvy and Mather in New York. She is the recipient of numerous industry awards, including the London International Advertising award, One Show Interactive award, and HATCH award. Ms. Pillsbury has an M.F.A. in dynamic media from Massachusetts College of Art.

How important do you feel an online and/or print portfolio is in securing a creative position in the interactive design industry?

Essential—don't bother without it. Seriously.

As a creative director, what do you look for in an online portfolio? What contributes to an overall portfolio design that stands out and grabs your attention?

First and foremost, the work. But a half-thought-out "container" can definitely take away from good work, while a great portfolio concept can really differentiate you.

How important do you think a brand or overall visual identity is in the success of a portfolio design?

Brand is so much more important than branding. I'm not looking for your cool logo, but I am trying to find out who you are, what you can do, what's interesting about you, what makes you different, and where you are going.

In general, how many pieces of work do you think a student should include in his or her portfolio?

It depends ...12 is a good number. I definitely think quality over quantity. People aren't going to sift through project after project looking for "it." The best portfolios are full of individual projects that demonstrate multiple skills and talents at the same time.

Do you have any advice for someone (especially a student) who is working on his or her portfolio and/or other promotional materials?

The people reviewing your work probably don't have a lot of time to spare; first impressions are literally make it or break it in this industry.

Brand is so much more important than branding.

I'M NOT LOOKING FOR YOUR COOL LOGO, but I am trying to find out who you are, what you can do, what's interesting about you, what makes you different, and where you are going.

CHRISTINE PILLSBURY

Creative Director, BEAM Interactive & Relationship Marketing, Boston, MA

Q&A: Interview with Shauna Haider, Graphic Designer, Nubby Twiglet, Portland, OR, *http://nubbytwiglet.com/*

Graphic designer Shauna Haider has built a name for herself over the last five years through her internationally recognized design studio, Nubby Twiglet which focuses primarily on branding and web design.

Combining her razor-sharp design aesthetics with a passion for branding and marketing, Shauna has teamed up with the likes of Adidas, Forever 21, Nike, Smith Optics, Virgin Records, and The Wall Street Journal on various creative endeavors. Additionally, Shauna has partnered with upwards of 100 small businesses to create memorable branding experiences.

As a designer, you've created a number of brand identities, several created for photographers. How do you go about capturing a photographer's "brand" and translating that into an identity? What was this process like with photographer Luke Copping?

Overall, when it comes to creating an identity for photographers my number one rule is to never overpower their work with a branding solution but to instead complement it. I want viewers to appreciate the branding but I never want to distract from it—there's a very fine line. When I'm working on potential solutions, I'm always thinking about the icon component and how that works with the rest of the branding because these days, it especially matters for watermarks and social media icons.

With Luke Copping, I wanted to create a simple, timeless wordmark and a symbol that was as sleek as his work. The symbol is made up of four "L's" which form a cross shape. It's powerful and modern all at once, just like his photography.

How do you see a personal brand identity functioning for photographers and designers? Is it important for professionals to have?

These days, it's more important than ever in part because creative fields have gotten so much more competitive. Having professional looking branding conveys that you take your work seriously. When potential clients come across a creative's work, they don't necessarily know anything about them. Those first impressions do count.

The more comfortable and at ease you make them during that initial introduction, the better the chance you'll win their business.

It's true that a photographer's craft is paramount but adding that extra polish through branding will set them ahead of their competition.

Do you have any advice for a photography student who probably can't afford to work with a designer? Or a designer who is just starting out?

For creatives who are starting out with small budgets, my advice would be to keep your branding as simple as possible. Simplicity implies that you're confident enough to let your work shine and conveys sophistication.

The cover design to Luke Copping's portfolio book is beautiful. What were your thoughts about approaching his portfolio? Was your approach different with his magazine promo?

I'd worked with Luke for a few years before we ever got to his portfolio—it was important for both of us to start small and work our way up the project ladder. This allowed us to work out all the kinks and inconsistencies and figure out what worked best. As time went on, we realized his symbol was one of the most powerful parts of his branding, especially when multiplied as a pattern.

Luke's magazine was definitely more commercial because it was meant to be a promotional item. But portfolios are the equivalent of a photographer's bible. I wanted to step it up a notch in sophistication with the tonal pattern on the front. The overall approach was quieter but the photos still tell the full story, from beginning to end.

*See work on next page.

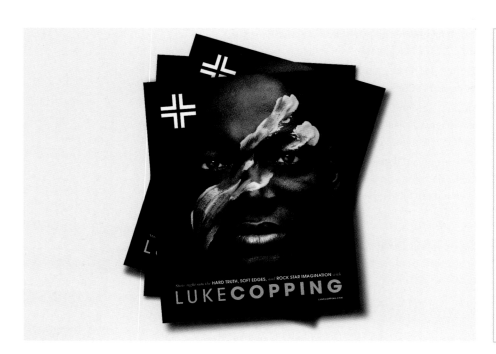

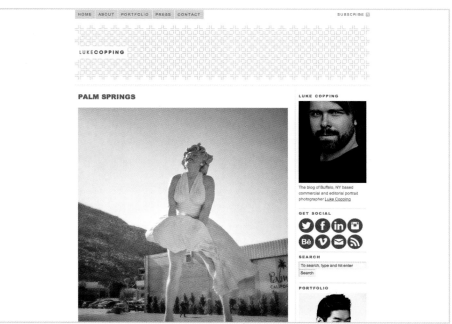

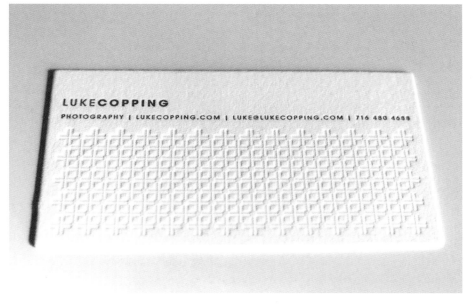

LUKE COPPING, PORTFOLIO & PROMOTIONAL MATERIALS, Buffalo, NY.

Q&A: Interview with Luke Copping, Photographer, Buffalo, NY, *http://lukecopping.com/*

Over the last few years, you've collaborated with designer Shauna Haider (aka Nubby Twiglet) on a number of promotional projects for your photography business, including your brand identity and portfolio book. Why did you decide to work with a designer?

I think that the DIY movement is a really positive thing in general, but I also found that as I focused more and more on making images it was all too much to keep up with. I also found that I was eternally dissatisfied with how I was representing myself visually—I would come up with a logo or a type treatment that I felt I really liked, but six months later I was restless and insecure about it again, so I ended up heading back to the drawing board and redesigning everything on my own again. This cycle kept going for a few years, with me constantly mutating my branding, website, and promos in ways that were ultimately unsatisfying, ineffective, and boring.

The great epiphany that snapped me out of this was when one of my mentors, a photographer I had assisted for some time, gave me a great piece of advice—"Pros work with pros", meaning that if I thought of myself as an expert in my field, than I should also understand that others are experts in theirs and trust their insight and focus in areas where I myself was weaker. The added benefit of this was that working with a designer I trusted would allow me to focus more on creating images. Over the last few years I have run with that philosophy and been really lucky to build an amazing support network of creatives like Shauna whose work and advice I trust and are unbelievably talented in their own creative specialties.

What has that collaboration been like?

Collaborating with Shauna has been an incredibly positive experience for me. We have worked on a number of projects together and the level of trust I have in her work just keeps growing. She has offered a wealth of insight to me over the last few years of projects in collaboration of design, blogging, site usability, and more—and I still get really excited when I know an email is on the way with concepts or proofs of a new project. Shauna has even revamped elements of my brand that are much less visible than my site and promo materials. For instance, we recently updated the look and format of my estimates and invoices—

documents that many people don't see until they are actually working on a project with me.

What do you think your brand identity says about you and your work?

It was important to develop something that was striking and memorable and yet versatile and supportive of the images rather than competing with them. Unlike branding elements that I had created for myself in the past I felt really at home with what Shauna had put together. The mark itself has become a really recognizable part of the brand, it is often used without the accompanying logotype of my name and many people immediately associate it with my work and style. This is exactly what I wanted from an identity system, something that was uniquely me and as much a part of the overall brand as the work itself. I also really love that this identity has been able to grow over time—we have done numerous variations for specific projects over the years like colored versions outside of my normal palette and the lattice of logos that I often use now as a design element, all of which are true to the core ideals of my brand but we aren't afraid to change it up and have some fun with it.

You have a number of pieces which you use in promoting and marketing yourself—portfolio, magazine, portfolio site, blog, reel, email campaign, etc. Have your thoughts about marketing yourself changed over the last few years?

I used to think of marketing as a very formal exercise, that there was a right way I had to do things to be successful, but over the last few years and working with Shauna I have been having a lot more fun with it and been a lot more free in my efforts. There is still a structure that gets applied to the process, in terms of having a budget and a calendar that I stay accountable to in order to make sure my marketing is consistent, regular, and manageable, but I don't look at it as a chore any more. I get really excited about the marketing pieces I work on and create with Shauna (or in the case of the video piece—Solomon Nero) and I view them as creative outlets in their own right. The magazine is a perfect example of this—taking my images and working with Shauna to put them in a really fun editorial context that makes use of type, layout, and graphics to present my work in a really cool way. I always want to be trying new things with how I market my work and my brand.

THE DIFFERENCE BETWEEN GOOD DESIGN AND GREAT DESIGN IS

intelligence.

TIBOR KALMAN

Influential Graphic Designer

COVER DESIGN

The creation of your own portfolio book is a creative statement about the value you place on your work and craft. It is important that your portfolio book function in two important yet different ways—addressing both the exterior and interior book design (discussed in the next step).

Cover Design

Your book cover design needs to get you noticed and distinguish you from "the crowd." It needs to communicate your unique talents and experiences in a positive and memorable way. To do this, you need to capitalize on your own unique creative vision. Distinguishing yourself from hundreds of other seemingly similar candidates will provide you with a vital competitive edge. Therefore, it is important that your portfolio book not simply be a container for your work, but act as a well-thought-out and well-crafted creative statement, in and of itself. Creating your own unique book will also demonstrate your commitment and dedication to your profession. This is especially true in our competitive creative industries where creative professionals distinguish themselves by taking the initiative to make sure that they show their very best right from the start. This chapter will guide you through a number of steps in order to help turn your brand statement into a visually compelling concept and design.

Your Approach

There are a number of approaches you can take with the design of your portfolio book. Depending on where you enter this process, your approach may vary. Keep in mind that you should be making conscious decisions that will ultimately provide a means to get you noticed and differentiate you within the marketplace.

At the most basic level your portfolio book is a formal exercise in print design and bookmaking. In addition, your cover design should reflect consideration of your brand statement. The purpose of your cover design is to get you noticed and differentiate you from the crowd. The style or "look and feel" of it should connect with your target audience immediately and reference the type of work you've done and/or want to do. As creative individuals we are in the business of concerning ourselves with working to translate ideas and abstract qualities into tangible and cohesive visual messages. Such is the process of developing a creative concept and design from your brand statement.

In the art and design world this is often referred to as the "look and feel." Visual properties as defined by such things as color, image, symbol, material, typeface, and even composition are given significant consideration to make sure that the "look" accurately works to communicate the desired "feel" of the message. For example: The look of a fractured composition could feel edgy; the look of diagonally composed type could feel dynamic; and the look of a large red bull's eye could feel confident and bold. Your cover design has the potential to distinguish you as a creative professional and leave a lasting memorable impression. By referencing a conceptual idea and/or your brand identity you can connect all the components of your comprehensive portfolio package together into one clear and concise statement.

There are a couple of ways to think about your cover design:

Level 1: As a formal print design and bookmaking solution.

Level 2: As a conceptual statement that leads to a visual direction and/or a brand identity solution.

As part of your design approach, carefully consider the book's size and aspect ratio relative to your imagery, construction materials, paper (weight, type, coated/uncoated), and binding (all discussed in more detail later in this chapter, Step 3B and Step 5). Additionally, while it will add to the cost of your book, you may want to consider special printing techniques for the cover—such as emboss/deboss, die cut, spot varnish, foil stamp or even letterpress, silk screening or folding techniques. Refer to the "Resources & Links" section of our website for a further breakdown.

Style, in its most general sense, is a specific or characteristic manner of expression, design, construction, or execution.[1]

— Steven Heller and Seymour Chwast

Note: Consider the entirety of the book—front, back and spine.

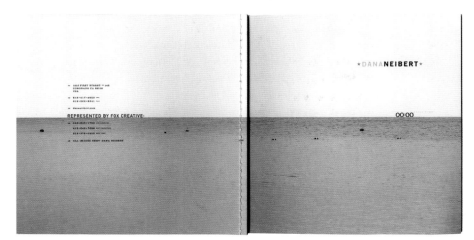

DANA NEIBERT, PORTFOLIO BOOK, Coronado, CA.

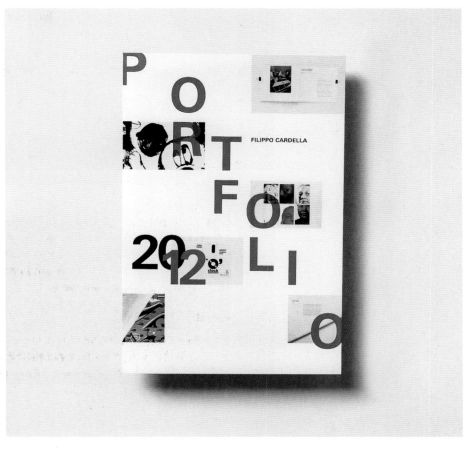

FILLIPO CARDELLA, PORTFOLIO BOOK, Pisa, Italy.

JOEL SILVA, STUDENT PORTFOLIO BOOKLET,
Faculty of Fine Arts at the University of Lisbon.

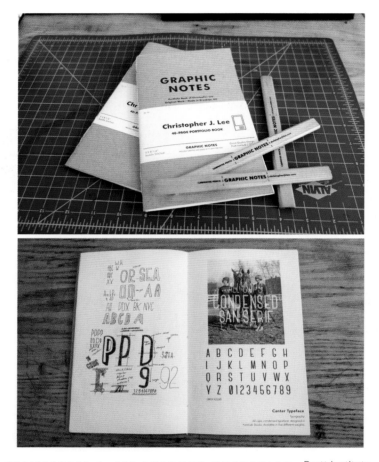

CHRISTOPHER J. LEE, STUDENT PORTFOLIO, Pratt Institute.

Now that you know what you want to say, you need to figure out how best to say it. To sell yourself you need a brand. To sell your brand you need a big idea. The next step in this process is to develop an overarching visual idea or concept—something that can provide the basis for the direction of your visual design. A visual concept can be more loosely or tightly defined. It can be a literal translation, or on the other extreme, act as an abstract reference to your brand statement. Whichever direction you head in, you should start by doing some thinking and sketching.

There are several ways to proceed:

- Connect your brand attributes to specific imagery or icons that are symbolic of you, your work, or simply your artistic vision.

- Reference a specific visual system or genre that works well to represent you.

- Utilize a conceptual methodology like satire or symbolism to develop an idea and take advantage of related visual systems and methods.

- Use your brand statement only as a launching point and work from there to brainstorm a concept or message.

Good design IS ALL ABOUT MAKING OTHER DESIGNERS FEEL LIKE IDIOTS BECAUSE THAT IDEA WASN'T THEIRS.

FRANK CHIMERO
Illustrator, Graphic Designer & Writer

Q&A: Interview with Gail Swanlund, Co-director and Faculty, CalArts, Graphic Design Program

Gail Swanlund is a designer and professor, and co-director of the graphic design program at CalArts in Valencia, CA. Her work has been exhibited at the San Francisco Museum of Modern Art and she has been recognized by the American Center for Design, AIGA, and The Type Directors Club. Her work has been featured in *Emigre*, *Eye*, *Print*, *IdN*, and *Zoo*, and has been published in various design anthologies, including *Graphic Radicals/Radical Graphics*, *The Graphic Edge*, and *Typographics 4*. Professor Swanlund received a master's degree from CalArts.

What kind of portfolio or bookmaking course do you teach? What's the course name? What level is it geared toward? Is it a required course?

In the B.F.A.4 year (the fourth year of the undergraduate program), students curate and design an exhibition catalog in their core design class. In the spring, the B.F.A. candidates prepare a portfolio, including resume, website, reel, and a printed book.

What do you think makes for an outstanding portfolio book?

Innovative work with a thoughtful concept supporting the thoughtful form.

How important is a print and/or online portfolio in securing a job in the industry?

It's essential. You can't hide anything with a printed book and it really helps support, for example, a reel, to show off typographic detailing, composition talents, skillfulness, and so forth.

In general, how many pieces of work do you think a student should include in his or her portfolio?

10–20 really great pieces. Get some advice from teachers, professionals, other pals. Don't overload the portfolio with too many projects, but do have some projects held in reserve in case the interviewer shows interest and wants to see more or something specific.

Understanding the Range of Possibilities

There are many ways to proceed with your approach. You need to discover what works best for you. You may perhaps decide to create a composition through illustration or photographic montage that references a narrative. Perhaps you are interested in developing a broader metaphor for your portfolio, like Jessica Hische's *Body of Work* [pgs. 42–43]. Perhaps poking fun at an idea, product, or company through a clever parody or witty satire is more suggestive of your personality. Or, you may simply want to reference certain aesthetic qualities that can be expressed more abstractly. For example, an intricate pattern can communicate a sense of focus and attention to detail. While a composition developed from expressive lines and shapes can suggest a spontaneous dynamic energy. Even one image, be it witty or serious or bizarre or subtle, can communicate volumes about who you are as an artist. Whatever you decide, *be conscious of the images, symbols, shapes, and visual styles that you reference*. Don't just randomly choose things for no reason. Remember that out of all the concepts and subsequent visual references in the world, whoever views your portfolio will identify you with the ones you do choose.
Make sure you know what your portfolio design will communicate about you.

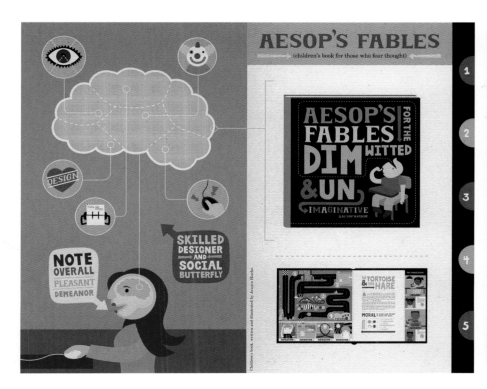

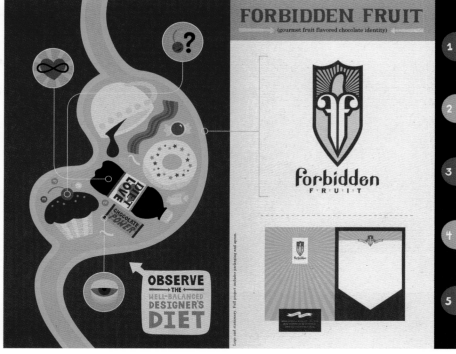

JESSICA HISCHE, STUDENT PORTFOLIO, Tyler School of Art.

Jessica's concept is developed through the use of a visual/verbal pun, playing with the phrase "body of work." The concept, color palette, illustrations, and typographic treatment all work beautifully together to communicate a whimsical, animated, and witty approach to her portfolio. This is also a great example of a portfolio that is a completed piece in and of itself. Clearly, it stands out and communicates Jessica's unique creative vision and artistic talents.

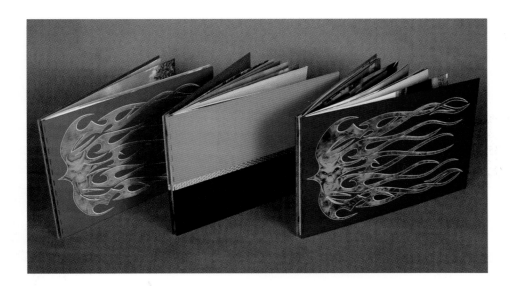

The glossy, metallic surface and "tricked-out" custom-painted designs of Roger Snider's portfolio books set him apart and reinforce his niche specialty shooting big rig trucks.

ROGER SNIDER, PORTFOLIO BOOK, Los Angeles, CA.

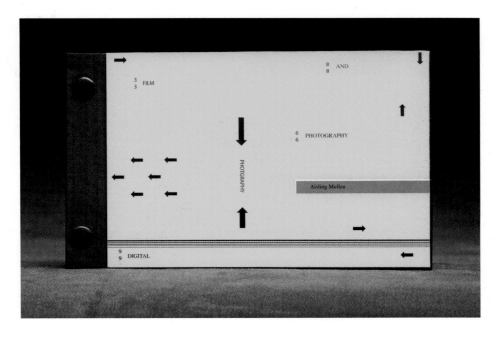

AISLING MULLEN, STUDENT PORTFOLIO, Endicott College.

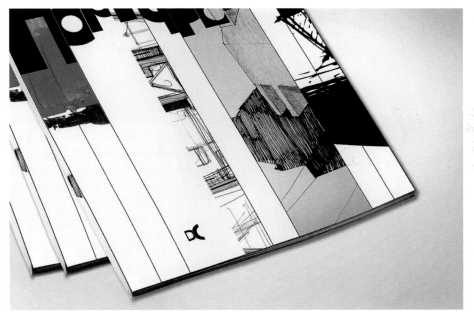

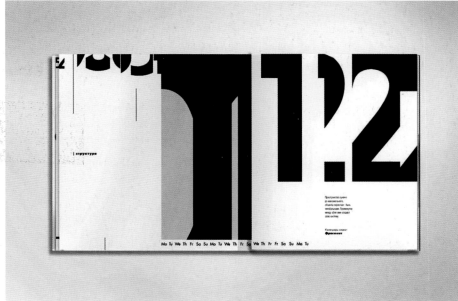

DENIS KOCHEDYKOV, PORTFOLIO BOOK, Moscow, Russian Federation.

The work in my portfolio was divided into genres and collected in separate chapters. For each chapter, there are unifying expressive features: the first chapter is called "structure / destruction" for the graphics, the second is "volume / space" connecting mainly architectural designs, and the last "invoice / surface" which features paintings. The overall theme for the book is collage—divide into parts and pieces then combined to make new stuff. This is reflected in the structure of the book and depicted on the title page and on the cover of the book.

— Denis Kochedykov

Conceptual Methodologies Defined

If you want to create a more tightly defined concept, investigate the following conceptual methodologies:

- *Satire:* Works great as a strategy to create concepts that are witty, sarcastic, edgy, and relevant.

- *Parody:* Spoofs, caricatures, humorous imitations—it's always fun to poke fun of something at its own expense, but these concepts need to be relevant and meaningful in order to be successful.

- *Narrative:* Whether linearly defined stories or loosely strung together nonlinear references, narratives describe a sequence of fictional or nonfictional events.

- *Symbolism:* Symbols do well to connect to abstract ideas and nonliteral references. If used strategically, the use of symbolism can bring a lot of meaning to a piece.

- *Metaphor:* Metaphors are poetic in nature. They are often used to explore abstract ideas through an underlying connection to a (sometimes seemingly unconnected) tangible idea or object. For this reason, while difficult to achieve successfully, metaphors often make for the development of some very original and thoughtful concepts.

- *Visual pun:* Witty, relevant, and fun, visual and verbal puns can be a great method for grabbing someone's attention and remaining memorable. The usage of puns also references the field of advertising—as this technique has been historically used to great advantage in this industry.

KEN GEHLE, PROMOTIONAL BOOK, Decatur, GA.

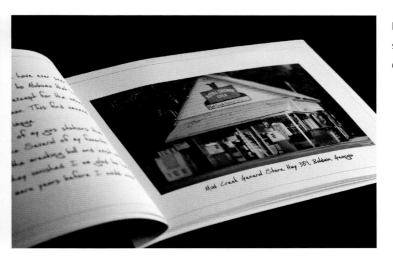

Ken's promotional book makes use of a narrative structure to pair photographic images with his own observations and comments.

Sketches and Word Associations

If you don't know where to begin, sketch out some ideas with paper and pencil. Brainstorming fresh and thoughtful ideas is difficult. You don't want to present a concept that is too generic or obvious. One way to get the ideas flowing is to do a word association (you can do the same thing with images too). Start with the words you wrote down in Step 1—those qualities that define you and your work. Write down each word across the top of a piece of paper, and underneath each create a list of associated words. Write down anything that comes to mind—be creative and let your mind wander! Think of places, people, objects, and symbols that might be associated with the qualities you defined. Then from this list of words, circle those that seem more interesting and less obvious. Do the same thing again with these words and try to think of other things that might relate. In this way you may discover references that may help you develop a more interesting and unique idea.

Moodboards

The creation of moodboards is common practice in design, advertising, and marketing. A moodboard is essentially a collection of found imagery that defines a particular concept, style, or overall "look and feel." Moodboards are often used to inspire and communicate a sense of brand and visual direction. They should make an impact on the senses. The selection of imagery can be based on whatever strikes you—color palette, image, type, texture, composition, pattern, etc. It shouldn't be limited to subject matter. Seek out and derive materials from magazines, photographs, materials, fabrics, books, and other types of visual forms (if you don't want to cut up something, scan it and print it out first). If you come across something (say, a traffic sign or architectural detail) that you like, snap a photograph of it. Try to keep a visual log of things that inspire you. Keep in mind the brand attributes that you've used to describe yourself.

From the materials you are searching through, cut out the parts that relate to your vision and inspire you. Paste them onto something like poster board. Creating moodboards is often quick and easy so it's a great way to try out a variety of ideas and directions. Create as many moodboards as you like—trying out different "looks and feels"—and create a range of ideas that you can step back from and evaluate. It's a great way to decide what you do and don't like.

Promotional Exercise

Produce a single promotional piece that presents you or your work through a particular concept. This exercise is designed to expand your thinking and stimulate ideas that eventually could be used as the launching point in the development of a larger portfolio concept. Focus on: *Ideation—the generation of ideas*.

Rather than trying to conceive a portfolio concept from scratch (even if you have already developed one) this process will allow you to experiment with packaging or presenting your work through a thematic approach to a *concept-driven piece* on a smaller scale. The intention here is to use this smaller scale process as a sketch for a larger potential idea without the burden or pressure of having to consider this larger effort.

To help you through a process of generating concepts and ideas for your visual approach, work on a single targeted marketing piece. Your approach should make reference to your brand statement and utilize a concept or method targeted toward a particular client or market.

1. Pick a client or clients and a particular market.

2. Pick an approach—stylistic, conceptual, formal, etc.

3. Develop a single marketing promotional piece. Start with something small, such as a:

 • Two-sided postcard

 • Matchbook or box of matches

 • Invitation to your professional launch party

 • Set of stickers

 • Small mailing

Q&A: Interview with Kristen Bernard, Designer, Graduate, Endicott College, Beverly, MA

Kristen Bernard is a graduate of Endicott College, Beverly, MA. She graduated in May '09 with a B.F.A. in Visual Communications (concentration in Graphic Design), and a minor in Communications. She is the Marketing Web Director at EBSCO Information Services. This interview was conducted when she was a senior at Endicott.

Were you a student when you created this piece? Was it created in response to a course assignment?

At Endicott, we are all expected to complete a portfolio class, where we create a book, website, and other materials. In one assignment, we were directed to "brand" our design style. This was challenging because we had to develop a concept that reflected our individualism, style, and taste for design. To arrive at my concept, I listed some words I thought described who I was and how I designed. I came up with words such as "clean, organized, structured, bold, and balanced." With these words in mind, I began thinking of the "+" sign with its balance and structure to inspire my book.

How did you arrive at the idea or concept behind your piece? What do you think it communicates about you?

With my cover design, I wanted to demonstrate that I could be counted on for solid graphic design skills—focusing on type, layout, and color. I wanted to communicate a formal, clean, and structured look. For this reason, I chose to reference the Swiss International Typographic Style for my inspiration.

What was the most challenging part about creating this piece?

The most challenging piece to this assignment was trying to target who I am as a designer. With limited professional experience, I relied on examining my personality to come up with my "brand." However, as my personality grows and evolves, I would expect my design to grow and evolve as well.

Do you have any advice for a student currently working on his or her portfolio and/or other promotional materials?

Any advice I could pass on: Collect any design materials you admire, are inspired from, or are generally attracted to, and tape them into a sketchbook. Subscribe to creative publications and become a member on design-based websites. In addition, you may really love an idea you are working on, but be prepared to throw it away and start from scratch if you find yourself going nowhere. Don't force anything.

KRISTEN BERNARD, STUDENT PORTFOLIO, Endicott College.

TYPE
PHOTO
FINE ART

+ + +

KRISTEN BERNARD

Q&A: Interview with Jamie Burwell Mixon, Professor, Mississippi State University

At MSU, Professor Jamie Burwell Mixon is the coordinator of the graphic design emphasis area, teaches graphic design, and continues to design for select clients. Mixon was named an MSU Grisham Master Teacher in 2004 and won an MSU Grisham Teaching Excellence Award in 1996. She has twice been selected as MSU's CASE Professor of the Year nominee. (She *loves* teaching.)

Over the years, student designs created in her classes have been published in *HOW* magazine, *CMYK*, and *Creative Quarterly*, as well as won awards in ADCMW's The REAL Show, the International Design Against Fur poster competition, *USA Today*'s Collegiate Challenge Competition, the AAF ADDY Competition, and DSVC's National Show, among others. (She *loves* students who love design.)

What kind of portfolio course do you teach? What's the course name? What level is it geared toward? Is it a required course?

I teach ART4640 Advanced Graphics. This is a capstone portfolio course required by all MSU graphic 3design emphasis students. Students are required to take this course their last semester.

What do you think makes for an outstanding portfolio?

Wow! So many things go into the making of an outstanding portfolio! Certainly excellent design, concept, and perfect craft are expected. But also the ability to edit out your weaker work; a portfolio is judged by its weakest piece. When in doubt, throw it out! In my experience, when a student has complete confidence in their portfolio—without any doubt or hesitation—it shines bright!

How important is a print and/or online portfolio in securing a job in the industry?

Yes! Both are important. A student must be ready for all opportunities. If a student is in contact with a potential employer online and secures an interview, then the printed self-promo piece is used as a leave-behind. A printed piece may also be used as a foot-in-the-door technique to introduce the student to a firm and generate interest in their online portfolio, thus securing a face-to-face interview or portfolio review. Students must be quick on their feet, flexible and persistent in the search for a great design position! One thing is certain: The student must know all there is to know about the firm they are contacting and be genuinely interested in it!

SO MANY THINGS GO INTO THE MAKING OF AN

outstanding portfolio!

Certainly excellent design, concept and perfect craft are expected.

JAMIE BURWELL MIXON

How important is the brand or overall visual identity of the portfolio package (including book, website, resume, business card, etc.)?

In my portfolio course, students essentially create an entire brand for themselves. Self-promo, website, CD, and portfolio format are all visually and conceptually consistent with each other. It's not easy; the hardest, flakiest client is often yourself! The great thing is that a student can achieve amazing results by working hard and paying attention to detail. Students often feel overwhelmed at the beginning of their last semester. I encourage them to tackle one day at a time; check one thing off of their list each day. It works! Professors schedule due dates not to be cruel, but to create a framework for student success.

In general, how many pieces of work do you think a student should include in his or her portfolio?

MSU students have around 10–12, but some of those will be a series of 3 or a campaign of, say, 5 pieces. If a student has a few extra pieces, they can switch out what they carry to an interview, depending on what that firm is looking for. Always be in tune to the specific interview situation.

Do you have any advice for the student currently working on his or her portfolio and/or promotional materials?

After seeing lots of students go through the same portfolio process each semester, it's pretty easy to see why certain students are more successful than others. Hard work, passion for design, and attention to detail come to mind. I can see when a student's work is created out of *love* for design rather than fear of failure. Both get results, but I'd much rather work with the passionate designer! An excellent portfolio secures an interview; the designer behind that portfolio gets hired. I always tell my students to work hard, be brave, dream big, and aim high.

Book Size & Proportion

As you consider your book's concept, design, and overall form you will need to think about the book's size and proportions. If you are making your own custom book, you have quite a bit of freedom as you consider what will work best to accommodate the work in your portfolio and your book's concept and design. In general if your book width is smaller than 8 inches you run the risk of your images/designs not being legible. If your book is larger than 15 inches you run the risk of the book being unwieldy to hold and look at. Keep in mind that a book at say 15 × 11.5 inches would be 30 inches across when open. That's a pretty large book. You may also need to consider shipping costs if you plan to send books out. If you go with an online publishing service check out the sizes and costs available. Some standard sizes are: portrait 8 × 10 inches, landscape 10 × 8 inches, 14 × 11 inches, and square 12 × 12 inches. If you plan to work with a printer (for either digital or offset printing) or a custom bookbinder, check with them first to see what they recommend. Keep in mind that the size and proportion of your book should be based first and foremost on what will work best to accommodate images of your work—considering various aspect ratios and issues of legibility. A book that is square or close to it (like 10 × 8 inches) can work well for images that run both horizontal and vertical.

Dominant Elements

The visual focus of your cover design should reflect your brand statement and subsequent design concept. It may also refer to a brand identity that you have developed. As you visually translate your ideas you will need to decide how best to communicate your message through *specific design decisions*. Start by determining the *dominant elements* that you want to emphasize in your cover design. They should reflect the area of the industry you want to work in and communicate who you are as an individual creative. As such, the primary visual elements used in your design should be most closely associated with the type of work you want to do—that is, photography (the image rules), illustration (show off your drawing talent), brand (think logotype and brand scheme), advertising (such as witty image and word combinations), or design layout (think type and grid!). Establishing the right dominant visual elements to communicate your brand message is essential.

Subordinate Elements

You should spend some time thinking about the *subordinate elements* you would like to include in your cover design. The use of subordinate elements should of course be supportive to the visual message and not distract from the primary elements used. As mentioned before, the standard visual components of a "look and feel" include color palette, iconography, or stylization of imagery, and one or two specified typefaces. For brand designers, a logotype may also be a key element to consider. There are, however, less obvious aspects to consider as well. A visual identity should include the way in which the visual elements are joined together within the composition—like a composition that feels balanced and harmonious versus one that is full of dynamic energy and tension. In addition, a visual identity should address issues of scale and proportion.

Compose the Elements

Next, you need to take your design direction a step further and figure out how to compose each element within the overall cover design. For example, while a photographer may focus on the use of photographic imagery in his or her design, there are many, many visual techniques that can be used to interpret and communicate a specific message. So whether as montage, collage, sequence, digitally manipulated, large, small, abstract, close-up, etc. is totally dependent on what you want to communicate and the direction you decide to take in order to communicate it. As you sketch, comp, and work through this process, make sure to consider your design as a whole and work to integrate all the elements together as one cohesive statement.

Again, the foundation for this direction should come from the work you did in Step 2—defining your brand statement and big-picture concept. For example, a more "formal" brand does best with formal balance, classical text treatments, subtle color, and harmonious, proportional divisions of space. By contrast, a young, witty, dynamic brand relies more on asymmetry, dynamic forces, quirky balance, bold color and typographic styles.

Consider Material and Formal References

As part of this exploration you should also consider material choices, especially for the front and back cover. What would vinyl, metal, or even canvas communicate about you and your work? You should consider all these aspects to some degree, depending on your discipline, background, and experience. As you continue to make choices, remember that the physical form of the portfolio is completely up to you; however, you should consider what forms best communicate for your purposes and also practical issues such as portability. As you consider the structure of the book, remember that there is just something tangible and reassuring about holding a book in your hands. Think about its weight, size, texture, and the types of materials used to construct it. All of these aspects are part of the design of your book (see Step 3B for more information on materials and forms).

Logos

Too often inexperienced designers think that a simple monogram, overlapping or combining two or more letters to form one symbol is a logotype. Simple monograms are things you see on fancy towels, not on visual communications portfolios. There are, of course, interesting ways to combine letterforms to make a logotype, but this requires careful study and practice. Logos can also be simplified pictorial symbols or abstract shapes. Creating a successful logo is challenging and difficult to do. A logo should be visually distinct enough so someone can immediately recognize it and relate it to a specific brand. It also needs to be abstracted and simplified enough so someone can remember it. If you've developed a personal logotype in the past and have received positive feedback about it, then it is perhaps a good idea to consider using it in the design of your portfolio. If you haven't, you may want to consider skipping this part and think more about the style of typeface that you will use to spell out your name or the title of your book. A poor personal logo is always an indication of overconfidence and inexperience.

THEORETICAL UNIVERSE, Boston, MA.

STEPHANIE KATES, Endicott College.

COLOR

Finding the right color combinations to establish tone and attitude is essential. Color is the first visual component we perceive and can be the most memorable (based on Gestalt cognitive theory!).

Certain color palettes can reference a specific genre or visual system. Color can be associated with a specific time, place, or culture. Think about the vibrant colors associated with 1970s punk versus the more formal palette of the Swiss Typographic style. Sometimes, it's only one or two colors that really capture the spirit of a genre, style, or time period. Consider if historic or contemporary color trends and styles make sense for your work.

You may decide to work with images or illustrations that include a multitude of colors. That's fine, but at some point you'll at least need to think about choosing a few specific colors for the typography and graphical elements. Aspects of your color palette should continue into the interior page design of your book in order to provide continuity throughout. A specific color palette can also be effective in order to unite other pieces of your comprehensive portfolio, such as a website, resume, and perhaps even a business card or promotional piece.

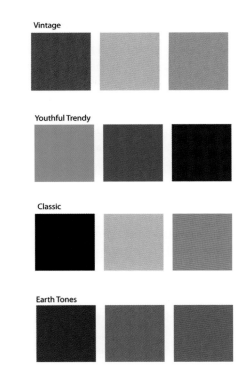

Vintage

Youthful Trendy

Classic

Earth Tones

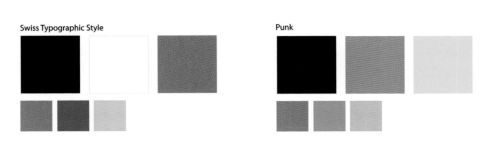

Swiss Typographic Style

Punk

Note: Try the Color Guide palette in Adobe Illustrator for a variety of helpful color schemes and options, including tints/shades and split-complements.

Color Palette: Dominant, Subordinate, Accent

A traditional color palette starts with three colors. In many cases two of the colors often harmonize with each other. This can be done by choosing colors that are near each other on the color wheel or by choosing colors with a similar tone (amount of gray). The third "accent" color is usually brighter and bolder. It is often used sparingly to call attention to important information and helps to establish a hierarchy of information.

Hue, Brightness, and Saturation

The perception of a color is greatly affected by its value and saturation; in planning a color combination, value and saturation are as important as hue.

- Saturation = intensity of color (hue). The saturation of a color is determined by the amount of gray added to it.

- Value = the lightness or darkness of a color. The value of a color is determined by its respective lightness or darkness.

Color that is more saturated tends to be described as bold, vivid, intense, clear, and rich. Color that is less saturated tends to be subtler and is often described as muted, neutral, timeless, and classic. Sepia tones are a good example of less saturated color.

Define the Palette
1. Dominant Color
2. Subordinate Color
3. Accent Color

Example = pink, red, maroon

Note: Be careful with very saturated colors. They are often "out of gamut" and cannot be printed accurately.

To create more neutral colors:

Shade = Add black to darken a color.

Tint = Add white to lighten a color.

Tone = Add gray to mute a color tone.

Web links:

http://kuler.adobe.com/

www.colourlovers.com/

Symbolic and Emotional

Color, more than any other visual property, tends to evoke the most visceral and immediate emotional reaction. It can be used to create symbolic meaning or reference a specific genre or style. Our psychological and emotional reactions to color may be based on cultural connotations or personal experience. Whatever the reason, color is an important aspect of establishing a mood and context to your work. It's important to know how certain color combinations will affect these reactions.

- *Symbolism and context:* Take red, for example. It can mean blood, stop, anger, or love—all very different meanings. One must look at its context in relationship to other colors, images, symbols, and text in order to understand its symbolic meaning.

- *Cultural color combinations are more locally understood:* For example, red, white, and blue can symbolize the United States to Americans or the United Kingdom to the British. Black is often associated with death; however, in parts of China and Japan, white is traditionally associated with death.

- *Universal colors:* These are more globally understood. For example, green is typically symbolic of the environment (although in the United States it can symbolize money as well).

- *Functional color:* Use color to establish visual emphasis and hierarchy.

- *Color as brand:* such as McDonald's yellow and red combo, Starbucks' green, UPS's brown, or Coca-Cola's red and white combo.

Need Help: Three Different Strategies

1. If you are using a specific image as a main element in your design, pull a dominant color from the image itself and build your palette around that. In Adobe Photoshop, go to Filter > Mosaic to pixelate the image and get a better sense of the dominant colors.

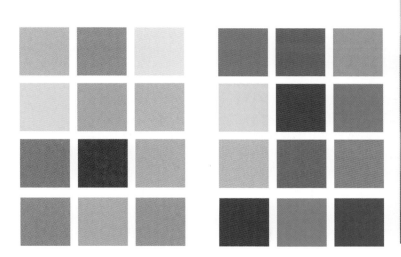

Images and Iconography

Imagery and Visual References

When visual elements are used within a cover design they can function solely as formal devices designed to move the eye, and structure the composition. In this case visual elements may not have been intended to convey a specific meaning, but may reflect a style or visual approach. A visual, whether it is a photographic image or illustration, can be used to more concisely reflect your brand and contribute to your visual identity. There are many approaches to including visual elements and imagery that build meaning and references into your cover design. Beyond logos and known symbols, visual references and relationships between visual elements can come together to create a reading within the composition. With an understanding of how visual information can build meaning, a good design can be strengthened by informing it through thoughtful combinations of visual elements.

Look and Feel

The most fundamental method to build a characteristic reference or quality that will support your visual concept is through stylistic references. The incorporation of a visual style that is identifiable is one method of bringing visual character to your work. This can be done through formal elements that are associated with the particular style or the stylistic elements of a known movement in art.

Appropriation and Visual References

A very common practice today, appropriation has been fostered by the flexibility of digital information and imagery. It is a simple matter now to scan, photograph, and place visual material from any number of sources. The concept of appropriation is a grab-bag term to refer to any kind of repurposing and recontextualizing of photographs, stylistic elements, logos, and historical or culturally significant visuals. The essence of appropriation is the application and use of an image, or visual *in its entirety*, wherein the original reference or context is clearly recognizable and creates an association or identification. An appropriation can be an end unto itself, presenting you as a creative who taps into a broad and varied palette of ideas.

2. Split complementary—a set of three colors forming a triangle on the color wheel. One color is coupled with a pair of colors adjacent to its complement (usually the accent color). Work with the interrelationships (commonalities and variation) between hue, intensity, and value to develop a color palette that has strong visual contrast, but doesn't compete with too much tension.

3. Add a bit of gray to move away from more typical "crayon" colors. Work with color tone—matching the tone of two colors will help to relate them. Neutral tones often make for good background colors. They work well to accentuate bolder hues. In addition, earth tones such as brown, tan, and olive can also be used to make colors more neutral.

For a list of copyright resources, go to www.noplasticsleeves.com.

A Note about Copyright and Appropriation

Appropriated imagery has been a part of visual works from artists dating back to the early 20th century. Notable artists such as Andy Warhol and Shepard Fairey have incorporated visual material from a variety of sources with a range of interests and intents. Now, with digital workflows, it is very easy to appropriate and combine imagery from a range of sources. As a result there is more debate about the merits of works that rely so heavily on appropriated source material and legal ramifications of pushing the envelope of fair use. Ultimately, the use of appropriated imagery is subject to both legal and aesthetic interpretation and the judgments vary greatly.

The bottom line: One cannot sidestep copyright and ownership in appropriating materials. While styles and characteristics can be used and referenced, **the appropriation of entire works that are not in the public domain, such as trademarks and copyrighted images, is illegal**, and you can be subject to lawsuits and financial penalties. While certain kinds of uses, such as parody and satire, are allowed under fair use definitions, you need to understand the degree to which your use of an original work is legal or not. It would not reflect well on you as a professional if a potential client were to recognize a copyright violation in your materials.

Understanding Copyright Law: Basics and Resources

You should assume that any creative work is copyright protected. This would include images, trademarks, designs, written words, music, and so forth. Unless the work is in the public domain (and you must be certain that it is), someone owns the copyright. It doesn't have to be registered with the U.S. Copyright Office to fall under the protection of copyright law. Further, within a copyright protected work, other original elements are also protected. For example, you may own an image within which there is a logo for a particular retail business. Your copyright doesn't extend to the logo of that particular business. It is protected as well, and would require an agreement, or at least a release to be included in your work. This would also apply to individuals represented within your work, even private property.

Another issue is creating new works while using other original works. If you are incorporating an original image in a new work, it must be different enough with respect to the original, or you must have transformed the original enough for it to not be recognizable (created a "transformative work"). This can fall into gray areas and the best policy is to avoid violating someone else's rights over any particular work.

There are many different aspects to copyright and its application whether the work is for commercial purposes, fine art, criticism and commentary, or satire, to name a few. This is a complex issue that has grown in complexity with the expansion of digitized resources, music, and materials. There are numerous and varied terms for copyright, and if in doubt, you can find many resources to assist you.

Iconography

Iconography, in a nutshell, is the interpretation of signs and symbols in works of art. Traditionally, art historians have studied iconography to interpret the meaning and intent of historically significant works that reflect religious liturgy and incorporate symbols. The examination of iconography as applied to contemporary forms such as film and media involves interpreting images through the recognizable references within them. While this is fairly well established, it is not necessarily a uniform practice.

Attention to iconography and the allusions and associations to time, historical periods, styles, movements in design or art, as well as cultures or systems of information, can bring meaning to a work or design. Generally, visual icons are rooted in a culture or context and have clear, understandable associations. This differs from appropriation, in that appropriated visuals retain a direct relationship to their origin, whereas iconographic visuals tend to be general and have broader references that aren't necessarily rooted in one particular use or context.

Using Iconography versus Visual Icons

It is important to be able to make some distinctions between culturally determined visual icons, which are commonly understood symbols and signs, and the broader use of iconography. Commonly understood signs and symbols can be religious, part of corporate culture, or even linked to particular cohorts or communities. For example, Christian crosses and the Star of David are religious icons. Flags and peace signs are icons rooted in a movement, or society. Iconic images can be established through historical circumstances. The image of the Twin Towers in New York City will forever be an iconographic reference to

the tragedy of the September 11, 2001 terrorist attacks. The historical image of Uncle Sam is now an icon that has transformed. Originally linked with patriotism and service during World War II, it has a broad reference that can read as the paternal figure of "government." Numerous artists (Seymour Chwast and Micah Wright) have since used the image of Uncle Sam as shorthand for government when making a critical work that attempts to challenge or skewer government authority. Your use of iconography can be far reaching. Some examples that can be a reference include: cultures (Americana, British aristocracy, online networks), industries (medicine, automobile), processes (science, law), or time periods (Victorian era, the 1950s). The use of particular visual references in order to build an idea or association can work toward informing your visual identity or creating a specific association regarding your work.

Noah Webb (on the following page) provides a good example of using iconography in a small promotional work that presents personal images taken from his travels. His "passports" are simple stapled folios, each having a slightly different visual character consistent with the country in which the images were made. A simple concept, it is well executed, with a textured vinyl cover and foil stamping which mimics the look and feel of a real passport. Within the folio hand cut photographs are tipped in to the pages and are presented as a small series. The iconography of the cover conceptually connects to the content within the folio. Further, the books as "passports" are metaphor for a visual voyage that is contained within. These books enable him to show a small, cohesive body of work in a thoughtful form that is simply executed. The value of creating a piece such as these is they offer an intimate viewing experience that takes his work out of the expected context of a standard portfolio or online site.

Tip: Signs and symbols function most effectively as simplified reduced forms. By eliminating detail and reducing forms to basic elements, images and visuals can read more broadly.

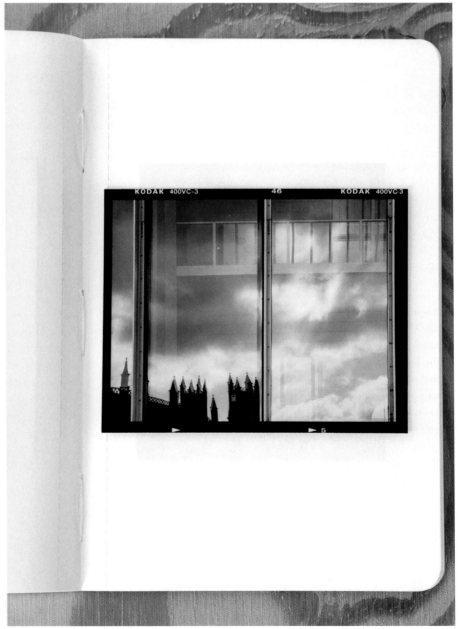

NOAH WEBB, SEWN FOLIO, Los Angeles, CA.

Building Visual Texts

Extending the relationships between images can be achieved through a reading of images or a visual text. Meaning is formed additively, wherein the denoted meaning of the imagery, or allusions and associations within the imagery, as well as stylistic or formal elements combine to suggest the larger whole; the "reading" of references and content found within the whole image builds to a particular idea or set of associations.

These combinations of *discrete images* need to be thought through in order to be sure that the viewer's reading is directed in the intended way. Depending on the cover design, the imagery can be structured and ordered in a number of different ways. A grid structure can invite reading between images, and the proportions of this grid and placement of the images will affect the direction of the reading. Linear placement can be expected to follow the conventions of reading a western text. Left to right and top to bottom reading is often the default starting point for a viewer.

In this image (right) documents and photographs are combined to create a reading that references history, personal experience, and systems of identity. The use of photographic imagery identifies the content as derived from real events and experiences. A defective snapshot reads
as a personal image, while documents and forms, with their dates, add another layer of authenticity. Finally, the handwritten text adds individual character, and the aged appearance of the images through their vintage color and tone creates a reading that speaks of the past.

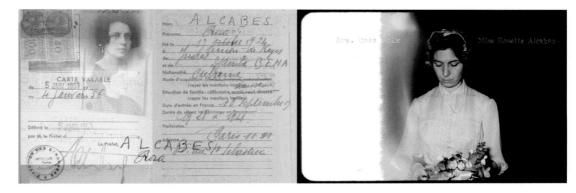

LARRY VOLK, from *A Story of Roses*.

Another form of combined imagery and visual elements in a contiguous space falls under the rough category of *photo collage, montage,* or *image compositing.* This is a common practice in which elements of appropriation and iconographic references are used to build meaning. Collage as a practice differs from montage in that the work is physically combined (typically glued) to create the image, and the material aspects of the work are as much of the reading as the combined whole itself. Montage is a seamless process and the visual whole is the emphasis. Photo montage has a long history within visual arts practice. Jerry Uelsmann is one of the most well-known pioneers of the seamless photo montage perfected in the darkroom. Currently, digital processes makes it fairly simple to create a seamless whole. Within a composite/montage or collage the viewer's reading of relationships between images and elements can be directed through common techniques that can include hierarchy, visual weight, contrast, and juxtaposition to name a few.

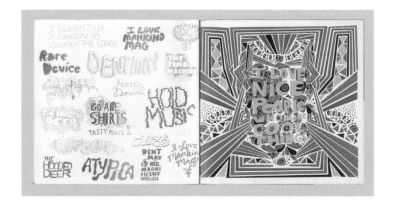

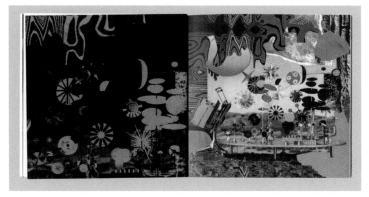

WILL BRYANT, STUDENT PORTFOLIO, Austin, TX.

In this example, Will Bryant combines a variety of styles and materials within the space of individual pages. The result has the reference and feel of collage, but digitally generated elements are integrated as well. As an illustrator, it reflects methodologies, style, as well as the ability to work more freely with an open page.

Overview

Some compositions are more organized and structured. These can be referred to as "clean and clear." Such a composition may utilize a grid structure to subdivide the space evenly and organize visual elements so that they are aligned to each other and proportionally spaced apart. Other compositions are freer, or even more "chaotic," expressing a more dynamic energy and bold playfulness. There are, of course, compositions that communicate a little of both—it's not necessarily one or the other, but a continuum of choices. Perhaps one element breaks out of a grid structure and is thus itself a more expressive focal point. Compositions can also be symmetrical or asymmetrical, straight up and down or on an angle. Experiment with the possibilities.

Hierarchy

Use hierarchy to develop visual weight and balance to focus attention. All elements within a composition should interact with each other—they should feel like independent parts that are united within a larger whole—and some should be more dominant than others. Don't forget about the back of the book either: Design your cover as a spread, considering both the front and back at the same time.

Negative Space

Activate not only the positive space, but also the negative space in your composition. In most cases, in order to create a visually compelling composition you need to do more than just put an image in the center of the page. Work to activate the compositional space by cropping visual elements and utilizing scale, depth, and angle. Work on your composition so that it isn't static. Remember: Your design should be engaging and interesting to look at. If you get stuck, try subdividing the space or cropping a visual element. Use the space, don't just plop something down and forget about it.

Testing Out the Size & Proportion

Consider the *design and usability* of your portfolio book. Ask yourself if the size, orientation, and proportion could change when you work out the interior layout of the book. Remember that your work is the most important part of your portfolio and should be visually supported by the book's design. Try some example spreads now to see if this will be an issue.

Consider if a size or aspect ratio out of the ordinary would make a stronger and more memorable impact on your audience. However, you need to keep in mind the manner in which you intend to use and distribute your portfolio. Nonstandard design sizes can create additional costs for printing, construction, and shipping. For example, if you want to be able to mail your portfolio you should consider a slightly smaller, more standard size so as not to incur additional shipping costs. Such considerations present a challenge, but can also yield some interesting, inventive solutions.

Always print your design out to get an accurate feel for the physical size of the piece and manner in which the elements are reading!

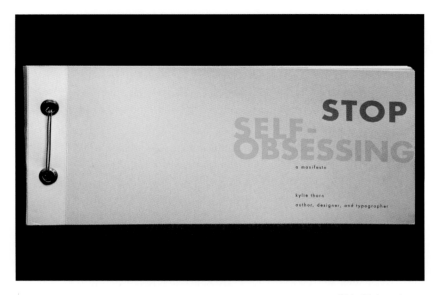

KYLIE STANLEY, STUDENT PROMOTIONAL BOOK, Ohio University.

Overview

Depending on your expertise in this area and the visual style of your cover design, you may want to push your use of typography or just keep it simple. Keep in mind that different typefaces say different things. Each genre of typeface has certain qualities associated with it. For example, there are sans-serif typefaces that are described as "modern" and "clean" (Univers, Futura, Helvetica Neue), and also serif typefaces that are described as "classic" and have more visual contrast to them (Bodoni, Garamond, Caslon). Sans-serif typefaces are usually great for short lines of text (titles, subtitles), while serif typefaces work best for longer paragraphs. There are also decorative typefaces to consider (distorted, techno, handwritten). These are often used in a limited fashion to call attention to a word or line of copy. They are also typically a bit more difficult to read and need to appear larger in scale.

As most designers know, there are times when type is not just part of the design, but the design itself. In this way typography can be the focus of your cover design or integrated into the composition with other visual elements. It could be used concretely as purely a visual component, like texture. In such cases, one is less concerned with readability and more concerned with how the type functions as part of the composition's overall "look and feel." On the other hand, you may very well decide to use type more pragmatically for informational purposes (like to state your name or the title of the book). Lastly, you may even decide to leave type out of the cover design entirely.

Words of Advice

- Decorative typefaces are not easy to read and typically need to be larger.

- If you're stuck, experiment with type, looking to different genres or people for inspiration. For example, David Carsons' typographic treatment is fairly notorious—fractured, flipped, pushed off the page, inverted, distorted, cut up, mix-matched, etc. (Of course, you need to make sure that the style you are referencing still reflects your brand statement.)

- Consider not only the positive, but also the negative space of letterforms.

- Use a typeface that is a little less ordinary. Don't just use one of the standard Microsoft typefaces, like Papyrus, just because you can't think of anything.

- Take a look at concrete type, using type as a visual element within the composition.

- Consider *tone of voice* by utilizing properties such as scale, color, bold, italic, and the style of typeface. Consider how typography can help give life to your message.

- Consider phrasing—think about the value of space in between letters (kerning) and lines of text (leading).

For the Designer

Nothing says both inexperienced and careless more than poor basic type skills. Don't forget to pay attention to:

- Kerning
- Leading
- The typographic rag

Tips

1. Perhaps there are typefaces associated with a particular visual genre that has influenced your brand. For example, the sleek and jazzy art deco typefaces of the early 20th century are quite distinctive with their stylized, geometric shapes and graceful lines. You should explore the kind of typeface that fits best with the brand style you are trying to communicate.

2. Check out type foundries online to browse through a large collection of typefaces.

3. Look around—books, signs, product packaging, clothing.

Copy

It's not just what you say, but how you say it. Although you may be more visually than verbally minded, a significant component of a concept and/or brand identity is the copy associated with it. Copy can be an integral part of a design concept. It can take the form of a title, a tagline, or simply a more clever and creative way to refer to a piece of work. By using less typical words or phrases, you can be sure to make your portfolio that much more memorable. In this brainstorming phase, think about how you may want to refer to your portfolio. This process may even help you come up with an overall idea about how to proceed.

Consider:

- Writing with attitude as part of the brand. Consider your tone.

- Providing real information—making what you say meaningful and relevant to your target audience.

- Acknowledging that copy is an important aspect of design. Typical design and advertising agencies pair a designer with a copywriter as part of one integrated team.

- Being concise, relevant, and memorable (in a positive way).

- Trying to avoid the same old, bland, vague language.

- Being careful of using obvious clichés. While it's okay to start with a cliché as a means to spark an idea, make sure you work on taking it to the next level by coming up with your own unique twist.

Web link: *www.myfonts.com/WhatTheFont/*.

Visual References

George's postcard series (right) references the iconic visual simplicity of Saul Bass and Paul Rand. It's also an example of some great copy, which drove the concept for this self-promotional piece. George's portfolio book was then designed in a similar style.

As referenced in an earlier exercise, look to history, current trends, and your own work as inspiration. The key is to make your approach support the intention for your brand. Think about which references are important to utilize in order to communicate your concept and message.

GEORGE GRAVES, STUDENT PROMOTIONAL,

Endicott College.

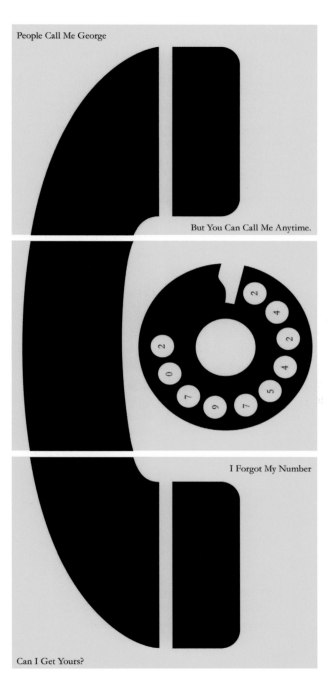

People Call Me George

But You Can Call Me Anytime.

I Forgot My Number

Can I Get Yours?

Visual Properties and Techniques

In order to develop a more defined and unique visual statement you will need to do a lot more than just put an image down in the center of a composition. You will need to create a cover design that has style and communicates your brand in a manner that is both innovative and meaningful. Your "look and feel" should be created and defined through the emphasis of certain visual properties and the application of specific visual techniques.

Making Something New and Unique

Take this opportunity to make something new and unique. Don't just repurpose a work that is already in your portfolio and use it as the cover design. Instead, develop a design that works best for this specific design problem. Think about all of the visual properties you have to work with. Perhaps you will choose to be concerned with aspects of scale. Or perhaps color, texture, or shape. Perhaps you will focus on the balance of all three. Your visuals may tend to be more detailed in nature in order to make specific references, or more abstract and simplified, referencing broader more universal themes. You may choose to consider aspects of dimension, direction, or motion. You may decide to extrapolate aspects from a previously designed piece or pieces in order to arrive at a new solution. Perhaps there is even an approach that you have employed in a particular project that you can now carry over into this portfolio design.

Experiment

As a visual artist you should experiment with a variety of visual techniques in order to help characterize the meaning of your visual identity and concept. As tools in the visual communications process, each technique carries certain associations that can help express a visual tone or message. There are many diverse techniques and each one can be applied subtly or more dramatically, alone or in combination, depending on the desired aesthetic. However you determine—through techniques like variation, distortion, montage, simplicity, exaggeration, repetition, juxtaposition, intricacy, and fragmentation—you can continue to define and support your desired visual message.

Through the emphasis of some visual properties over others and the manipulation of those properties through various techniques you have the means to create many unique solutions. By working through the visual process you will find the one solution that works best for you.

Caution: Often Less Is More

Don't throw everything but the kitchen sink into this design. You need to make informed decisions about the visual properties and techniques you will utilize. Making decisions means deciding what to use and what not to use. The use of too many techniques will water down your visual voice and design style, and obliterate any associated meaning. If you are struggling because you have more than one specialty area, consider creating multiple books (one for each area), instead of trying to merge multiple references together.

Important Notes

You should use all your own original imagery in your design. If possible, don't rely on any stock or web imagery. If you do use stock imagery, make sure you buy the rights to use it.

Sketch, sketch, sketch!

Revisit the cover design after the interior page layout is determined—changes to size, proportion, etc. may need to be made.

As always, make sure you play with silly ideas on paper too, they get the creative juice flowing.[2]

— Fernando Lins, Art Director and Interface Designer

ART DOES NOT REPRODUCE THE VISIBLE; RATHER,
IT MAKES visible.

PAUL KLEE
Artist

MATERIALS & FORMS

There is a great deal of variety in the methods and construction of a book or portfolio. Our intention is not to turn you into book artists, as much as offer you a range of possibilities in an effort to support the visual identity and presentation you wish to create. The work of bookbinders and book artists can involve intricate detail and exquisite craftsmanship. While this may or may not be purposeful in relation to your intentions, an understanding of what can be designed and constructed is important for developing your portfolio.

Binding

The basic goal is to make a book that functions well and allows you to present your work in a context that you have designed. In exploring how your portfolio is to be bound, *flexibility* is a consideration. A standard binding with a hard board cover is not something that can be easily taken apart when you wish to change the content in six months. Simpler, flexible bindings allow you to be fluid and create materials that can be easily tailored to a specific audience on-the-fly.

Some of your choices may be determined by your skills. There are numerous binding methods that allow for clean presentation and function effectively without requiring extensive experience in book construction and book binding. Furthermore, even if you hire someone to build your book for you, an understanding of the types of bindings and materials will inform the process of having your book made.

The following books and bindings are easily constructed with a minimum of skills and materials. They all take the basic form of a codex, which is a set of pages, bound together.

Glued Back-to-Back Binding

A glued binding or adhesive binding that does not allow for page replacement, but is inexpensive and easily constructed [below]. This binding allows you to print all of your page spreads on single-sided paper, and avoid the complications of two-sided or duplex printing with a desktop printer. The limitation of this binding might be that of page size and page count. A book of 30 pages up to 8 × 10 inches is a workable size and page count, as beyond this the book may require a stronger binding and spine.

Spiral Binding

This can be a flexible and inexpensive choice that is readily available and can be easily replaced. While it is used as a common office report binder, the spiral itself can be an appropriate binding as long as it fits within the visual identity you have developed.

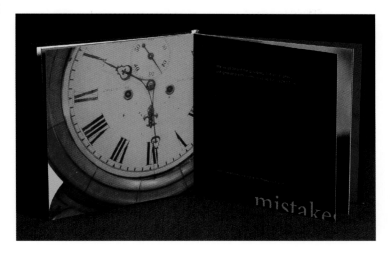

ROSIE FULTON, BACK-TO-BACK BINDING, Endicott College.

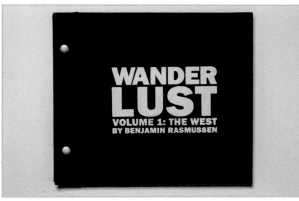

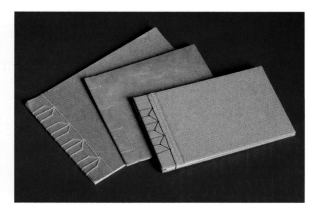

NICOLE GOBIEL, SEWN PAMPHLET, Endicott College.

BENJAMIN RASMUSSEN, POST AND SCREW PROMOTIONAL BOOK, Denver, Colorado.

AMANDA NELSON, STAB BINDINGS, Charlottesville, VA.

Stapled or Sewn Pamphlet or Booklet. Similar to a back-to-back binding in that it has a limited number of total pages due to its method of construction, this method is easy to create and requires either a sewn or stapled closure to hold the pages together. It does require two-sided printing to create the page spreads. There are inexpensive staplers available that are designed to accommodate the depth of the page, allowing for center stapling in the gutter or fold of the booklet.

Post and Screw. This is a removable binding for easy replacement of pages. The pages can be single-side printed or duplex printed. These are easy-to-create bindings with hard board covers that can be opened and changed when needed without very much effort. They each have a particular appearance, but are not substantial enough as to overshadow a cover treatment.

Japanese or Stab Binding. This binding incorporates similar board covers as the post and screw, but has a slightly different appearance since the binding is sewn together with a three-, four-, or five-hole pattern.

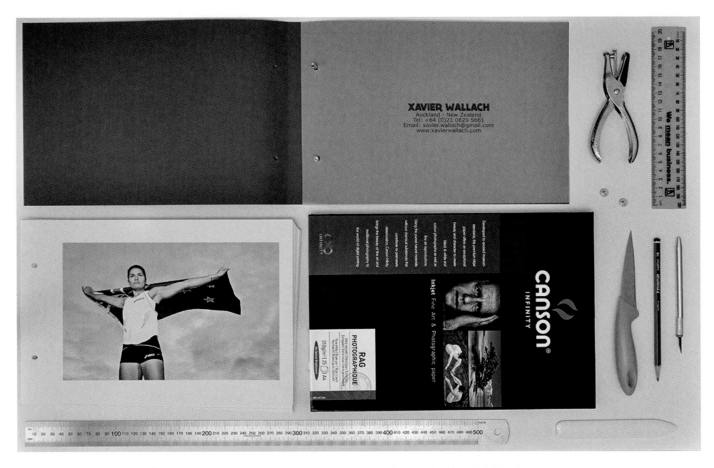

Unconstructed binding or folio—
portfolio that is not formally bound together,
but held in a container as loose materials.

XAVIER WALLACH, POST AND SCREW PORTFOLIO, TOOLS, AND MATERIALS,
Auckland, New Zealand.

This image of Xavier Wallach's softcover binding illustrates that with
an inkjet printer and some basic tools you can produce a very effective
and low cost portfolio book. Go to Step 5 for instructions on making a
hardcover, post and screw binding.

Covers: Softbound versus Hardbound

Constructing your own covers allows you a range of options for page design and form. Literally, you can bind anything from a standard rectangular format to a round book with round covers. Traditional hardcover books are made with "board covers." Board covers are commonly made with book binder's or Davey board that is easily cut and glued together. Typically, binder's board is covered with book cloth, buckram (leatherette), or printed paper, but can be used raw or uncovered. Book cloth is available in a variety of colors, and is quite flexible and strong. It has a backing to prevent glue from seeping through the cloth when making covers. In designing and making your covers, standard-issue book cloth is a starting point, but take a trip to any store that has custom-made papers, or a fabric store, and you will realize that there is a rich variety of choices available to you. You can use sizing or backing on a variety of cloth to utilize it as a book covering material. Covers with materials such as metal, vinyl, wood, and plastic are all options that can be exercised as long as they feel relevant to your concept and design.

Softcovers can be made of any paper, they can be printed, and, as with board covers, made to any size you determine. Because softcovers are lighter, you can utilize a less robust binding. They offer a great deal of flexibility since any printed page can be used as a cover. Referencing the appearance of a particular type of softcover book can drive a concept as well. *Comic books* and *Zines* are good examples of softcover productions that could be utilized as a portfolio concept. Essentially a stapled pamphlet, they are easy to produce and offer great flexibility.

ALLISON V. SMITH, PROMOTIONAL MATERIALS, Dallas, TX.

CHRIS CRISMAN, POST AND SCREW PORTFOLIO, Philadelphia, PA.

Spine, Hinge, and Clasp: Closed versus Open

The spine is the back edge of the book, where the pages and covers are joined. Depending on the number of pages in the book, the spine can vary in thickness. Spines can be open, as seen in a stab binding and post and screw (p. 71) and the back-to-back binding [right]. Closed-spine books don't necessarily require tying or some kind of closure. A closed spine can be made of book cloth and can be functional or decorative.

Just as the spine can be open or closed, the leading edge (fore edge) of the book can be open or closed. The leading edge of the book can have a cover or "flap" that can close via a magnet, a clasp, or any number of methods.

The limitation of closed-spine and closed leading edge books is that the width either of the spine or the closure needs to be made to accommodate the width of the book's assembled pages, or book block. This does not allow for significant changes to the number of pages in the book. If the book gets thinner or thicker, the binding will appear too loose, or be difficult to open and close.

A simple cloth tie can be an elegant way to create a closure for a bound book, or folio. Book artists often create **custom clasps from wood, plastic, bone, and metal**. Common hardware and closures can be repurposed into book binding clasps and hinges and are worth exploring as well.

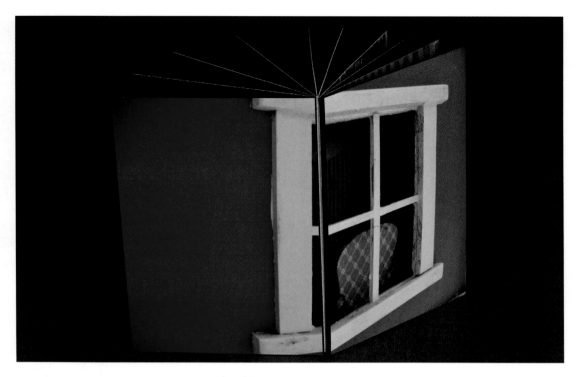

ANN PELIKAN, ARTIST'S BOOK, Ipswich, MA.

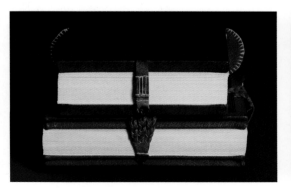

AMANDA NELSON, CLASP CLOSURES, Charlottesville, VA.

AMANDA NELSON, BONE CLOSURES, Charlottesville, VA.

Variation: Sewn or Stitched Bindings or Nonadhesive Bindings

There are a great many intricate nonadhesive bindings that incorporate decorative sewing of the spine to construct the book. These can be elaborate and elegant. The nature of this binding style can create an emphasis on the craft and material of the book, as the method of binding is distinct and a visible element. Depending on the body of work and the concept behind the portfolio, this element of the book's construction and structure can contribute to the visual identity of the individual who incorporates it. This example (right) is a sampler of sewn binding stitches. From left to right: kettle, coptic, double cord (raised cord), single cord (raised cord), recessed cords, tapes, kettle.

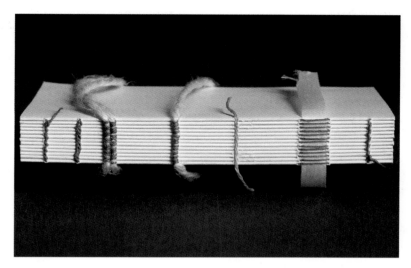

AMANDA NELSON, STITCHING SAMPLER, Charlottesville, VA.

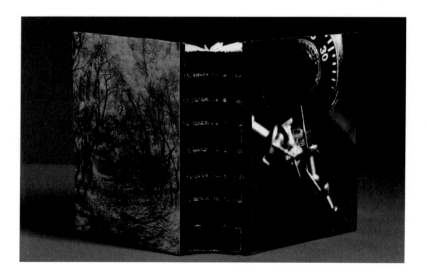

AMY GRIGG, COPTIC STITCHED BINDING, Endicott College.

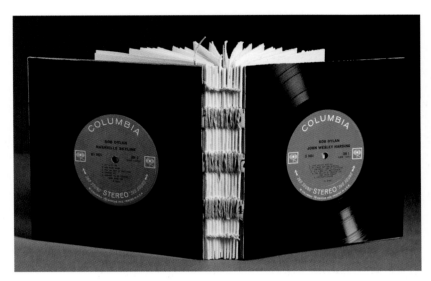

NICOLE GOBIEL, COPTIC STITCHED BINDING, Watertown, MA.

KARYNE BOND, DIE CUT ALUMINIUM PORTFOLIO, Montreal, Canada.

Wood, Metal, and Alternative Materials

Cover materials do not have to be derived from standard book binding supplies. The choices are unlimited if you wish to explore other kinds of fabrication and book covers can be made out of a variety of materials other than traditional board and cover stock. Metals can be hinged and fabricated to create a unique look and feel. Plastic and vinyl can form colorful and durable covers that can contribute to a unique visual identity. The range of such choices is a function of the visual concept you wish to explore and the practicality of making and maintaining the book. Making a unique object can be an effective way to have your work stand out from the other portfolios that are being reviewed. We recommend exploring the book binding resources in Appendix A as well as online resources to learn about the possibilities for book construction.

Windows, Cutouts, and Insets

In making a custom cover, you can embellish the cover form with various elements. Beyond the cover cloth or papers used, a cover can have windows revealing an inner page, and those can vary in size depending on the relationship of the cover image to the interior page. Making a cutout in a board cover is a simple matter of cutting and measuring prior to construction. The layout and content of the interior page behind the cover needs to be designed and considered to work with the cutout or window.

Inset images, labels, or other visual elements can be built into a cover design as well. The inset can create a focal point on the cover and allow for a custom label or title. This again is a simple matter of preparing the book board prior to covering it (see Step 5: Book Construction).

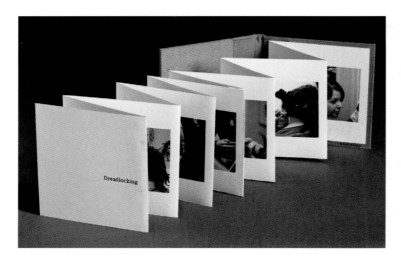

HILARY BOVAY, ACCORDION-FOLD BOOK,
Endicott College.

Accordion-Fold Bindings and Concertina Bindings

Accordion-fold or fan-fold books provide an opportunity to present a sequence of images or images and text that can be easily printed and assembled. Covers can be glued or nonglued, and made of board or papers. There are many variations and printing is simplified by having to only print to one side of a page. Longer sequences can be achieved by joining folded sections with glued tabs or folded pieces.

In this variation (left), **wraparound board covers** with a hinged spine are built and the folded book is attached to one end panel. Once opened, the book can be extended out to be seen in its entirety, or can be viewed folded as sets of facing pages.

For folded pleat or expanded pleat, a strip of paper is folded and pages are attached to the fan-folded strip. This allows for spacing between each page depending on how thick the folds are in the pleated strip.

Separate covers: In this variation (below) by David Le, the accordion-folded sequence is adhered by the end pages to two separate board covers. This book can have closures, which can wrap the book, or an independent closure for each edge.

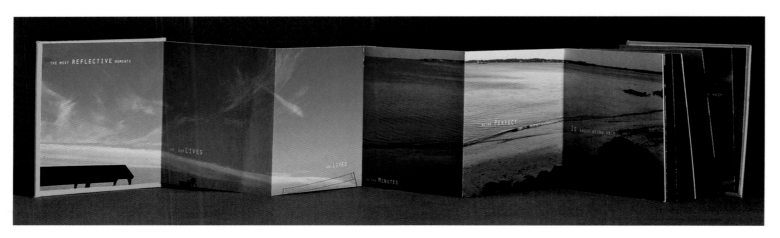

DAVID LE, PANORAMIC IMAGE, ACCORDION-FOLD BOOK,
Endicott College.

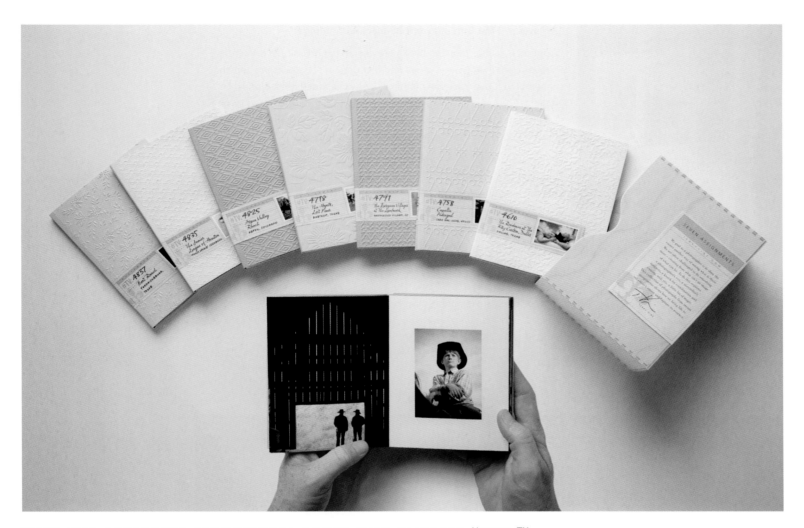

TERRY VINE, SOFTCOVER PROMOTIONAL BOOKS WITH SLIPCASE, Houston, TX.

Terry Vine's beautifully crafted books feature embossed paper covers
and a wooden slipcase. They were made as a series of seven books,
designed to correspond with seven project galleries on the web.
The attention to design detail and craft conveys a message of
beauty and quality.

Folded Pages and Inserts

A folded page can be built into a single set of pages or as a component of the entire book. This allows for the presentation of multiple images or a series of works without having to distribute them over multiple pages. Images that may require a longer aspect ratio than that of the overall book can also be presented with an extended page that is folded [opposite page top left and right]. Inserts allow one to include additional pieces within the portfolio. These can be constructed items, or samples of a particular piece, or a leave-behind, such as an electronic version of the portfolio.

Flag Books

Flag books represent more complex page construction and visual interaction as a result of the binding method. They reflect the potential for books to be more than simply a device to hold and organize images or text, but a complex object.

Embossing

With embossing, text is imprinted into the paper, creating a raised impression. Commercial printers can create custom dies to emboss (or deboss creating a depressed imprint) paper.

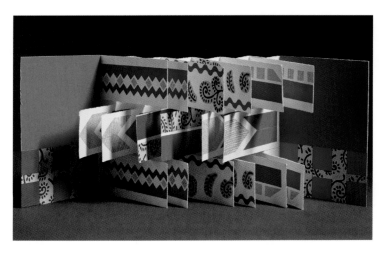

NICOLE GOBIEL, FLAG BOOK, Watertown, MA.

DANA NEIBERT, PROMOTIONAL WITH EMBOSSED FLAP, Coronado, CA.

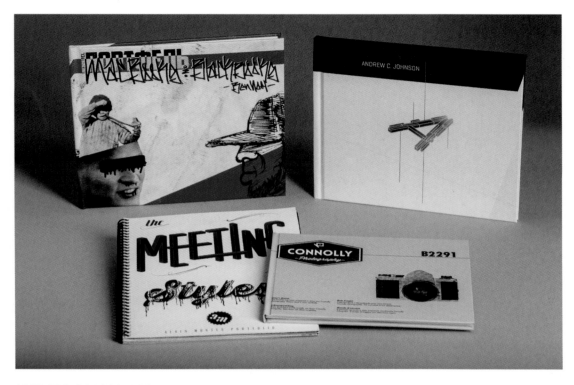

Commercially Available Book Binding

Many individuals and artists are using book printing services through online retailers. With the development of digital short-run printing, online book printing services have grown. These services run the gamut from consumer-oriented low-cost book creation options via online photo hosting and finishing sites, to those which are aimed at professional photographers and artists. The range of options in terms of format, customization, paper stock, and print quality is quite varied. Frequently referred to as "print on demand," the greatest advantage of these services is lower cost than traditional book printing and the ability to create one-off versions. This allows for tests and adjustments as well as changes, and creating books tailored to specific work and clients. There are numerous services, and one should seek out those who specialize in photo books or image-based books. Self-publishing services for text-based books are less likely to consider issues of design or the quality of the reproductions.

Consumer Retail Services

Online photo-finishing services offer book or album creation options that usually are perfect bindings or hardcover bindings. These are inexpensive and of reasonable quality. They typically use proprietary software for layout and uploading your book and have a number of standard-size book/page combinations. The limitations of these providers are often the paper stock and image quality. The biggest issue for the designer is the lack of fine control over the placement and treatment of type. Most of the software systems used to create books are not intended for sophisticated and precise control of image and text. All that being said, they can provide an option for limited-run multiple editions and are inexpensive even when printing only one book at a time.

Apple's iPhoto, Shutterfly, and Snapfish are a few examples. They are very inexpensive, and with a little diligence one can produce a fairly good product. The consistency of the finished product may be an issue here as well but they are so low cost one could probably print multiple tests to work out the bugs if necessary. What you produce becomes your face in the world, so if better control over the design and production is needed, there are a number of options.

Higher Quality Options

Blurb, My Publisher and Lulu, as examples, offer proprietary formatting software or browser based workflows which make it fairly simple to put together your book. They have a number of fixed formats and options, including text formatting, multiple-image page layouts, hard or softcover from the same layout, and uploading directly from the software. These are reasonably priced and you can produce a high-quality single book or inexpensive multiples that could even be used as leave-behinds.

Book printing on demand has evolved over several years and now many of the established printers support PDF to book workflows that enable professionals to work through InDesign. This workflow affords you much greater control over page design and typography. Blurb, for example, has InDesign templates and a plugin enabling book production and upload. Further, printers such as Lulu and Blurb offer a range of papers from basic to premium and enable you to tailor your book to your budget and needs.

Professional Services: Paperchase and Pitko Photobooks

These are examples of print-on-demand services that are oriented toward professional photographers and artists. They have higher-quality papers and inks and offer professional services such as proofing, custom stamping, and embossing. In each case, books can be designed, and built with templates or with custom-designed variations. The costs here are at least 50 percent more per book, but you have the ability to proof, select paper stock, and make a much higher-quality product.

Print on Demand Magazines

With the development of print on demand book publishing another format which has become available is a perfect bound magazine. Magcloud and Blurb both offer portrait magazine formats which are high quality and relatively inexpensive to produce. These can be used as an option for a printed portfolio, as well as for custom promotional works. Examples of these are found in Step 7.

Color Management

The use of ICC (International Color Consortium) workflows is becoming more of the norm with online publishing services. As print on demand options have expanded, printers have become more responsive to the needs of professionals for accurate reproduction. Magcloud and Blurb as examples offer ICC profiles to employ a color-managed workflow. The use of color profiling allows you to preview or soft proof all your images in relation to the type of printer to be used by the service. Check with the individual vendor for their printer specification. Color management and ICC workflows are discussed more in Step 5, Book Construction.

For a list of online printing resources, go to *www.noplasticsleeves.com*

Design is a plan .

FOR ARRANGING ELEMENTS IN SUCH A WAY AS BEST TO ACCOMPLISH A

PARTICULAR PURPOSE.

CHARLES EAMES

Architect, Graphic and Industrial Designer, Filmmaker

LAYOUT & SEQUENCE

The main objective of the interior page layout is to demonstrate your abilities and experience by showcasing visual examples of your work. This constitutes the "body" of your portfolio and serves a different purpose from the cover design. Examples of your work should provide the tangible proof of all the promises your cover design implied—that you are indeed talented, skillful, and knowledgeable! So, the primary visual focus of your page layout should be on the work itself. Additional compositional elements and textual information should not distract or undermine your efforts to establish a clean and clear visual presentation of your work.

Q&A: Interview with Hyun Sun Alex Cho, Creative Director, Ogilvy and Mather, New York, NY

Alex Cho is an innovator in graphic design. Her strength comes from her ability to communicate the needs of the client through creative ideas that deliver strong visual identity and message. Ms. Cho is focused on creating unique experiences through multiple media and channels, producing outstanding results for her clients. In her current position, she has created digital advertising campaigns for major brands like Unilever, IBM, DHL, Kodak, SAP, Motorola, Aflac, and Wyeth.

How important do you feel an online and/or print portfolio is in securing a creative position in your industry?

It's very important to have an up-to-date portfolio early on in your career. It's the only way to prove you've got the skills and talent.

How important do you think a brand concept or overall visual identity is in the success of a portfolio design?

I believe that the work is the most important part of a portfolio. However, a portfolio that has a strong concept and identity can showcase the strength of one's talent. Having a strong visual identity can also help you stand out from the crowd, so it's more memorable. This should not be distracting to the presentation of the work itself though.

In general, how many pieces of work do you think a student should include in his or her portfolio?

I recommend around 15 pieces for the student portfolio.

Do you have any advice for a student currently working on his or her portfolio and/or other promotional materials?

It's important to show confidence in your work. Make it simple and easy to view the work and let the work speak for itself. Also, include some variety but show the best pieces that best reflect your talent. If there's a certain area of the industry that you are interested in, make sure to include more pieces for that area of expertise.

Visual hierarchy is used to establish an "order of importance" for various visual and textual elements within a compositional layout. Through the use of visual emphasis you can direct someone's attention to certain elements on the page and even direct what he or she will see first, then second, and so forth. **Visual emphasis essentially draws your attention to a particular area through the use of contrast and highlights certain aspects by making them visually dominant.** This can be done simply through the use of a bold color, larger scale, or an area of texture within a flat field. Visual emphasis can also be achieved through more complex means, such as creating visual tension between juxtaposing elements or by creating a more intricate shape or image. Whatever the visual technique, this is one of the most important aspects to consider when beginning the layout of your interior pages. In designing these pages it will be important to establish a clear visual hierarchy while also providing continuity and consistency among pages throughout the interior sequence.

One Page versus the Page Spread

You should consider whether or not you want to make use of the entire page spread (both the left and right page together) or just one page (typically the right side). In part, your decision should be based on how you intend the book to open and whether or not it will lie flat. If it won't, although working with the entire page spread gives your composition more "room to breathe," it may feel awkward if both pages can't be viewed together. Your decision may also be influenced by the page size and proportion you choose for your overall portfolio (which should be influenced by what will work best to accommodate images of your work). If you are working with a larger page size, perhaps you don't need any extra room. Just keep in mind that you shouldn't crowd images of your work, and you will need to leave a healthy margin of space around them.

To turn two pages into three, use a gatefold (fold out). This is a nice technique for more landscape oriented pieces that you want to show at a larger size instead of condensing into the book's aspect ratio. Also works well for a triptych.

GRETCHEN NASH, STUDENT BOOK, California Institute of the Arts.

DENIS KOCKEDYKOV, STUDENT PORTFOLIO, Moscow, Russian Federation.

The first step is to figure out what elements you want to include for each work. At a minimum you should of course include at least one image for each piece.

Number and Size

You should decide up front the number and size of imagery you want to include for each project. So, for example, you may decide that all landscape photographs are displayed at 7 × 5 inches and 300 dpi (dots per inch). Perhaps for certain types of work you decide to include a series of images or thumbnails in order to showcase important aspects, close-up details, or even sketches of the work at various stages. You may want your work to fill the entire page (full bleed).
If so, your book size should match the aspect ratio of your images or you will have to crop. When presenting a three-dimensional (3D) piece, you may want to include a number of images that showcase the work from various angles. For an animated film or motion graphics piece you may decide to include multiple "key" frames as part of a sequence of images.

Keep in mind that the orientation (and aspect ratio) of each piece should remain as close as possible to the original. While the physical size of the imagery within the composition is somewhat dependent on the overall page size, remember that the work itself should be the focus and should probably take up the greatest amount of space possible within the page layout.

Quality

Images of your work should be reproduced directly from their native digital file format and then converted (if need be) to a high-quality standard bitmap format. Image resolution should be at least 300 dpi for print and photographic work. For web or motion projects try to capture screenshots on the highest resolution monitor you have access to. If a work is three dimensional, it is recommended that you digitally photograph it (or ask someone who can). Your images should be physically large enough on the page to see some actual detail within the work itself. There is nothing worse than opening up a portfolio and not really being able to see the work because the images are physically too small or simply poor quality. Potential employers shouldn't have to squint or hold your book up to the light in order to see your work.

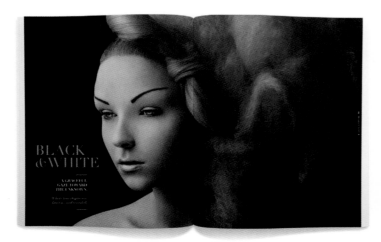
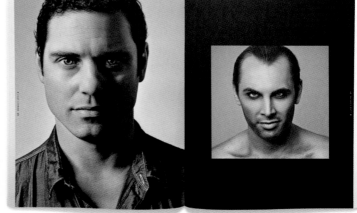

LUKE COPPING, PROMOTIONAL MAGAZINE, Buffalo, NY.

Labels

You may decide to include a title or some other system of identifying each work, like simply numbering. The size of the work is often included, especially for larger-scale projects. You may want to consider providing a reference to the date, season, or year in which the work was completed. Often it is appropriate to include the medium and even materials used, especially if significant to the process or creation of the work. For interactive work, you should also include a URL to the live website. You may also decide not to label your work—especially for photographic portfolios.

Remember that the focus of each layout should be on the work itself. Include only as much information as you think is really necessary to appreciate the work and/or the manner in which you organized it. Say, for example, you are organizing your portfolio as a timeline, demonstrating the progression of your capabilities over a period of time. It would then of course be important to include a reference to the date or school year (junior year, senior year) in which the work was completed. You could, for example, decide to include dimensions for all your work, or just for those pieces for which you feel scale is an important aspect.

As you figure this out, try to be as consistent as possible with the types of information you are providing throughout the book. Depending on how you group and organize your work, it may also be appropriate to contextualize a series of work with an introductory statement or title. Such information could be presented on its own separate page preceding the series. This can be especially useful to help explain the thinking behind a more complex or lengthy endeavor, such as a senior thesis project.

One of the biggest challenges that designers have to overcome is simply deciding on the amount of content and information to use.[1]

— Steven Snell, *Smashing Magazine*

Composition: The Grid

One of the most broadly used techniques in page layout design is the utilization of a *grid structure*. A grid divides the compositional space into proportional units and is used in almost all magazine, book, and newspaper layouts. They provide a strong means of grouping and organizing information and ensure both consistency and flexibility across a multi-page sequence. A grid structure consists of evenly spaced horizontal and vertical lines that interconnect to form uniform grid modules that can be proportionally subdivided even further. Together, the grid modules form a number of columns and rows, creating an underlying structure that can guide the placement of content on the page. Content-related elements, and sometimes even compositionally related elements, align to the intersecting points on a grid. Typically, grids also include a consistent margin along the outer edge of the page and in-between individual columns (called "gutter space," which is necessary when dealing with multiple paragraphs of text). In a traditional layout, it would be considered "bad form" to place content outside of this outer margin.

Note: Label each piece in a manner that is meaningful to the target audience. Titles or labels specific to an educational institution (like a course number) are problematic because they don't mean anything outside of that institution.

Number of Columns and Rows

The number of columns and rows within a grid structure is entirely dependent on the content itself—amount, groups, and variation. It is best to avoid having all your content clustered together, and at the other extreme, making it all into separate little parts. The amount of content and number of groups usually determines how many columns and rows you need.

Typically, as the number of rows and columns increases, so too does the flexibility of the grid system. However, grids that are more complex than need be (too many columns and rows) often defeat their organizational purpose. Too many smaller grid modules can render spatial relationships unclear to the eye and make it difficult to see what the positive and negative spatial relationships are supposed to be.

Within a portfolio book, the amount of content needed for each page layout is probably not very great. Most often you are working with a few images, a couple of lines of text, and a compositional element or two. So in most cases, a simple grid structure (a range of three to six columns/rows) will do the trick. Keep in mind that the number of columns versus the number of rows will be different unless you are working with a square format.

If you find you need greater flexibility in terms of positioning content within a particular page layout, cut a column or row in half (or even thirds). As long as you always subdivide the space proportionally, your grid structure will hold up.

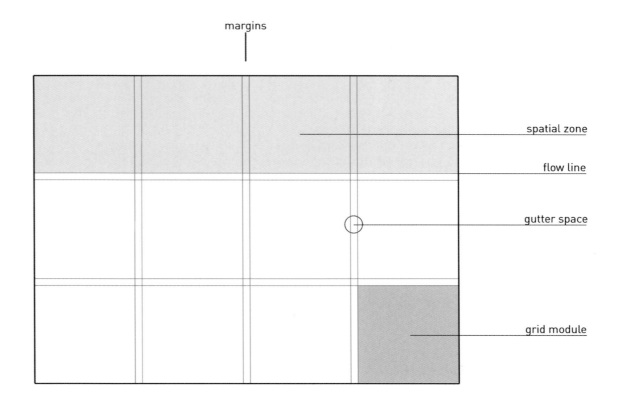

margins

spatial zone

flow line

gutter space

grid module

Grouping: Alignment and Proximity

When elements are broken up and interspersed randomly throughout the composition those elements and the spaces between them appear disorganized and unrelated. By grouping elements you can create stronger, more organized relationships. In turn, the negative space becomes better consolidated. This creates a more simplified and cohesive perception of the composition and its elements. While there is an implied connection between all elements in a composition, if you study the content closely you will discover that some elements functionally belong more closely together than others. Keep in mind that you should place more emphasis on some groups and less on others (hierarchy).

The grid provides a strong organizational structure that can help group and connect various types of content together. This is done through the use of *alignment* and *proximity*. By putting elements in closer proximity to each other you create a perceived contextual relationship between them. A grid module represents a fixed unit of space that can be multiplied and divided proportionally in order to group and separate content by means of a consistent increment. When you align content you place elements along the same vertical or horizontal axis (grid line). This creates an invisible line connecting those elements together. This "line" also creates a sense of movement and direction as it activates the composition. Using alignment is an especially useful technique when you have a limited number of elements to work with, but still need to break up enough of the negative space within the composition. Through the use of alignment you can physically separate elements across the composition while still implying a connection between them.

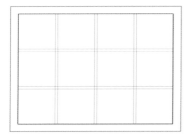

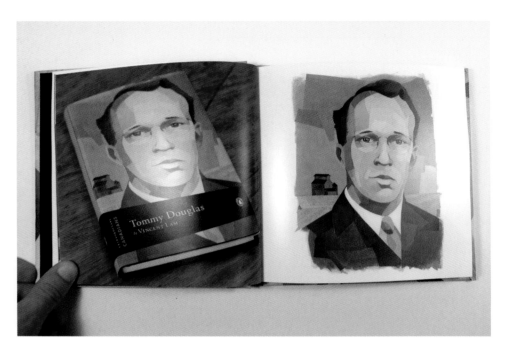

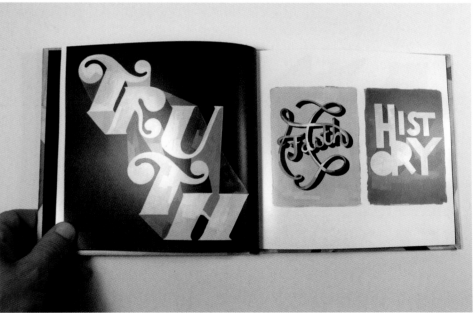

Image Layouts

As you review your work, decide which pieces can be displayed in a similar manner, either because they are the same aspect ratio or because they are part of a series or simply in the same category of form or medium. This will allow you to begin narrowing down the different types of image layouts needed. There should be consistency in the number and size of imagery within work that falls under the same category. At the same time, you'll still need to allow for enough flexibility within the layout to account for a variety of work. You should, though, try to limit the variation between pages as much as possible. You want your portfolio to feel cohesive and a big part of that is deciding on a limited number of possibilities. This doesn't mean that there can't be exceptions, but it does mean that you should be consciously making decisions about how the layout of your work will fit together as a whole. Keep the book's size and orientation in mind— it's unprofessional to make someone have to rotate a vertical book to see a horizontal image (or vice versa). Account for all the sizes and variations needed to display your work properly.

DARREN BOOTH, PORTFOLIO BOOK, Canada.

In this example, while the size and number of images varies, the placement of both the title and the top left corner of the image is consistently placed in the same spot within the grid structure. This systematic approach provides for a well-organized visual layout, achieving cohesiveness and unity across multiple pages.

Negative Space

Layout design is as much a consideration of the arrangement of elements you add into the composition as it is a consideration of the spaces left between them. In general, compositions become more visually active when they are subdivided into discrete areas of positive and negative space. By breaking up larger areas of negative space with visual elements (a title, an image, a compositional graphic, etc.), you can start to activate these "empty" areas and engage the entire composition. Furthermore, when you subdivide the composition into proportionally equal parts (such as with a grid) you can interconnect the positive and negative spaces by establishing a geometric relationship between their relative sizes and the increments of space between them. Through repetition, these areas of positive and negative space compliment each other and establish a rhythmic pattern throughout the composition and even entire sequence of pages. Through this organizational scheme a sense of unity is created and content is not just left "floating" in an empty background.

Design is as much an act of spacing as an act of marking.[2]
— Ellen Lupton, Author
Thinking with Type: A Critical Guide for Designers, Writers, Editors, and Students

Margins of Space

Unless you decide to present your work at full bleed, it is important to provide negative space around images of your work (and any bodies of text explaining that work) so that each can be viewed as cleanly and clearly as possible. Figure out the margin needed and then be sure to apply that consistently to images and text throughout the portfolio sequence. It is recommended that you additionally avoid heavy frames or outlines around images of work, as these can be distracting. Let each piece speak for itself and be seen as is, devoid of anything taking away from it.

Single-Column Grid

Consider the following for a single-column grid structure:

- Most basic positional framework.
- Need to pay attention to margins.
- Classical approach: margins are larger on the side and bottom and smaller at the top, and the inner margin is half the outer margin.

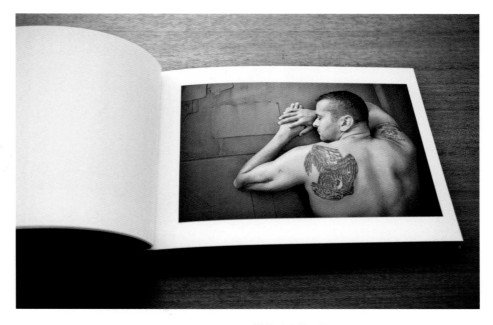

CHRIS CRISMAN, PORTFOLIO BOOK, Philadelphia, PA.

DANA NEIBERT, PROMOTIONAL BOOK, Coronado, CA.

Don't let the materials become the focus of the communication— your images need to be the focus.

— Dana Neibert

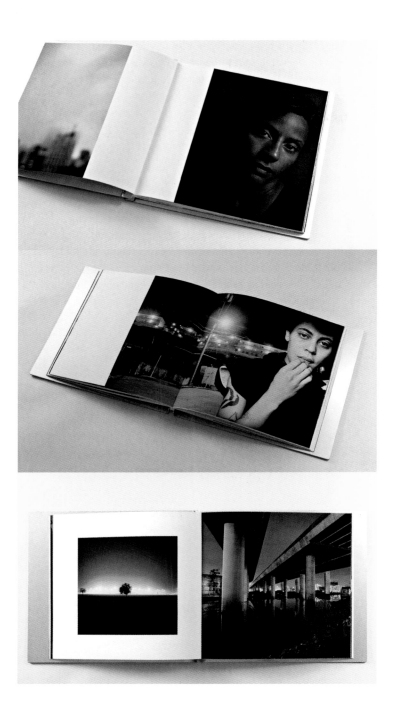

Spreads & Margins

Two adjacent facing pages are together called a spread (also referred to as a double-page spread). Traditionally a text block rests in a consistent spot on each page and margins are of equal size around that page. The inner margins can appear larger (double the outer margin) because the inner margins from both pages are seen together on the interior of the spread. In general, narrow margins create a sense of tension as elements interact with the edge of the page. Wider margins establish a sense of stability and calm.

The margins around the page, however, do not have to be equal. In fact, there are classical page designs that set the outer and bottom margins wider. In addition and especially if you are considering a hand-bound book, you may want to set the inner margin generously wider than the outer margin. In doing so you won't have to worry about content getting pushed into the gutter—the place where the two pages meet in the middle and where the book is bound. Typically, unequal margins create a more dynamic visual tension throughout the spread.

If the page margins are not equal you will need to consider that the recto (right) and verso (left) pages have slightly different layouts— essentially mirror images of each other. As such, an image on the left side page aligns to the grid from its top *left* corner and an image on the right side page aligns to the grid from its top *right* corner. This way, content on both sides is spaced equidistant from the outer margin—which should be the same width. In any case, the gutter margins should take into consideration the amount of space needed for binding.

In addition, the order and arrangement of pages in a book (termed pagination) also needs to be considered.

WINNI WINTERMEYER, PORTFOLIO BOOK, San Francisco, CA.

Sequence

As mentioned before, the use of a grid can be a vital component in providing continuity among pages, structurally connecting each page together in a sequence. **A grid structure can provide a guide in the consistent placement of elements, especially those that will repeat throughout a sequence.** Doing so often unifies pages together and creates an expectation that certain elements will remain in certain "zones" from page to page. This allows the reader to concentrate on the important stuff and not get distracted by page numbers that jump around or blocks of text that move randomly about from page to page.

Through the utilization of a grid structure you can easily move elements based on the proportional increments of the grid module. In this manner, the movement of elements from page to page will not seem random, but will reference an underlying visual system that can be repeated. By referencing the grid and moving elements by proportional and consistent increments you can create variation and flexibility across a sequence while still establishing a unifying and discernible interconnected pattern.

In most publications there are at least some elements within a layout that remain in the same spot throughout. This is especially true for those publications that are more densely populated with content. However, even with more sparsely populated layouts, it is a good idea not to allow elements, whether content related or compositionally related, to move slightly and randomly from page to page. This can make the elements appear as if they jerk around in an awkward, sloppy, and unprofessional manner. So, try to keep at least some elements in exactly the same spot from page to page (or start in the same spot from page to page).

By using a consistent start point for varying image sizes and a consistent increment of space to adjust for the placement of text, you can account for a variety of sizes and aspect ratios. Additionally, as previously discussed, keep in mind any differences between recto and verso page layouts when working with a spread. If you do move elements around from page to page, do so with consideration and intent.

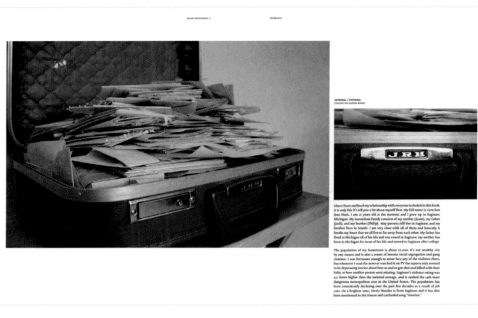

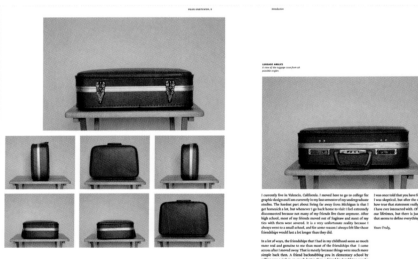

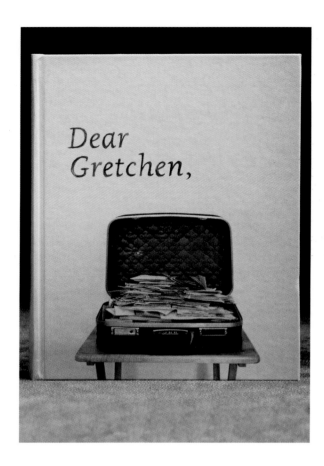

Software note: Use the grid system available in Adobe InDesign to help you work out proportions and lay out the page.

DESIRE IS A NATURAL MINDSET. THIS HUNGER IS NOT SATISFIED SUPERFICIALLY THROUGH SECOND BEST. THE ONLY WAY TO PUT THIS EAGER FEELING TRULY TO REST IS BY BREAKING THROUGH THE BOUNDARIES OF POSSIBLE AND INTO THE IMPOSSIBLE. GRAPHIC DESIGN IS BRIMMING WITH SEEMINGLY IMPOSSIBLE SITUATIONS, BUT THROUGH INTENTIONALLY CHANNELING ONE'S DESIRE TO SURPASS THE MUNDANE, BEAUTY IS ACHIEVED.

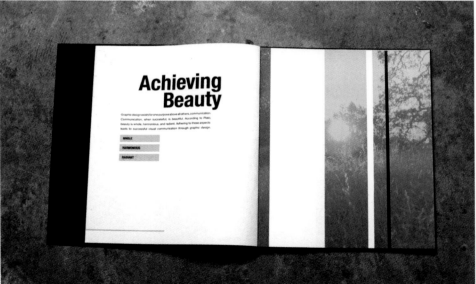

JORDAN, HONNETTE, STUDENT PORTFOLIO, Los Angeles, CA.

Special Inserts

Pages within the interior of your book can be designed as title pages or include plain old copy to introduce a project, tell a story, or provide some context for your work. You can also include special inserts within your portfolio book. These can be used to make the book more interesting and feature something in an unexpected way, such as with a close-up, full-page bleed or pop-up image. The more considered and well thought out your book, the stronger impression it will make.

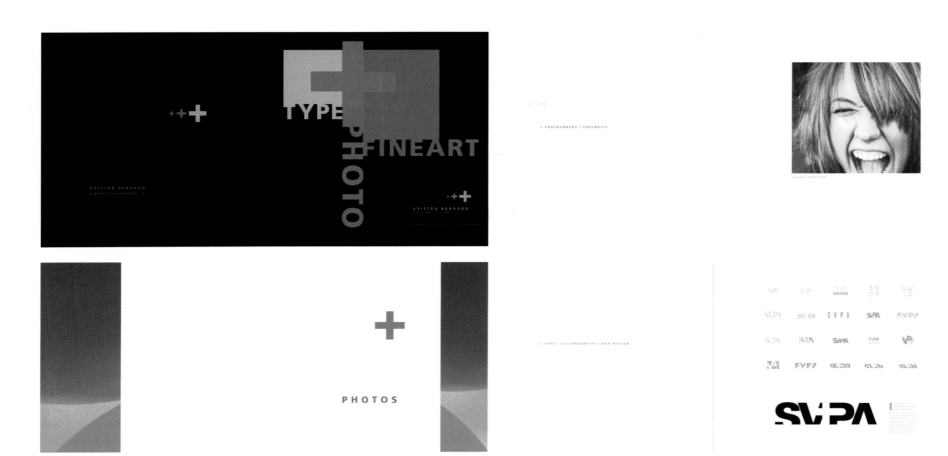

KRISTEN BERNARD, STUDENT PORTFOLIO, Endicott College.

Extending the Visual Identity

A visual identity system works through repetition of specific visual elements. It's important to make sure that there is consistency throughout the entire portfolio book and other related parts so that your visual voice is communicated in a consistent and cohesive manner. Consider which visual aspects from your visual identity and cover design should be carried over into the interior layout. At the very least you should consider using a consistent color and typographic reference from cover design to interior layout. These aspects will also be useful in visually uniting your resume and any other promotional pieces. Keep in mind that while *you should not incorporate distracting graphics into the interior layout*, you can make more subtle secondary visual references. Graphical and linear elements can activate the compositional space and support the primary content by creating movement and directing the eye's focus. Work to ensure that all elements are cohesive and well integrated.

Text on the page functions as not just information alone; it is also a visual element that must be considered within the overall design. It has weight, texture, movement, and an implied sense of direction within the composition. Be conscious of how the typography will affect the overall hierarchy and balance of your layout. Keep in mind that the text should be secondary to images of your work, so try to keep it simple. When working with typography, especially as part of a multi-page sequence, it is important to develop a typographic system that can be applied consistently throughout.

Typographic Systems

You will need to create a *style guide* of sorts that determines typeface specifications—typeface, weight, size, color, and any limited variations depending on function and usage. You should limit the number of typefaces to probably one or two throughout the portfolio. If you are using more than one typeface, don't use it randomly, but decide which typeface to use for which elements, and keep that consistent throughout the book. As a rule, serif typefaces are easier to read for larger blocks of text. While given a shorter amount of text, sans-serif typefaces are usually considered "cleaner" and look more modern on the page. For informational kinds of text, always keep legibility in mind. For this reason, the use of decorative fonts, if used at all, should be used sparingly and reserved for special titles or other more graphical typographic treatments. Keep in mind that you can also work with the space between lines of type (leading). Doing so can prove aesthetically and functionally useful at times.

Typographic Range

For a limited amount of textual information, a single type family with a range of styles should suffice. However, if you decide to extend the typographic possibilities, you will need to pay close attention to how well the individual typefaces integrate and harmonize with each other. Typically, the use of multiple type families, usually limited to one serif and one sans serif, can help with hierarchy and create more visual contrast, color, rhythm, and texture. Working with a greater typographic range can also appear more "sophisticated," but only, of course, if done well. Most serif/sans-serif typeface combinations are based on their comparative letterform characteristics, such as similar width, x-height, or other proportional relationships. It is possible to combine two serif or sans-serif typefaces, but only if they are considerably different from each other.

+ **PHOTOGRAPHY | PORTRAITS**

+ **TYPE | ENSIGHT PUBLICATION**
Growing Up Veggie | InDesign and Illustrator | Published Fall 2008

Typographic Hierarchy

A typographic system determines the hierarchy of information within the overall text on the page and even within each grouping of text. You should determine which types of information are most important to emphasize. If you are including three lines of text—say title, medium, and date—you will need to determine which of these three to make the most visually prominent. Keep in mind that we usually de-emphasize the types of information that are most redundant (such as page numbers in a book). In this example, if most of the work is of the same medium or the medium is quite obvious by looking at the image, it may be a good idea to make this bit of textual information less prominent.

If you are not organizing your work as a progression, perhaps the date is not as relevant either. So, in this case, we are left with the title as the primary bit of text, used to identify each individual piece by name. The title in this case can then be emphasized in a variety of ways. It is a good idea, however, to keep it simple and only emphasize through one visual means. This can be done by simply making the text bold, using an accent color, or even making it a point size (or two) larger. This differentiation does not need to be too complicated. A simple shift can be enough contrast to distinguish it. Remember that you don't want to create too much contrast, because such visual tension would draw the eye away from the image of your work. **Use a limited number of fonts and type styles to create contrast and direct the eye. Changing the contrast can be accomplished by altering not only the typeface, but also weight, color, form, and structure. To the right are three different typographic systems, all using the same type family.**

Legibility

Legibility is of concern when placing text along a vertical or diagonal axis. While such orientations can certainly make a composition feel more dynamic, keep in mind that it makes the copy more difficult to read and should probably be limited to simple lines of text. Another concern with legibility is, of course, size. One of the biggest mistakes made in layout design is in making the size of the text too large or too small. The typical size of body copy (paragraphs of text) is 9, 10, or 11 point, varying slightly depending on the typeface used. This is a rule of thumb to consider for multiple lines of type, such as for image captions.

Titles of course can get somewhat larger, but again, shouldn't detract from the work itself. You'll need to find a balance between size, placement, weight, color, and opacity that works within your composition. Of course there are always exceptions and you should think about how you want your type to function. If you are creating title pages or experimenting with inserts you may very well want to utilize the typography as a more prominent feature.

Title of Piece
Medium
Year

Title of Piece
Medium
Year

Title of Piece
Medium
Year

Tips and References

- When using more than one typeface, make sure they are very different.

- Never use all caps for body copy or for highly decorative typefaces.

- Always have someone else proof your copy.

- Always proof your own copy at least twice.

Look to historic design masters and reliable texts for guidance and inspiration. Some to check out are: *Swiss Graphic Design* by Richard Hollis; *The Elements of Typographic Style* by Robert Bringhurt; *Grid Systems in Graphic Design* by Josef Muller-Brockmann; *The New Typography* by Jan Tschichold; *Typographic Design: Form and Communication* by Rob Carter, Ben Day, and Philip B. Meggs; *Thinking with Type: A Critical Guide for Designers, Writers, Editors, and Students (Design Briefs)* by Ellen Lupton; and *Typographic Systems of Design* by Kimberly Elam.

Paragraphs

Finally, for multiple lines of text, try experimenting with leading. Leading is a term that comes from the "old" days of typesetting and letterpress. It refers to the amount of space between lines of text. As you open up the space between these lines you lighten their combined textural appearance, making each line function on more of an individual level. This works for identifying information (title, date, etc.) since each line is able to function on its own. Such an approach can sometimes be useful since it allows you to activate more of the compositional space.

Also, **align** and **justify** (left, right, or forced).

From all these experiences the most important thing I have learned is that

LEGIBILITY AND BEAUTY STAND CLOSE TOGETHER

and that type design, in its restraint, should be only felt but not perceived by the reader.

ADRIAN FRUTIGER

For the Nondesigner

If you are less experienced with typography, using a sans-serif typeface family can be a good option. Such typefaces provide a number of dynamic variations in weight (bold, thin) and proportion (extended, condensed). Since each variation is part of the same family, they retain properties of the same underlying letterform anatomy. This means that all the variations will work together in complete harmony. Some of the most commonly used typeface families are: Univers, Helvetica, Frutiger, and Futura.

Need Help: Recommendations

Try these time-honored typefaces; most designers would agree that they are industry standards. (There are many, many excellent typefaces out there and this list is only a partial list, meant to provide you with a few suggestions.)

Avenir, sans serif, *designed by Adrian Frutiger in 1988*

Bodoni, serif, *designed by Giambattista Bodoni in 1798*

Caslon, serif, *designed by William Caslon in 1734*

Clarendon, serif, *designed by Robert Besley in 1845*

DIN, sans serif, *designed by the D Stempel AG foundry in 1923*

Franklin Gothic, sans serif, *designed by Morris Fuller Benton in 1902*

Frutiger, sans serif, *designed by Adrian Frutiger in 1968*

Futura, sans serif, *designed by Paul Renner in 1927*

Garamond, serif, *designed by Claude Garamond in the 1540s*

Gill Sans, sans serif, *designed by Eric Gill in 1927–1930*

Gotham, sans serif, *designed by Tobias Frere-Jones in 2000*

Helvetica, sans serif, *designed by Max Miedinger and Eduard Hoffmann in 1957*

Helvetica Neue, sans serif, *designed by the D Stempel AG foundry in 1983*

Sabon, serif, *designed by Jan Tschichold in 1967*

Univers, sans serif, *designed by Adrian Frutiger in 1956*

Note: This material applies to any creative who is working with images. However, for photographers this is especially significant; thoughtful consideration of picture relationships can make for a much stronger photographic portfolio.

Photographers by training present images on a singular basis, and often the assignments and projects undertaken dictate that they do so. By default, images are often edited and organized in relation to the type of image or type of assignment. While this is clear and easy to manage, if your portfolio is going to function as a statement, it needs to be considered as a set of related images that comprise a whole, or body of work. You can be assured that your images will readily reveal *what you photograph or the types of photographs you make.* But you want your images to do more: express your overall vision and the scope of your abilities.

Sequencing is working with multiple images and thinking beyond a single image presentation, to a more complex set of relationships between photographs. Through sequencing you can shift the emphasis from the obvious and take advantage of relationships between adjacent images and across images within the ordering to create a stronger statement that functions as a body of work, rather than a grouping of singular images.

Image Sequencing across Multiple Pages

Photographers frequently make extended bodies of work and their organization within a book format can be key to effectively conveying the idea or expression intended in the photographs. Ordering (sequencing) photographs across multiple pages requires attention to both relationships within facing pages, as well as those from one page set to another.

True sequencing of photographs is not a simple linear progression or order within a book. A useful text which addresses the subject of image sequencing is Keith Smith's *The Structure of the Visual Book.* When placing images in a progression, the ordering is made more complex and substantive by having the elements within the photographs reference each other. This interaction between images is based on

what Smith defines as "referral." Direct referral is "an intentional relationship set by the picture maker from one specific element within a picture to another element within the same or another picture".[3] Working from aspects found within the photographs themselves allows one to create relationships between photographs in multiple ways and in particular, support "movement." Movement, as Smith describes it, occurs image to image as well as between images through these references. Subsequently, your ideas and what you wish to convey are delivered more effectively taking advantage of references within and between the photographs.

Editing: Where to Start

All edits start with having a strong body of work. From there the goal is to put together a concise group of images. There is a threshold to the number of images in a portfolio at which point you overwhelm the viewer, or the sequence simply becomes repetitive. Websites tend to allow for the inclusion of much more work, although the very same principles applied here can bring focus to a web presentation. For photographers an average number would be 20 images.

For designers, you should consider the number of works you present and in particular if those works have multiple components. In the case of any multi-component project you may wish to present a number of deliverables as well as show process materials related to concept development. If so, you may want to reduce the total number of projects in favor of fewer, more extended works. As mentioned in Step 1, 8–15 pieces on average is a good number. A smaller number of well-considered projects can be more effective than too many works that result in your portfolio losing focus. See the additional considerations for designers in the latter part of this chapter.

All books are a combination of physical, visual, and conceptual transitions. The book may emphasize one extreme, ... while downplaying the other extreme. ... But the visual book remains a combination of all three, with visual transitions at the center.

— Keith Smith, Author, *The Structure of the Visual Book*[4]

Strategies for Sequencing

Sequencing can be an overwhelming process and there are some practical approaches that can help get you started.

1. **Get the images off the screen and on to a wall or table.** Work with them in hard copy form. This is one instance where imaging technology is cumbersome. Print them out, a 4 × 6 will do. Pin or tape them up to a wall or spread them out on a table. It is much easier to quickly move images around when you can pick them up.

2. **Work with images in small groups.** Don't try to work the whole edit. Identify strong images and start building from there. Make clusters of three or four images.

3. **Connect images through formal elements:** line, color, visual weight, positive-negative space, as well as the structure of the composition. You are trying to find connections between images, which support visual transitions. Find differences as well as similarities. This also allows you to identify different elements to link and refer to, when building the larger sequence. When combining, consider what creates a strong focal point with a cluster of 3 images?

4. **Combine the smaller groupings together** through the aforementioned elements and referral to establish movement. Look for elements found between images that pull the viewer through the progression of the sequence in addition to those which support transitions between adjacent images. For example, this could occur through the repetition of a formal element (color) that appears and reappears in succeeding images.

5. **Pacing of movement** is affected by how the referred elements appear in the ordering of the images. Do certain elements appear, and then reappear later in the sequence of images? You should, however, avoid repeating too many frames that are either formally similar, or similar in terms of content and subject.

 Further vary the placement of complex dense images and more simplified constructions, or subjects. This will enable movement from quick reading images to images that are more complex, or detailed, requiring a closer reading. Don't try to pack the most dynamic images into one continuous run; allow for ebb and flow, so as not to overwhelm your viewer.

6. **Create a strong progression of images to start the sequence** and try to end strong as well.

7. **Once you have put together the overall sequence,** look for focal points which draw your attention and places where the movement of your viewing slows down, gets stuck, or loses focus. Try to maintain a sense of movement and pace through the sequence. The images should in effect draw the viewer through the sequence as a result of the visual relationships you created. The idea is not to make this a seamless flow, but one which pulls the imagery together and supports viewing the body of work as a whole.

Note: you can build clusters of images that are based on relationships of content, particularly if you are working with a narrative. However, that content is going to be better served by developing visual relationships that tie the imagery together.

LARRY VOLK, SUFFRAGIO TRIPTYCH, SX70 Series.

LARRY VOLK, SWAMPSCOTT, SX70 Series.

Creating Interplay and Image Relationships

Images placed together can build on each other by having connections based on formal elements, such as color, line, negative and positive space, pattern, and repetition. Images can also be linked by content and subject matter. Movement between images can be achieved by drawing the viewer's eye through pattern, or a progression of content. The content can present a narrative, or simply an interaction around related content. A larger creative leap can be taken by creating relationships and readings of disparate images, which hold together on formal terms or otherwise wouldn't be seen together.

In the first example (top, left), the formal structure of the photograph is the basis for the *triptych*. There is movement within the frame: A single element (light on the wall) or multiple elements positioned within the frame shift across the three images.

In the second example (below left), you have a narrative progression or a progression that implies the passage of time—a progression builds from left to right around a specific content or action. The figure in the image changes position within the first and third frames, suggesting movement into view and out of view. The middle frame, being empty, exaggerates the shifting position of the figure by creating a gap in the reading, as if the figure had moved through the frame.

In this, *diptych* (top left), the images are related by a formal element (color, shape, negative or positive space) even though the content of these images is unconnected. The formal similarity unifies the pairing and draws the viewer's attention, while the dissimilarity of content requires the viewer to consider the images again and creates a more complex reading. Ultimately, the intention is to build a larger impression or association, in this case to a particular place or environment.

In the second example (bottom left), the images are connected by related content and formal elements: the physical spaces and the play of light and shadow. Each image builds on the other and allows the photographer more flexibility in representing the subject because the individual frames do not have to convey the entirety of the subject. The use of two frames allows for more range in composition, and the possibility of movement between them. The interplay between the combined images is intended again to build to a larger whole, while still reading as a pair of individual images.

LARRY VOLK, VITERBO DIPTYCH, SX70 Series.

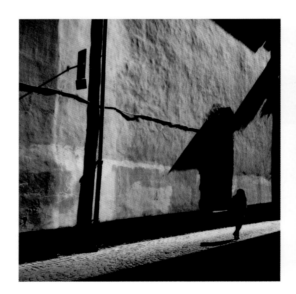

LARRY VOLK, SHADOW BOCCE, SX70 Series.

A Sample Sequence

Arne Hoel is a documentary photographer and multimedia producer working with international development organizations and aid agencies based in Washington, DC. This group of images spans his work in international development working with NGOs and foundations. My interest in putting together this body of images was to show his range of visualization, as a photographer, the visual character of his work, and the scope of his experience. While the images are derived from different projects that had specific content and subjects, they are related enough visually to be combined into an overall edit. These are drawn from what had been initially 3 separate categories: Development in Action, Corporate /Industrial, and Travel.

Working with Images in Small Groups

In this first set, (top left) three images are connected by a strong central focal point and strong diagonal lines that draw to that focal point, and formally tie the images together. Movement (left to right reading) is enhanced by a progression of cool to warm color tone.

In the second set, (center left) three images are related by the appearance of a figure in each image. Movement from left to right is fostered by the changing position of the figure, and a progression across the three images wherein the face appearing in each image shifts from obscure to fully revealed by the last frame. Again, movement (left to right reading) is enhanced by a progression of cool to warm color tone.

When combined, (bottom left) the two groupings of three create an overall progression of blue, green, to red/warm tone, which then repeats. Further, the progression leads the viewer through a number of views of different individuals and allows us to see variations of Arne Hoel's ability to construct portraits.

In this set of 3 (opposite page, top), a circular form in the left hand frame creates a formal link to the center image with a circular form seen in the center of the frame. The center image, which additionally has a hand gesturing below the bowl, is connected to the third image by the hand that appears in the foreground. While these images have varying content and composition, they are linked by formal elements or objects found within the image which encourages movement and reading from left to right.

All images this page and opposite, ©*A R N E H O E L / T H E W O R L D B A N K ,* *W W W . A R N E H O E L . C O M ,* **Washington, DC.**

This set of 4 (above, center) are linked in two ways which enhance movement. First, the images are connected by the appearance of a primary color (red) in each. Secondly, a rhythmic progression [A, B, B, A] has been created by the appearance of a strong geometric form in the first frame, followed by 2 frames with faces/figurative elements and a return to a strong geometric form in the last frame.

This sequence of 6 (above, bottom) also shows a progression of changing pictorial space. Moving from left to right, the first frame has a strong foreground element that extends to a long view. The next frame employs a closer, middle distance view with central focal point followed by a frame with a close-up view with foreground focal point. The next frame pulls back to a middle view and the last two frames have long views each of which has a central focal point and strong diagonal axis.

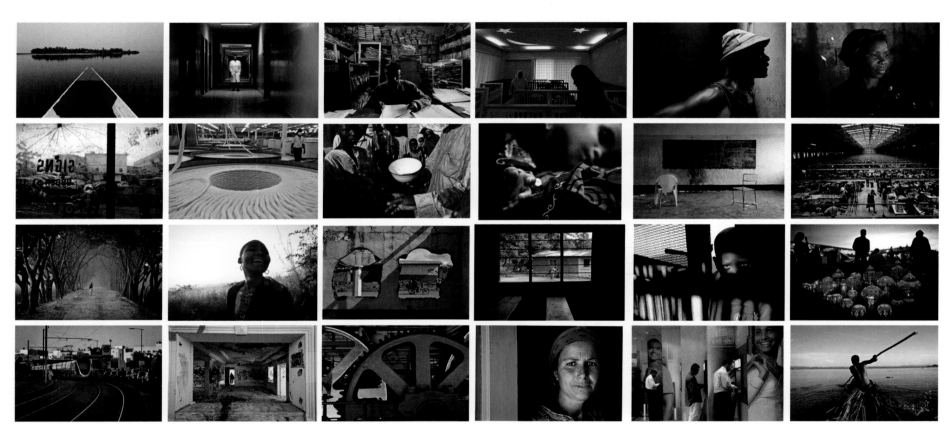

© ARNE HOEL / THE WORLD BANK, WWW.ARNEHOEL.COM, **Washington, DC.**

The final edit (opposite), attempts to foster the kind of movement established in the initial groupings which enables more effective image to image transitions encouraging movement through the sequence of images. Pacing is varied through the repetition of primary colors, image construction, and subject matter. For example, portraits are scattered throughout the sequence creating focal points. The goal of the overall sequence is to demonstrate a range of seeing, with variations in subject matter and context in an effort to represent the breadth of the photographer's work and ability in a concise and cohesive manner.

What About Different Bodies of Work?

Do you combine them all, or will you need to make different types of portfolios that are specialized? There are tradeoffs with both approaches. A tightly edited book can effectively combine different types of work, as long as they are not so disparate that the presentation will seem disjointed. In making one singular book, if you have an overall

style or aesthetic, it can be advantageous to show how this finds its way into different subjects and image types. Your goal is to craft a cohesive vision while showing the range you have with image making.

The rationale for separate books is to be more targeted with respect to your audience, as it may be more useful with particular clients to show a body of work that is specific to one kind of subject or approach. As always, research your market and consider how your body of work will be received. There is always a risk of being pigeon-holed, but if you know what the interests of a particular set of clients are, attending to this can be the most effective course to take. Another rationale for separate and distinct books is if you find the edit just does not read well or is too lengthy. As always show your edits to trusted eyes and get feedback before you commit to it.

ALL BOOKS ARE A COMBINATION OF PHYSICAL, VISUAL, AND CONCEPTUAL TRANSITIONS.

The book may emphasize one extreme, ... while downplaying the other extreme.

... But the visual book remains a combination of all three, with visual transitions at the center.

— KEITH SMITH, AUTHOR, STRUCTURE OF THE VISUAL BOOK [5]

Considerations for Designers

Creating a sequence for a portfolio of your works, even if they are varied by type of design or media, can contribute to a stronger, cohesive presentation. Just as with a sequence of photographs, the relationships within a page spread, as well as the pace and flow of your sequence, are not something to be overlooked. The relationships between images that are described in this chapter have application to the presentation of other types of work. As you consider the order of your portfolio, attention to flow and progression of your work as well as the creation of the transitions and pacing will only enhance their delivery to your viewer.

- As mentioned in the introduction to the book, a well-thought-out portfolio should tell a story about your capabilities and your vision as a creative. What do you want your viewer to understand about you as a designer, and how do the selected works reflect that?

- When sequencing a body of work as a designer, it is important to think about the area of the design industry that you are trying to break into and emphasize works which reflect this. For example, if you have a strong interest in branding or UX design, then you should use this as the basis for organizing your portfolio and tailor the sequence to this.

- When editing, if there is a work that feels unrelated, or tangential to your intended goal, don't include it. Better to appear focused than appear that you are all things to all viewers.

- Start the sequence with strong examples that are specific to the area of the design industry that you are targeting as your goal.

- Think about which pieces you want the viewer to spend the most time with, as these will be the works that leave the strongest impression.

- As stated previously, 8–15 pieces is a good number to keep your portfolio focused, particularly if you have multiple component pieces, as below.

- In the case of works for which there are multiple components, such as a brand identity, include different examples from the deliverables making sure that the overall concept is clearly presented initially.

- Showing process works and design iterations is appropriate. Consider the sequence and think about creating a narrative that shows design development. Limit this to a few examples, as you don't want the viewer to lose sight of the completed work.

- While your portfolio may not be a sequence of a single body of work, you should still consider movement and visual flow. In any grouping, you should look to enhance movement between the works by finding formal elements that support visual transitions. Disparate pieces can be connected in this way and this will create a more cohesive sequence even when the work may not necessarily be related.

- As in any sequence, finish strong; while your portfolio may begin with strong works, the last thing your viewer sees should be memorable.

- For students who, as of yet, don't have a particular emphasis in their work, use a range of examples. However, having the examples flow into one another (as one might with photographs) can unintentionally create an unclear view of who you are. In this case, you could consider organizing the work into clearly defined sections to create points of emphasis. If you do have an area you wish to emphasize, you can place greater emphasis through showing more work in this area, and include other projects to support those areas that broadly highlight your skills and abilities.

Tip: Always print a dummy. If you are trying out sample page layouts and image combinations, print sample pages to scale. This will help in determining how your images are reading. In particular, if you are creating an extended sequence, print it out to see how it reads through the entire sequence. Pin it up on a work board, live with it. Make dummies and proofs to see if your work on the screen is working well on the printed page.

Scaling and Legibility

As any photographer or designer knows, the printed size of your images is going to have an effect on how they read and you should be conscious of how the scale of your image impacts its legibility. Some images benefit from running full page as large as possible. However, bigger is not necessarily better and some work is more effective at a smaller scale because this creates a more intimate viewing. Rather than bowl someone over with your large images, you can engage them in a subtler fashion. Certain images can be presented smaller, without having a dramatic effect on the viewer's experience of that image. A simple, more isolated subject will read better at a smaller scale than an image which has a densely packed frame or is finely detailed. Ultimately, you know your work, and how it should be presented. You should consider what size is going to be most beneficial within the limits of putting it into a reasonably sized portfolio.

Things to Consider

- For all of the ideas concerning "breaking out of the box" of traditional presentation, you must be careful and consider how you put together your work. If it isn't consistent with your visual identity and isn't appropriate to your work and your intentions, don't do it.

- Works seen on a page or facing pages should be there for a reason. You shouldn't be putting together images or projects that compete with each other, even if they are related by form, or type of work. Don't consider grouping images together unless they can build on each other. Saving space by creating multiple-image layouts is not the best rationale.

- As a photographer, if you are making an example of a family photo album, or a bridal album, don't make your work look like one, with multiple formats in a combination page structure. At best, this will feel like an overlay of a stock template; demonstrate that you put thoughtful care and attention into your work.

- Consistency will create a stronger presentation. If you employ image pairings or a narrative sequence, it is important to have a consistent plan of layout for the overall book where these different approaches can be highlighted and seen as distinct from the other images in a well-considered layout.

The type of book CANNOT BE ARBITRARILY CHOSEN AND THE CONTENTS STUCK INTO IT.

The binding and display will alter the contents and one type of book will allow better development of an idea than another.[1]

KEITH SMITH
Book Artist, p. 10

CONSTRUCTION

The primary advantage of constructing your own portfolio is that it allows you to build a presentation that is tailored to your needs from the standpoint of visual identity, your particular work, and even your budget. Beyond this, designing and building your own book reflects your ability to create and conceive from start to finish, including the ability to craft your own book. While your goals may not necessarily be a print-oriented career, the fact that you can conceive and design through a variety of forms, including a book, will reflect positively on your skills as a creative.

Finally, the portfolio book itself is a way for you to distinguish your portfolio from all of the other presentations. At minimum, it shows that you put thought, time, and energy into your work, and at best, it will be a unique presentation that will separate you from all of the others. The goal then in this chapter is to introduce some basic methods that can go a long way to making a portfolio that stands out and brings you attention.

Note. From a practical standpoint, simplicity and flexibility are key here. Assume that you will be adding new materials and pieces to the portfolio over time and choose a design that allows for replacing or changing parts of the portfolio. One approach is to find a simple binding that can be easily recreated if necessary. This would allow you to:

- Update your portfolio easily and quickly.

- Make multiple versions of your portfolio.

- Make variations of your portfolio in relation to the particular client.

Your binding should, in all cases, reflect and serve the intentions of your visual identity as developed in your cover and page design.

Methods to Construct a Book and Book Terminology

Books Created by Sewing Folded Pages Together

- A *signature* is a gathering of pages folded together from one sheet of paper.

- A *pamphlet* is a one-signature book. The cover of the signature is folded around the gathering of pages. The signature and cover, or the signature itself, are sewn together through holes in the pierced fold.

- A *multi-signature book* is a number of folded signatures that are sewn together with endpapers that attach the text block to the covers.

Books That Are Single Sheets Bound Together

- *Side-sewn books:* A group of individual pages (the book block) are bound together by stitching the block of pages to a set of board covers.

- *Post and screw bindings:* The book block (a group of individual pages) is attached to a set of board covers with binding posts.

Books That Are Created by Folding

- One-page books.

- Accordion and concertina books.

- Back-to-back bindings.

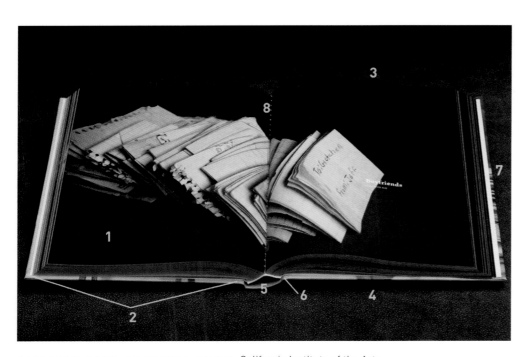

GRETCHEN NASH, S T U D E N T B O O K, California Institute of the Arts.

Parts of a Book

1. *Book block or text block:* Contains all of the pages and content.

2. *Cover or case:* A nonboard cover book is a softcover.

3. *Head:* The top of a book or page.

4. *Tail:* The bottom of a book or page.

5. *Spine:* Generally refers to the bound edge of the book.

6. *Hinge:* The flexible gap between the board covers and the spine.

7. *Fore edge:* The leading edge of the book, opposite of the spine.

8. *Gutter :* The valley in the center of the book that forms at the binding and spine.

Other parts include:

* *Signature or folio:* A group of one or more folded pages stacked together.

* *Endpaper:* Papers that are on the inside of the covers; these can be decorative.

Materials

- Davey board, or book binder's board, 0.070 thickness, or four-ply mat board.

- PVA glue (polyvinyl acetate); Sobo is a common brand. Other adhesives can be used; however, PVA forms strong bonds while retaining some flexibility.

- Methyl cellulose or wallpaper paste, which can be used as an adhesive, or added to PVA to extend it and slow down the drying time of the glue and make it more workable.

- Double-stick tape or ATG adhesive (see tip p.125).

- Book cloth is prepared with a paper lining to prevent glue from seeping through the fabric.

- Papers are used for accents on covers, endpapers, and cover stocks.

- Posts, screws, and bolts or fasteners.

Tools

- A snap-blade utility knife (Olfa or X-Acto). The snap blade makes it easier to maintain a sharp edge.

- Self-healing cutting mat.

- Metal or plastic triangle.

- Metal straight edge for cutting board and paper.

- Bone folder.

- Flat bristle brush for application of glue.

- Two-inch paint roller, also for glue application.

Printing Your Books

Printers

The number of digital printers and inkjet devices that are capable of reasonable image reproduction is dizzying. In printing a portfolio, you want to use a printer that is going to give you industry-standard quality. Anything less, and you are undermining your success before you even begin. Beyond commercial printing, the best-quality printers available are those designed for photographic reproduction. They use pigment ink sets that provide the broadest color gamut, the highest black density, and image stability. This will ensure that your portfolio will be produced and appear in the manner you intended. Canon, HP, and Epson are the industry leaders in digital photographic imaging.

If you are going to employ a printer it is recommended that they support inks that offer longevity and ICC workflows, both of which we will address in the following sections.

Papers

With the development of digital imaging for photography, the digital printer is now a high-quality tool for printing, and as a result there are numerous papers that could be used for printing a portfolio. Bright-white matte papers intended for photographic printing are inexpensive, easy to work with, and very high quality. Papers such as these are standardized, come in a variety of weights and surfaces, and have paper surface settings that tailor the printer's ink distribution to that particular paper.

There are other kinds of media available such as high-quality inkjet printable vellum, canvas, and papers that have a higher tooth or texture. These could be incorporated in a variety of ways depending on your design. Coatings such as InkAid™ are also available to allow one to prepare a surface for inkjet printing. A large-format digital printer can even accommodate "poster boards" up to 1.5 mm thick.

Note: Working with papers intended for the type of printer you have or the specific printer you are using has a number of benefits. The papers have coatings that are designed to absorb the inks from the printers consistently for the best tone and color reproduction. High-quality digital printing papers rarely absorb the ink into the paper substrate, but rather, absorb it into the coating. An uncoated paper is not optimized for the inks and may not print well or consistently with every color. An additional and important fact is that the coatings are designed to work with the inks to ensure color stability, and in some cases, archival longevity. It is possible to end up with a distinct color shift in your printed portfolio six months after you completed it as a result of an unstable paper and ink interaction.

When choosing a paper there are some caveats you should consider:

- Coated glossy or luster papers have coatings which can crack when folded.

- The coatings of matte papers can wear and scuff with use and handling. It is a good idea to have another copy of your portfolio available if your active copy shows wear or gets damaged.

- One option is to laminate the cover, which will protect the coating, but result in a different surface from that of a matte paper.

- Another option is to use a protective spray that is designed to make the matte surface more durable and extend the archival longevity of the print. Premier, Lyson, and Hahnemühle all offer products that have been used with good results.

- Heavier stock over 150 g, while wonderful for individual prints, can be harder to work with and will build into a thicker book.

Color Management

A well-designed book that is poorly crafted will not present you effectively. You should assume that the standard of printing for your book must meet the expectations of your target market—anything less and you will undermine your intentions. Best practices, using ICC workflows, allow for high-quality image reproduction of vector-based graphics, type, and color. Even though color management can be difficult to understand, it is well integrated into high-quality inkjet printing systems by manufacturers such as HP, Canon, and Epson. When printing your book you could make adjustments and changes as you print, but color management offers a far more efficient method of working that wastes less materials, time, and energy.

Color management essentially enables you to go from screen to print with consistency and predictability. By employing color management one is able to take a file from one condition to another, maintaining accurate color even when the mechanism for reproducing it changes; the intention here is to go from A to B and not have significant shifts in color or tone.

Using an *ICC workflow* and *profiles* enables you to take your InDesign layout, in a CMYK (cyan, magenta, yellow, black) color space, and send it to a printer wherein the color information will be converted and reproduced accurately.

Profiles are characterizations of the color of a particular device with a particular material (paper). They allow you to orient the software to the kind of color gamut and conditions in which your file is going to be produced and to make adjustments to the color based on those conditions. High-quality desktop and large-format digital printers use *destination* or *printer profiles* to correctly reproduce the color and tone of the files that are being printed. Generally, when a printer driver is installed, the color profiles provided by the manufacturer are installed as well. Aftermarket paper manufacturers provide free profiles that need to be installed by you.

Tip: Get Help

Most photographers should have experience with color management at this point if they are printing to inkjet devices. As designers frequently work with commercial printers, color management is often left to the printing professionals. Get help, if you are in over your head. You may have color management tools available with your own printer and have not yet employed them. If in doubt, test, test, and retest.

Duplex Printing

Duplex or double-sided printing is necessary when making a sewn or stapled pamphlet. It can be incorporated in the post and screw binding as well. Printers that are designed for duplex printing will allow you to use pamphlet and imposition features of software such as InDesign. Most high-quality inkjet printers are not duplex enabled.

If you do not have a duplex-enabled printer, you will have to print single-sided pages, printing the back side spreads individually. Usually with a printer that is designed for single-sided printing, registering the back side to the front side can present some challenges. It is highly recommended that you *test your printer* to see if your sides are registering, and if not, figure out what adjustments need to be made. You may have to shift contents or page position to achieve good front to back alignment.

Alternatives to Duplex Printing

Lighter-weight papers can be adhered together in a similar fashion to a perfect binding, creating a single page that is printed on both sides. For our purposes we call this a *back-to-back binding* and instructions on how to produce a back-to-back binding are found later in this chapter.

In a similar manner, some books incorporate a back-folded page. The fore edge of the page would be the folded edge, with the open ends of the folded page bound into the spine. This is easy to apply to a post and screw binding. In both cases the result is a slightly heavier page, depending on the paper stock.

Tip: Finding grain direction and gluing. All papers have a "grain" in which the fibers that make up the papers are aligned in one direction. Generally the grain of all paper and board should run parallel to the direction of the spine. By aligning all papers, cloth, and board in relation to their grain, the book will be less prone to warping when gluing.

To determine the direction of the grain, bend the paper or board slightly in a vertical direction and then horizontally. Whichever bend offers the least resistance is the one that runs parallel to the grain.

Tip: Again, make a dummy! As mentioned previously, making working versions or dummies will always lead to better books. You can print and roughly bind a version, which allows you to practice your binding skills and test out methods of construction. More important, you can check for the overall reading and sequence of your book, and see a real version of your final design.

In this construction, board covers are made separately with flexible hinged spines. The simplest design is to have two sets of boards, for back and front covers. The spine is open and the book, covers, and boards are joined with posts and screws. The same board covers can be used for a tied version of the binding, often called a stab binding or Japanese tie.

Materials: Chipboard, book cloth, endpapers, accent paper, glue/methyl cellulose, bone folder, brush, utility knife, and waste paper for gluing.

Note: When designing your pages for post and screw binding, add 1½ inches additional width to the left edge of your page to account for the spine and area of the gutter. This total length then reflects the size of the cover, which includes the flexible spine [see example, right].

Cutting Your Boards

When cutting your boards, a metal triangle or t-square is essential to make sure your cuts are square and consistent. Cut the height of the boards first. Then cut the overall length of the board, and then cut the 1½ inch spine out, marking both pieces so they are easily identified with the other set of boards.

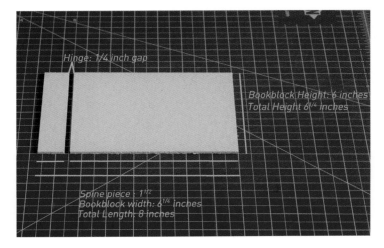

Hinge: 1/4 inch gap
Bookblock Height: 6 inches
Total Height 6¼ inches
Spine piece : 1½
Bookblock width: 6¼ inches
Total Length: 8 inches

Measurements: The cover boards should overhang by ¹/₈ inch from the edge book block.

- *Height:* Add ¼ inch to the height of the boards to create the overhang for the top and bottom edges.

- *Width:* Measure the cover to the same width as the book block plus 1½ inches for the spine. When the spine is cut from the width, the spine will have an additional ¼ inch gap (this is for the hinge) when glued together and this will produce the ¹/₈ inch overhang on the width.

For example, If the printed area of your book is 6¼ inches wide, your book should have an additional 1½ inches for the spine, plus ¼ for the gap making it 8 inches wide in total. If the height of the book is 6 inches, ¼ inch would be added to the height, making the dimension 6¼ inches.

Tip: Any fabric can be used for book covers by sizing it prior to gluing. Sizing is available in most fabric stores, the simplest of which can be ironed on allowing for alternative fabrics to be used in lieu of book cloth. One can also make custom-printed fabrics and materials by purchasing coatings that will allow inkjet printing inks to adhere to any surface. There are also fabrics that are designed to be printable, and can be used to create a printed cloth cover. Inkjet printable book cloth is now available as well. (Go to *www.noplasticsleeves.com* for a list of bookmaking resources.)

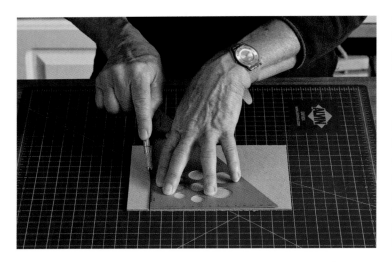

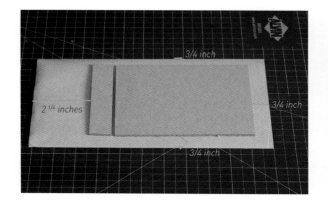

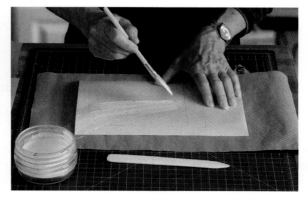

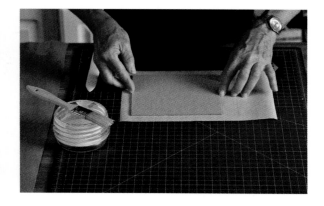

Measure and Cut the Book Cloth

Lay the book cloth face down on your table or work surface. Lay the cover boards and spine on the cloth. Make a ¼ inch gap between the spine and the larger cover board to form the hinge.

- *Height:* Add 1½ inches to the height of the cloth. This will create a ¾ inch edge that can be folded over the edge of the board and glued down. This is called a turn-in.

- *Width:* Add 3 inches to the width. This will allow ¾ inches for the turn-in on the fore edge and 2¼ inches for the turn-in on the spine edge. This *longer piece* will be folded over the end of the spine, onto the inside of the book, across the gap of the spine, to create a complete hinge.

Gluing

When you glue be sure to have plenty of scrap paper, or kraft paper, covering your work surface. You can use small pieces that equal the dimension of your book as waste sheets to sit under your materials catching excess glue. Be sure to remove the waste sheets from your work surface as you work to avoid getting stray glue on the book cloth or paper. Use an even, thorough coat of glue to the area of the cloth that you are gluing up. There should be complete coverage to all surfaces to prevent any puckering or bubbling where the paper and book cloth might not stick. Spread the glue from the center of the cloth out to the edge. Think of the pattern of the British flag, the Union Jack. If the cloth or paper curls, keep brushing and it will eventually lie flat and relax. Wait, as it will be easier to handle.

1. Take a new waste sheet.
2. Set down the book cloth.
3. Smooth the boards down with the bone folder.

Tip: If you draw pencil marks outlining the position of the boards prior to gluing, it makes it easier to place them down on the cloth once it has been glued.

Use two small scraps of book board adhered together, to check the gap for the hinge between the spine board and the cover board.

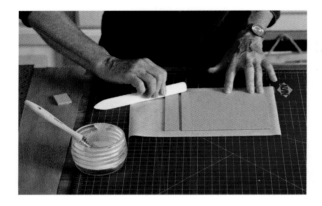

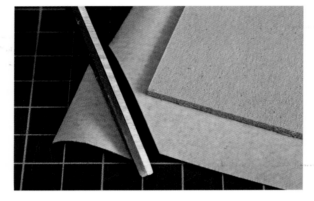

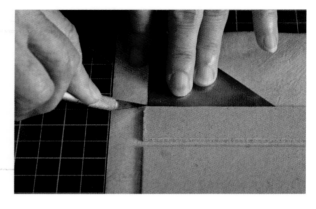

The *bone folder* is an essential tool in this part of the process for working the cloth or paper, as it should be smoothed out with no air bubbles, assuring complete adhesion. The edge of the cloth needs to be pushed and somewhat stretched over the ends of the board to create tight, clean edges.

Trim the corners of the fore edge with scissors as above. You will cut a triangle off the corner, leaving an ⅛ inch.

Trim the cloth at the spine edge. Use a small triangle to align your knife. Place the triangle ⅛ inch to the inside of the end of the spine board. Cut a straight cut back, and then cut outward at an angle away from the bottom edge of the board, as shown in the example above.

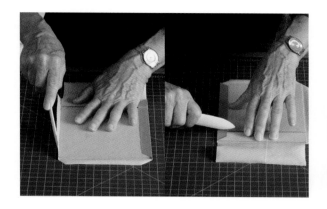 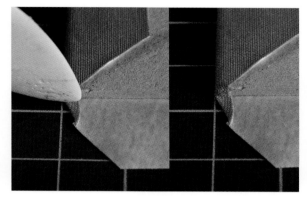 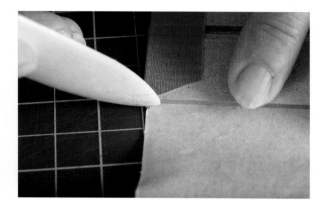

Now reapply glue if needed to the turn-ins on the top and bottom edges of the board. Use a bone folder to work the cloth over the top and bottom edges of the board.

At the fore edge, pinch the cloth in at the corners with a bone folder. Then turn the cloth over the board as you have done with the top and bottom turn-ins to finish the fore edge.

At the spine end, pinch the cloth at the corners as you have with the fore edge. Reapply glue if necessary (use your finger to see if it has started to dry). Fold the cloth over the edges of the spine and the hinge.

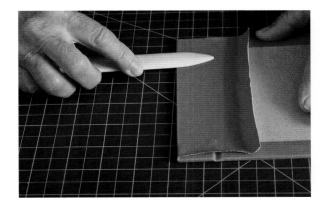

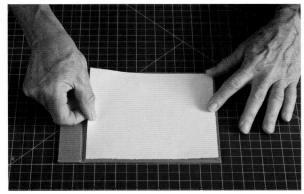

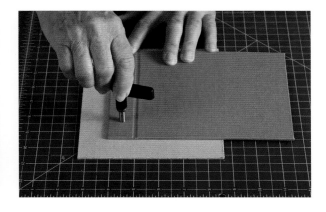

Use a bone folder to work the cloth over the spine board and across the gap of the hinge. Then work the cloth into the gap or valley of the hinge.

Measure your endpaper, or lining paper, to ¼ inch less than the height of the cover and ¼ inch less than the width of the board from the fore edge up to the hinge or gap in the spine. You will not cover the spine with paper.

Coat the paper with glue as you did the book cloth and apply it carefully to the inside of your cover, making sure you have ⅛ inch inset on all sides.

Once the boards are covered and endpapers applied, place them between paper or board and let them dry overnight under heavy weight.

Punching Holes in Your Covers and Book Block

There are a variety of ways to punch through the book block and covers. Frequently, the whole book, covers, and book block are clamped together, having been marked for drilling. A sharp drill bit is used with a drill to cut a hole through the covers and book block.

Other alternatives are a paper drill and a punch with a hammer. In the case of these options, it is good practice to mark one cover, drill the holes, and then align and mark the other cover via the holes you just punched. This assures that the holes on the front and back covers are aligned. The covers can be used to mark individual pages for punching, which insures that they will fit correctly.

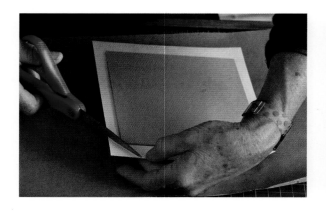

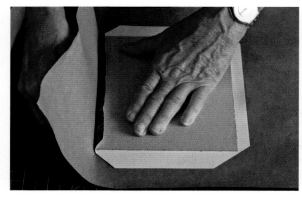

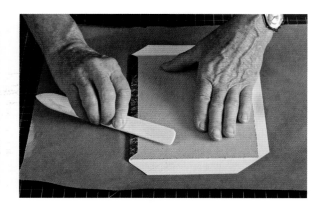

Good-quality inkjet papers can be used to make a book cover and can be applied in the same manner as book cloth. Lighter-weight paper, 160–190 grams, is recommended, as it is easier to turn over the edges of the binder's board. Matte paper is also recommended, as glossy coatings will more than likely crack when folded.

The measurements and proportions for using paper to cover boards are the same as using cloth. It is recommended, in the case of any book with a flexible hinge and spine, that you use book cloth in this area. The paper would not be strong or durable enough to tolerate the movement of the hinge. You cut the corners and pinch the edges just as you would a book cloth cover.

The trick to creating turn-ins on the top and bottom edges of the cover is to use the waste paper as a support to bring the paper over the edge. This avoids possible abrasion from the bone folder. The bone folder can then be used to do the final smoothing out of the turn-ins.

Tip: The use of double-stick tape or ATG adhesive makes for much easier construction when adhering pages together. It eliminates the problem of moisture, which can cause warping and pulling of the pages. Spray adhesive can be used but presents far too many problems, not the least of which is the need for ventilation.

Heavy-duty double-stick tape is available in a variety of widths and is easily applied to pages. The advantage of these tapes is that only one side of the adhesive is exposed when applied. The second side is exposed when the covering is peeled away. For a list of book binding resources go to: *www.noplasticsleeves.com*.

ATG is a 3M product and must be applied with an ATG dispenser or gun. It is available in ¼, ½, and ¾ inch widths, and is a product often used in the picture framing industry. While it can be used to adhere cloth, glue is still the preferred method for applying book cloth to board.

This binding with soft or hard covers is a simple construction that is easily reproduced and assembled. This allows for simple single-sided printing, without the registration problems of two-sided or duplex printing. Standard papers result in a glued page of a reasonable thickness. Each pair of pages is scored down the center to allow for better turning and folding. The cover can be made of slightly heavier stock.

The result is a simple, clean softcover book. This is well suited to books up to 8.5 × 11 inches. As the books get larger, the covers must be more durable to handle the weight and size of larger glued pages.

Each set of pages is printed one sided in pairs. It is helpful that you print in light score marks at the center of each page, which makes it easier to trim and fold the pages.

Once you have printed your page sets, you can trim and fold them. When printing, leave some margin of extra space at the edges of the page to allow for some trimming of the entire book once assembled.

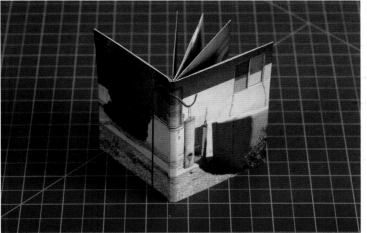

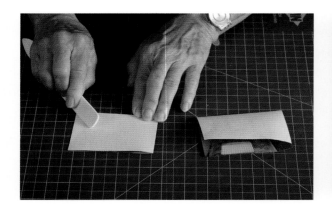

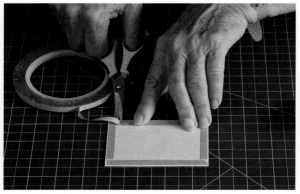

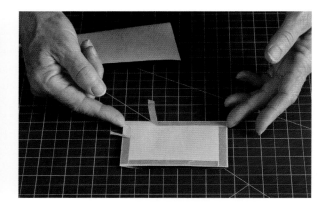

Use the bone folder to smooth the fold. Sometimes scoring the page will aid in folding, but you can only score the back of the printed page, as the coating on the printed side can be broken by the bone folder.

The backs of the page pairs are then glued to each other to form a set of joined pages. Here is where double-stick tape or ATG adhesive is the best choice. For example, pages 3 and 4, left and right respectively, are joined to pages 5 and 6 by adhering the back of page 4 to the back of page 5.

Tape all of the outside edges, spine edge, and fore edge, top and bottom, with the double-stick tape. At this point do not peel the covering off the tape to expose the adhesive.

Peel back the covering tape to expose the adhesive at 2 opposite corners. [See next example.]

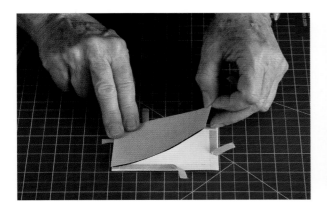

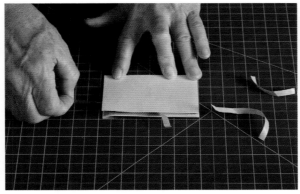

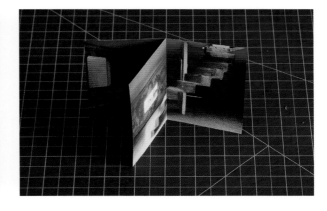

Align the edges of two folded sections. Align the two corners and place them down to adhere them.

At this point you can gently peel away the remaining tape covering by pulling it away from the edges of the pages and then smooth the edges together.

Continue adding folded page pairs to the back of the glued set to build the book block.

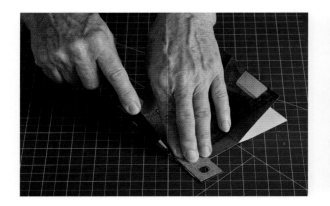

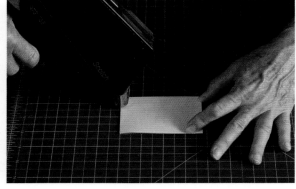

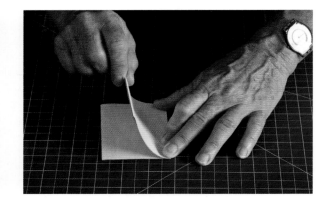

Once the page sets are glued a large cutting ruler and a heavy matte knife are needed. You must carefully cut through the pages to square up and trim your book. A book bindery, or a school that teaches book binding, may have a large guillotine cutter that is very handy for this particular purpose. A matte knife with a ruler can work just as well with a little patience.

The ATG gun is as effective as double-stick tape, with the one difference being that the adhesive is exposed once applied. As such, you have to be careful to align your page sets. The procedure is similar, but rather than taping all sides, you progressively glue edges starting with the fore edge.

Combine the pages at the glued fore edge. Then apply adhesive to the remaining three edges and carefully adhere the two page sides together.

Measure and Cut the Cover

For a smaller book of 10- to 15-page spreads, the same papers used to create the pages should provide an adequate cover. This material can be doubled up as well to create a stiffer cover, which will be stronger and provides better support for the book block.

The pages of the cover generally are sized to sit flush to the edges of the book's pages; however, if you use a heavier stock for the cover you could have an overrun of about ⅛ inch. The risk here is that the edge is exposed and vulnerable to being bent or damaged.

The cover page is glued on to the endpapers in the same manner as the page sets in the book block. Start with the front side of the cover. Use double-stick tape or ATG adhesive along the fore edge and spine edge. Do not tape beyond the dimension of the page. You don't necessarily need to apply adhesive to the top and bottom edges of the cover. Make sure you have the book block in the correct orientation. Align the first page of the book and adhere it to the inside of the cover.

Now measure the width of the spine, using the book block. The width of the spine should be the thickness of the book block. You will need to score the paper of the cover along the edge of the spine at either side of the book block. A ruler can help get the folded edge of the paper.

Make an additional score an ⅛ inch from the edge of the spine on the back cover. This third score creates a *gusset*. The gusset will move freely with the spine, creating flexibility when the book is opened.

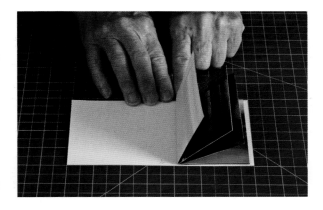

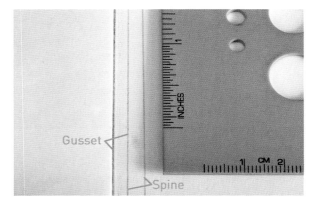

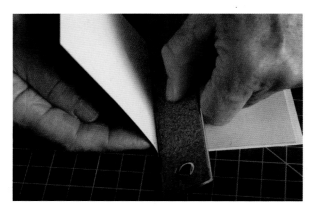

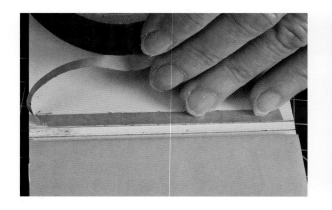 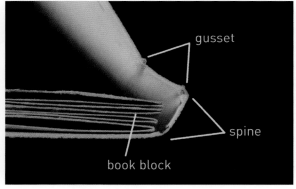 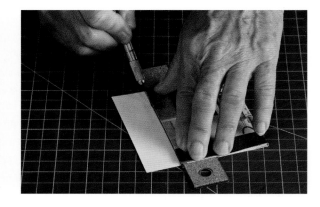

Apply double-stick tape or ATG along the gusset, but not in it, nor should you glue the spine.

With the spine of the book block unglued, it will move and bend freely as the book is turned.

You can make the cover slightly larger to allow for some misalignment, then carefully trim it flush to the page edges.

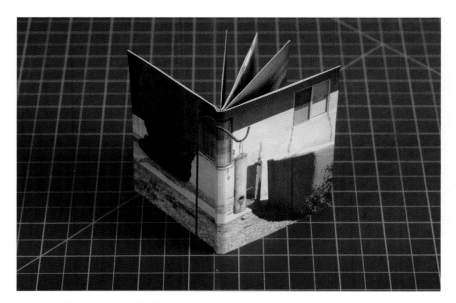

A finished back-to-back binding

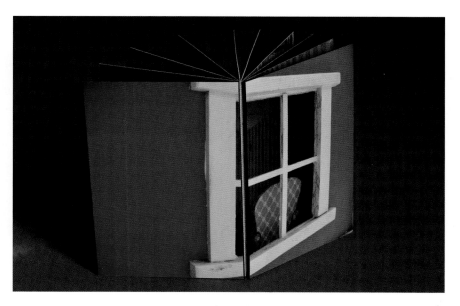

ANN PELIKAN, ARTIST'S BOOK, Ipswich, MA.

A variation in the same configuration is a book block with board covers, rather than a paper cover. A printed page can be adhered to the board and trimmed. One can use mat board or book binder's board (though this might be rather heavy). Cut the boards to the trim size of the book block. The spine is left open allowing for movement and laying the book flat. Apply double-stick tape or ATG adhesive to all four edges of the front page of the book block and the back page. Align the edges and adhere.

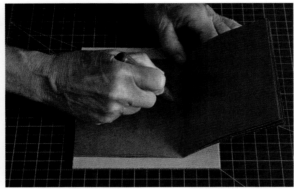

This is a simple way to make a bound book, or more accurately a booklet/pamphlet. The binding itself is easy and relatively innocuous. The printing of the book requires that you duplex the pages, and this can be a little more involved depending on your type of printer. You must be sure you *paginate correctly*.

Score each page (using a bone folder) and fold the page along its center. Then each folded page, or folio, is stacked with another folio, forming a set of stacked folded pages, or a signature.

The number of pages you combine could be 10–12 depending on the thickness of your paper. This would allow for 20–24 page sides. The page sides will always be an even number.

Just as in the perfect bind, once joined, the page edges can be trimmed, allowing for some irregularity when sewing or stapling. You can also trim the fore edges of the stacked signature to make the edges flush. Remember to print to an oversize paper, which allows for printing crop marks that can be used later to guide trimming.

You must align the pages carefully before piercing the center fold of each folio. An awl or needle can be used to pierce the paper.

A three-hole sewing pattern. The thread or twine is tied in the center of the book.

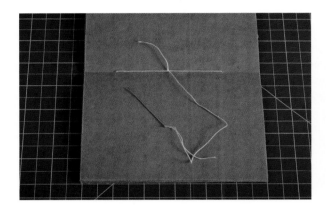 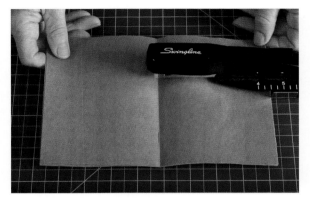 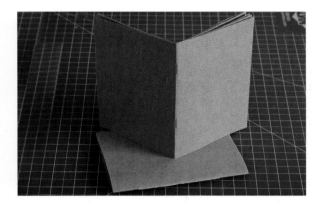

To have the knot reside on the inside of the signature, you must start it on the inside. Once thread is worked through, finish the sewing by securing the thread with a knot and trimming it.

The stapled signature is created the same way as the sewn signature, but it is finished with staples. This stapler is designed to accommodate the depth of the page. These are available at office supply stores and are reasonably priced. The number of staples used can vary depending on the size of the signature. Be sure to align the stapler carefully. While it is easier to align the stapler in the crease of the fold (as above), stapling from the outside creates a smooth appearance to the finished staple as in the example at the right.

INSETS AND WINDOWS

An *inset* creates a depression in which an image, or even a brandmark, could be placed after the cover is glued up.

Window and insets need to be cut prior to covering your boards. Measure and mark the position of the inset on the cover. As most book binder's board is laminated, one can score into the board and carefully peel up the layers of material, making the inset's depth about one-half the thickness of the board.

Note: Methyl cellulose added to your PVA glue extends the drying time of the glue and is particularly helpful when having to smooth a complex edge such as a window.

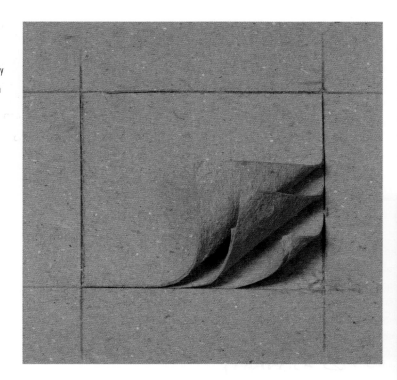

When gluing, the cloth or paper needs to be carefully set into the depression and worked with a bone folder to smooth out the inset. Use the bone folder carefully to smooth the cloth into the corners and over the edges of the inset. Then work the cloth outward from that point to smooth and finish the remainder of the cover.

The image is then placed and adhered into the depression created in the cover.

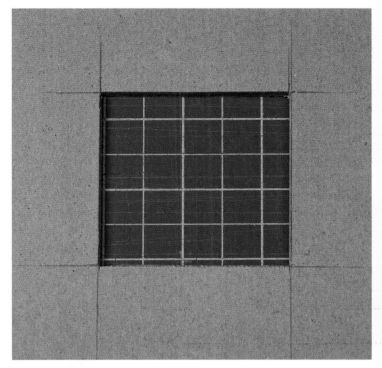

The next step is to adhere small triangular pieces of cloth over the corners of the window. This will ensure that no raw board will be visible once the entire board is finished.

As is the case with the inset, you will cover the entire board, including the window. Once covered, the cloth is cut out of the window, leaving pieces as turn-ins for each side of the window. A diagonal cut is made from the corner pulling toward the center.

The turn-ins are then glued and smoothed over the edge of the window.

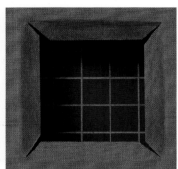

Windows need to be marked and measured in relation to elements on the interior page, which sit directly below the cover. This requires that the inner page be laid out and considered prior to cutting the window. The binder's board then needs to be marked and measured, creating a clean opening in the cover board prior to covering it with book cloth. Careful measurement is necessary here in addition to clean cutting.

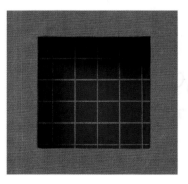

Design is not just what it looks like and feels like.
Design is how it works.

STEVE JOBS

Steve Jobs, co-founder of Apple and Pixar (2003)

ONLINE PORTFOLIOS & BLOGS

DEFINE THE EXPERIENCE

Whether you are an artist, illustrator, designer, or photographer there are a number of core concepts, strategies, and web trends that should be considered when approaching an online portfolio and digital presence.

This chapter focuses on the strategy, branding, and design of an online portfolio and digital presence (apps, blogs, social media, etc.). It does not go into depth about how to build, code, and develop websites. While some development strategies will be discussed, this is a huge topic unto itself and there are a number of excellent books and online resources devoted to the subject. Rather this chapter focuses on a holistic approach to your digital presence and looks at all the necessary parts. It's also worth noting that much of the content written in this chapter is targeted towards someone who has at least some understanding of digital media.

This chapter is broken up into two main sections—*What You Need To Know* and *How To Make It Happen*. First, we discuss the important aspects to consider when approaching your digital presence. In the second part, we discuss strategies to get your portfolio website and blog up and working for you (no matter what your technical abilities).

WHAT YOU NEED TO KNOW

UX Design

UX (User Experience) Design is a broad term that's concerned with how users perceive and feel about their experiences interacting with websites, apps and other types of digital channels. UX-centered design means putting the end user first. It looks at user needs and behaviors, along with usability concerns such as ease of use and the efficiency of completing specific tasks. So, the first thing to ask yourself is—who is the end user and what do they need from the online experiences you'll create?

Define Your Goals

In the professional world, project goals are usually defined in a *creative brief*. A creative brief literally *briefs* someone as to what a project's purpose is. It generally outlines the requirements and objectives of a project. A design brief should outline your vision for yourself and anyone else who will work on your site. Typically it starts by defining who the target audience is and the project's goals—including a brief overview of **who**, **what**, **where**, **when**, and **why**. Briefs (especially client ones) will also include project scope, deliverables, timeline, and budget. It's probably a good idea for you to define all of these aspects too. Start with bullet points of key objectives and goals. This should help you focus on the crux of the design problem in a clear and concise manner.

It should be noted that most online projects include not only a creative brief but also a *technical brief*, which outlines the technical scope and requirements for a web project. While you don't need something as robust as a technical document, you will need to eventually define the kinds of technologies and platforms that you intend to design and develop online content for, or discuss it with the person who is doing this for you. The web itself has many inherent characteristics and represents a unique blend of design and technology (form and function), offering opportunities and challenges. These need to be carefully considered in order to design a portfolio (and for most photographers a blog) that works effectively for the online experience. Many of these options are discussed later in this chapter.

Example of Goals:

- Integrate my brand identity into the design of my portfolio site and blog.

- Present my portfolio work in a clear, well-organized manner through simple navigation and large-scale images.

- Integrate social media into the site design by allowing users to tweet, pin, and Facebook certain portfolio images.

I started planning some large changes to my marketing plan and how I promote myself. I had two major goals for these changes: to make my blog a central part of my marketing plan, and to get away from generic promo emails that had little more functionality than a traditional print postcard.

— Luke Copping, Photographer

On any design portfolio I think it is most important to show the process a designer goes through with a project, instead of only the final result. That process is what defines you as a designer. Lots of people can just make something pretty, but that's not necessarily good design. I think that was my main goal; to show that I think and care deeply about the work that I do. I want my [online] portfolio to tell the unique story that goes with every project.

— Maarten Hoogvliet, Designer

As a photographer, I think it is critical that my website functions as a promotional piece—big, impactful images. I wouldn't send a large piece of paper to a photo editor with a tiny image on it. With this in mind the images cover the entire site.

— Nick Hall, Photographer

Define Your Target Audience

Consider the needs of your target audience and the outcomes you desire—both tangible and intangible (such as the "feeling" they are left with). Clarity of message is important. Knowing who your target audience is, what they are looking for, and where they are looking for

it will allow you to tailor your message more effectively. Do a little "market research" and ask existing clients, peers and consultants for their thoughts.

Consider the following:

- **Who** are you trying to reach with your message?

- **Why** do you want to reach them? For what purpose?

- **What** do you want them to know about you?

- **What** are the top 3 "take-aways" someone should have after visiting your website?

- **How** will someone find your website?

- **Where** does your target audience look for talent?

- **How** will someone be viewing your website? In what contexts, from what devices?

Print & Web

For most artists, designers, and photographers, both a print and online digital presence are essential for promoting and marketing oneself. Both serve important functions, in different ways, as part of a comprehensive portfolio package. If someone is seeing your book first, consider your website and other online components as an extension of an ongoing dialogue about you and your work. If it's the other way around, then your book can lead to a more concise and targeted discussion after you are first "introduced" online.

One caveat—if you are a digital designer or hope to break into that field, a portfolio book may not be necessary or even desired by those who would hire you. Many creative directors in the digital design field only want to see work in a digital context—like through your online website or via an iPad. In this case, your website and digital presence must be the showpiece in and of itself. If you are a student required to create a book for a portfolio course, explain this to your interviewer and ask if they'd like to take a look. They may very well appreciate the effort but still likely focus on your digital portfolio.

Tip: It's a great idea to include the URL to your online portfolio on your printed promotional materials—this allows someone a fast and easy way to find out more if they are interested.

An Integrated, Cohesive Approach

In many ways your online presence is even more critical than your portfolio book because it can reach more people, across any distance, faster than ever and when it's convenient to them. It's instantaneous. If a creative director is looking for a particular talent, chances are the first place they're going to look is online. They may come to your portfolio website directly or by another online route. Blogs and social media platforms provide an opportunity to become touchpoints— driving traffic to the ultimate destination that is your portfolio website. Make sure to connect everything with the same "name" (URL, Twitter name, etc.) and brand identity if you've got it. If a potential employer likes what he/she sees, a sit down meeting with your portfolio book can help close the deal. When you show up for your interview, think how impressive it will be when you arrive with your own custom portfolio book. And one that looks and feels the same as your website—identifying you and reinforcing you and your message.

It's guaranteed to be impressive and look professional if all components of your portfolio and promotional package are designed with the same conceptual and visual brand in mind. In the branding, design and advertising industries, messages must be consistently and cohesively conveyed through both print and digital contexts—tailoring the message for each medium's strengths.

Keeping Your Brand Voice Consistent

Obviously the web is a completely different medium from print. So, your portfolio book and printed promos can't just directly translate into your online presence. Unless you simply put a pdf together and go with that (not recommended), significant differences including interactivity, multimedia (motion, animation, video, sound) and the possibilities and constraints of technology all lead to some interesting challenges and solutions as you approach keeping your brand voice consistent across medium.

At the very least, aspects of your brand identity should be maintained across medium as it's important to present a cohesive and visually unified portfolio package—one that looks and feels the same all around. Keep consistent visual and verbal properties such as color palette, logo and/or logotype, distinguishing typeface(s) (utilizing web fonts when possible), and style/personality of written copy. All your materials should feel like a set—both digital and printed. This relates not only to your portfolio website on screen, mobile, and tablet, but also your blog, social media outlets, and any community portfolio "pages."

LUKE COPPING, HTTP://LUKECOPPING.COM,
Buffalo, NY.

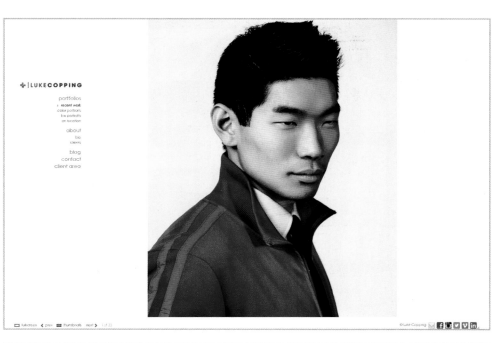

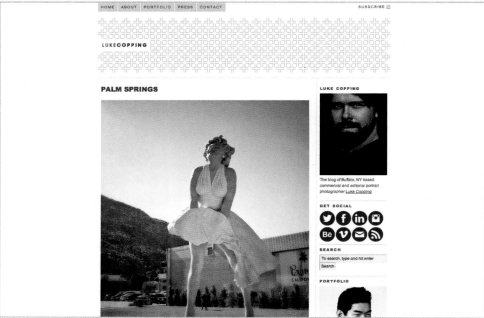

A consistently defined visual message will:

- Make sure you stand out with a clear, recognizable brand message across multiple mediums.

- Make sure your message is a memorable one because it will be consistently repeated.

- Orient your target audience providing a sense of familiarity as they move between materials. This will allow someone to focus on your work even more—as they won't need to spend energy trying to figure out if they are in the right place.

- Reflect on your ability to extend a concept and/or visual brand identity across multiple forms and mediums.

- Demonstrate professionalism and confidence in yourself and your message.

In advertising, a marketing campaign is often integrated across multiple mediums and formats. This "360-degree" advertising strategy means that from radio to billboards, magazine ads to television commercials, print to web, the concept, message, and visual approach all remain consistent.

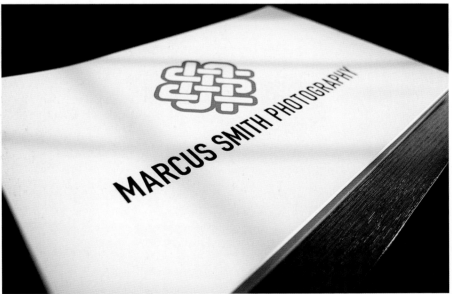

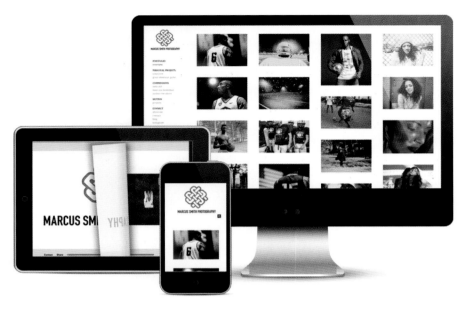

MARCUS SMITH, *HTTP://MARCUSSMITHPHOTO.COM/*, Chicago, IL.

For professionals, your logo design is a graphic representation or symbol of your business. It is a big part of your brand identity and should be used consistently across your promotional and business materials as an identifying mark. Logos can be more or less specific to a particular subject, industry, aesthetic style, and of course your name. The strongest logos are meaningful, distinctive, and versatile—holding up across medium, format and varying sizes.

Get Connected

The "online" world includes far more than it ever did and more than ever your online presence is a crucial part of marketing yourself and your business. It's a core part of your comprehensive portfolio package. So just having a portfolio up online isn't enough anymore. Your online brand should include your portfolio website, appropriate social media platforms (Twitter, Instagram, YouTube, Tumblr, Facebook, LinkedIn, etc.), a blog (especially for photographers), and maybe even include a portfolio of work on a directory like Workbook or community portal such as Behance. Having "multiple" coordinated and connected online presences will help you reach more people—specifically those that share common interests, potential clients and employers. Cultivating your digital presence will also demonstrate that you "get" the business you're in.

Your digital presence has an important job to do:

- To effectively reach your target audience and communicate who you are and what you do, building awareness and confidence in you and your abilities.

- To present your work in a clear and efficient manner.

- Keep those with a common interest, as well as potential clients up to date on your activities, work, and personal perspectives.

- To establish or extend your brand voice and concept through an online presence.

- To allow someone a quick and easy way to get in touch with you.

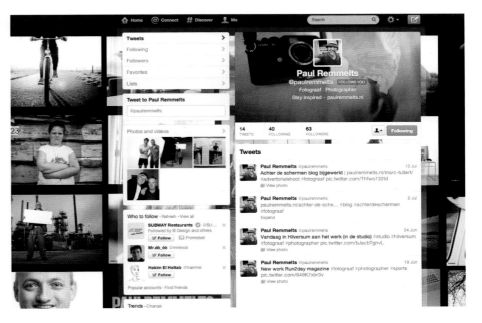

JORDAN HONNETTE, *HTTP://JHONNETTE.COM*, Los Angeles, CA.

PAUL REMMELTS, *HTTP://WWW.PAULREMMELTS.NL/ PORTFOLIO-5/*, Netherlands.

An Overview

First, let's take a high level look at the goals of your online portfolio and then look at some of the other components of your "online presence."

Your portfolio website has a very important job to do:

1. It must provide quick, easy access to your portfolio of work. Someone is ultimately at your website to see what you do and look at your work—doing so effectively is your first priority.

2. Your website can go one step further. It should support and enhance your brand statement and portfolio concept through your brand identity (if you have one) and/or by referencing the brand concept that you developed for your portfolio book or other materials.

3. Provide key information about how to contact you, access your blog, and social media connections.

Consider your goals and target audience:

* What images, navigation, copy, would you include in introducing yourself?

* What is the first thing on your site someone will see?

* How does it identify you?

* How will you stand out and remain memorable?

* What skill set is a client or potential employer looking for?

* What kinds of experiences do they want see?

* What kind of person would they want to work with?

* Are you communicating some personality?

Keep in mind that a potential employer or client will sum you up very quickly. If you are already a professional, ask yourself if you come off as an expert—someone really good at what you do within a particular area? Or is your message unfocused and unclear? Most people go first to a homepage. It's got to grab and impress them. If you expect someone to click past it and see more, you've got to make them want to stay.

Also, if you're a student or new to the field, by all means show some enthusiasm, give people a reason to believe you're hungry to work hard, grow, learn, and have a likeable personality! People in our industry are adept at looking at lots of portfolio sites so give them a good reason to spend some time to get to know what you have to offer.

Connecting Your Brand to Your Site

For those with a pre-established overarching concept, brand identity and/or visualization from a portfolio book or other printed materials, you should adapt those qualities, at least in part, to your website through references to logo, color, layout, typographic treatment, iconography, copy and/or imagery. Visual graphics or stylization of imagery could be brought over on a limited basis (like in the top header). You can also create new imagery, graphics, typography and/or icons for your website—keeping in mind the overall brand concept as it relates to your printed materials. This is true especially on the "homepage" and just like the interior of your portfolio book, it should be limited in gallery sections as such elements could detract from your portfolio work. Think about strategic ways in which your conceptual ideas and brand personality could be utilized and adapted for your online portfolio—ways that are most appropriately suited for the web. It can be subtle, but effective.

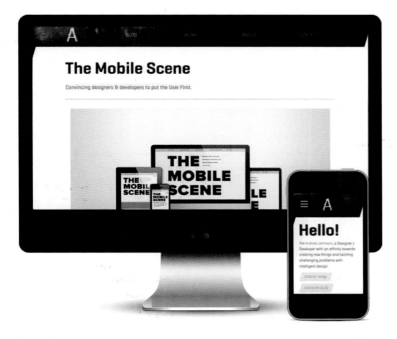

Andrew Johnson references the visual look established in his portfolio book primarily in the top header of his portfolio website. He says, "I took a top down approach to my brand, doing research on what designs and information structures worked best for applying to target job sites. The site had to hold a unique personal aesthetic that framed my work while being flexible enough to support evolving content and interests."

— Andrew Johnson, Design Student, Endicott College

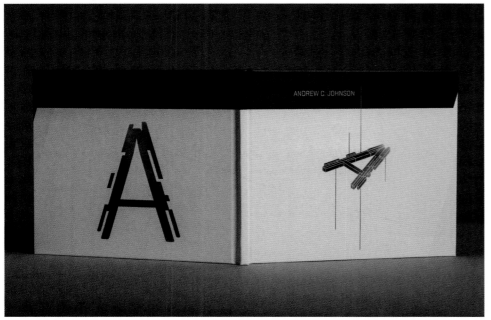

ANDREW JOHNSON, STUDENT PORTFOLIO, *HTTP://AETHERPOINT.COM/,* MA.

Concept & Personality

For people looking for a job: try to inject some genuine personality into your portfolio site. When you reach a senior level this matters less, because your work and experience take precedence, but when you're trying to get your foot in the door you need to be remembered. And when you do land that first job, be available for anything. Go for beers with your team, and build good relationships. They'll last you your whole career, and make the design world a smaller, friendlier place.

— Tom Kershaw, Creative Director

Simplifying the user experience does not mean your website has to be devoid of personality or creativity. Even if you have an established brand identity or "look & feel" to base your website design on, there are still many ways you can expand your creative, functional (and technical) ideas when it comes to your online portfolio. This is a whole new piece to add to your portfolio package—it should tie in with your other materials but also stand on its own as a unique component. If you don't yet have a "look" or concept that you're referencing for your website, now may be the time to create a more unique and memorable voice through your online portfolio's concept, design, and execution. Keep in mind that strategies and concepts for websites are developed with more than just the visual design in mind. Movement, functionality and interactivity are also key characteristics that should play a role in the expression of your ideas and ways in which you can utilize your online portfolio (and blog for some). Also think about how your site will look and function across device—desktop, tablet, and mobile.

Websites that are more customized in their look and functionality are most often not coming from an out-of-the-box web publishing solution. Consider that such sites need to be designed and developed by someone who knows what they're doing—either you or the person/company you hire.

First Impressions

Show people what you are capable of right from the get go. If you're a documentary photographer, give your audience a large captivating image of significance. If you're an illustrator, integrate your illustrations into the design of the site. If you're a graphic designer, knock our socks off with great web typography, icons, a strategic color palette, etc. And if you want to be a web designer go the extra mile and make your own website—showing off your coding and design talents. Being authentic to who you are and what you do, and showing you've got the goods right away in the site design, will connect you with your target audience immediately, motivating them to see more.

So think about the first impression you want to make and how that may influence the design and development of your website. What qualities are you trying to communicate immediately? Go back to your brand attributes and brand statement (from Step 2) if you need to refresh your memory.

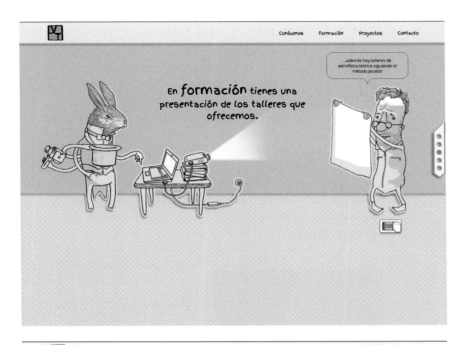

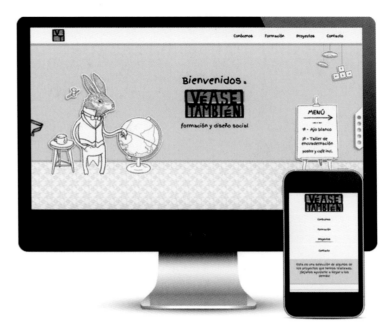

We are three Fine Arts graduates specialized in different fields but at the same time with a common view of the subjects. Hence, there was a long creative process taking great care with the details (like the slider navigator button). It has been developed in HTML5, CSS3 and it has taken into account a 'Responsive Design' approach.

— Carlos Gómez, Fine Artist

CARLOS GÓMEZ, ESPERANZA COVARSÍ, PABLO DOMINGUEZ,
HTTP://VEASETAMBIEN.COM/, Spain.

Technology, Trends, & Web Design

Just like with fashion, music, or architecture, where styles and trends change over time—web design is no different. There are aesthetic, technical, user interface, software/application and device-specific trends—all of which anyone designing and developing a website on their own or in collaboration with someone else, should be aware of.

Aesthetic Trends

Many trends come from the big tech and social networking brands. Take a look at what they are doing and you will be clued in to quite a lot. For example, for years Apple has had a huge influence on the aesthetic and interface design trends of websites and applications. Until recently, Apple's adherence to skeuomorphic design (mimicking the visual characteristics of real-world objects and applying them to digital "objects" or experiences to make them feel more familiar) greatly influenced the way applications and websites looked and functioned. But do we really need an online "bookstore" interface to include digital wooden bookshelves? Trends themselves only have certain lifespans before sentiments change and they are replaced. Case in point, skeuomorphism is on its way out and a "flat," more streamlined design approach is now in. By the time you read this, there's very likely a totally new popular trend dominating the field.

UI Design Patterns

Web designers and developers need to be aware of user interface design patterns. Take for example the popular menu icon depicted as three horizontal lines. It has become synonymous with revealing a menu on mobile devices and is used by some pretty high profile sites and apps (like Facebook). Just as with other icons, this one's meaning has become more ubiquitous as its popularity and usage has increased—becoming familiar and expected. In this case, it's less about an aesthetic choice and more about using the most appropriate user interface design symbol to communicate effectively and universally. Since a big part of the web includes interactivity, using the most recognizable icons, types of transitions, and functionality in your website is important in order to communicate properly.

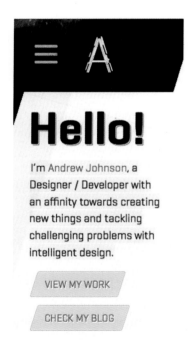

ANDREW JOHNSON, *HTTP://AETHER POINT.COM/,* MA.

Development Trends & Tech Influences

Current web technologies and development applications also influence how websites are not only made but how they look and function on an experiential level. For example, nowadays, content must look good and function well across devices (discussed in more detail later on in this chapter). That in and of itself is a significant shift in web design and development. It influences not only the development of websites but also the design and way in which we experience them.

There are strategies for developing websites that try to account for various web browsers, their multiple versions, differences in screen resolution, devices, and operating systems (whew!). Unfortunately, one size does not fit all. If you are designing and developing your site yourself or even just using an "out-of-the-box" web solution, it can be helpful to be aware of the terms and approaches regarding these issues (discussed in more detail later in this chapter). In addition, for those designing their own website, there are web standards for applications and technologies (at the core HTML, CSS, and JavaScript) that are important to be aware of, whether you code it all yourself or get some help.

I did the design and the front-end of every project myself. I had the framework (HTML5, jQuery, JavaScript and other things that are too difficult for me code-wise) developed by a friend.

— Maarten Hoogvliet, Web Designer

M.T. HOOGVLIET, *HTTP://MTHOOGVLIET.NL/,*
Rotterdam, Netherlands.

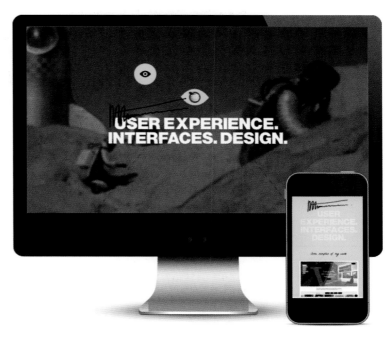

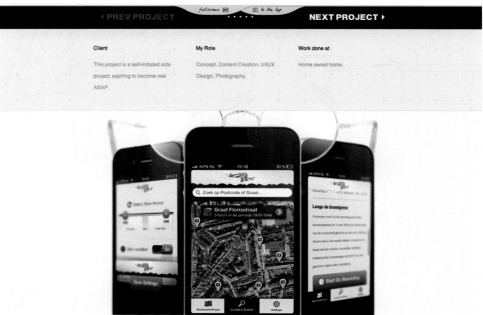

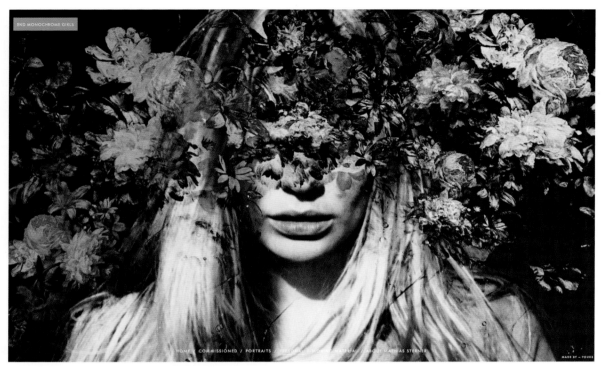

MATHIAS STERNER, *HTTP://MATHIASSTERNER.COM/,* London, UK.
Designed by: Yours, *http://weareyours.com*

Type & Image

The web industry has seen an explosion of typography driven web design in recent years—thanks in large part to Google Fonts API. Prior to this, unless one used a graphic, web designers were limited to a small number of "web-safe" fonts to choose from. Today, additional resources like Typekit and Font Squirrel provide more options than ever. On one level, a typographically driven web design is an aesthetic choice. More practically speaking, the use of webfonts whenever possible is important as they download faster and are more flexible—scaling up or down across varying browser size and device.

Another important trend, especially for portfolio websites, is that of large, even full-screen images. Images can also be "adaptive" and scale to the size of the browser or device making the "fit" work for more than just one specific screen resolution. You want your images to read as large as possible so someone can get a good look at your portfolio work. Most portfolio sites should look and function well within the standard 1140px grid system, as well as at smaller screen sizes (like on laptops) and for tablet and mobile devices. You may also consider how images will look on larger high-res monitors. When developing your site, percentages and breakpoints ensure the highest quality image no matter what the size of the viewing device.

Hello

How's it going? My name is Justin

I'm a Creative Technologist

I work at *Google, Creative Lab* (NYC)

I'm from England

I like | Javascript

CHECK OUT MY
EXPERIMENTS

WebGL GPU Particles
1 million+ particles being moved around on the GPU via WebGL

Unwrapageddon
Savour the anticipation with this gift that keeps on giving

JUSTIN WINDLE, *HTTP://SOULWIRE.CO.UK/,* New York, NY.

The parameters I set myself beforehand were that it should be simple in appearance and conversational in tone. Most of the work I release is under the pseudonym SoulWire, so I wanted to put a face to that. The experiments needed to run at the maximum possible size and so the design had to accommodate fullscreen project views with minimal additional UI, plus large image previews since the experiments are mainly in generative graphics and so a snapshot can say much more than a title and description.

— Justin Windle, Designer/Developer, SoulWire

Web type is utilized on the homepage of Justin Windle's personal site. He also includes a number of experiments on his site where he plays with the latest web technologies and development tools.

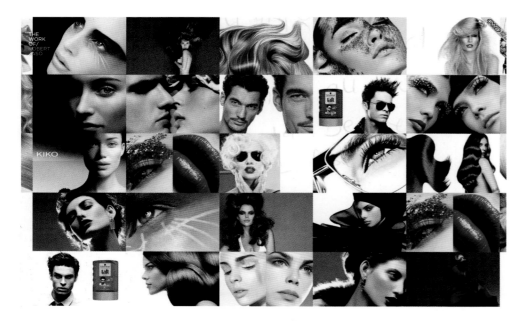

Flash

Consider that in recent web history, Adobe Flash™ ruled the online portfolio world and although it hasn't completely faded, it's used much more sparingly today. The Flash sites that once dominated were identifiable by certain properties contained within a finite space "above the fold" of the browser, including animated 2D vector graphics, integrated multimedia, and wipe, zoom, or fade transitions between content and sections of the site. Nowadays this type of online experience is less popular—replaced in large part with much longer singular webpages, often with scrolling effects (like parallax), CSS code-based animations and HTML5 video. Two major reasons Flash content declined is because it isn't supported on popular mobile and tablet devices and isn't easily searchable. As the market share increased for these devices, the production of Flash content fell off. Still, while Flash no longer dominates, many would argue that it's still a viable design and development platform.

ROBERT JASO, *HTTP://ROBERTJASO.COM/,* France.

Design credit: Mathieu Kobler – Werkstatt

Taking Advantage of the Web

There are inherent characteristics to the web that make it distinctly different from other mediums. Think about if and how you might take advantage of *current* web functionality, interactivity, and motion capabilities as related to the overall concept and goals of your website. Don't just do something because it's possible or "trendy" but do think about how you can strategically leverage what's available and what makes sense for your user needs and goals.

At a basic level, this may allow you to include additional types of content and/or enhance the overall user experience. For example, it's quite easy to create a slideshow and animate through a series of large images or include a video reel. There's also a flexibility online that's not possible with a printed book or promotional piece as content can be updated and changed whenever you want. With a content management system it's easy to swap out images, add, delete, and edit content with the click of a button. This is especially useful for blog content, which comes standard with a content management system on all blogging platforms.

Functionality

Think about the additional value certain functionality (ways someone will interact and experience the site) can bring to your marketing efforts and business. You may decide to add a search, lightbox, or "login" section for clients to download images and comps. You may even want to include shopping cart functionality and sell your work.

NICK HALL PHOTOGRAPHY, *HTTP://NICKHALLPHOTOGRAPHY.COM/,* Seattle, WA.

With my Lightbox I wanted to take the functionality a little further. I'd seen sites with lightboxes and sites with PDF creators but I've always found each one slightly limiting. So in an effort to have both we created a Lightbox section with custom PDF creation built in. My motivation behind this was that much like I want people to be able to spread my images through social media channels with ease I want my clients and target audience (ABs, ADs and Photo-Editors) to be able to collate, share, and download my images with ease and control.

— Nick Hall, Photographer

MARK SHERRATT, *WWW.MARKSHERRATT.COM,* UK.

It's a breeze to navigate photographer Mark Sherratt's
website. Just use the arrow keys to scroll through
the galleries.

Ease of Use

Focus on your user goals and the site's "ease of use." Consider
other means to access or view content—such as the popular use of
keyboard arrows to step through images of photos or other work. The
use of keyboard controls is a smart bit of functionality, as it is a nice
alternative to having to "click" a button repeatedly. It can make your
user's fingers (and mind) happier through its "ease of use." Consider
whether a slideshow should start automatically or require user
initiation. You may want to include an option for full-screen mode or
some other aspect that may add value to the experience.

Be aware that any interactivity, audio or motion should be used to
enhance and support the experience—not detract from your main goals.
Don't over-design the experience and make it difficult for someone to
find what he or she is looking for. Focus on simplicity of functionality,
basic transitions (no fancy canned effects!) and a visually simplified
layout design to communicate only what is key.

Linking Content

The web is a classic example of the term "hypermedia"—linking all kinds of content together in a non-linear experience. You can connect to your own content to and from varying sites and in varying forms. You can connect to other people and their content. You can even allow visitors to share your work on their own social media platforms—getting you even more visibility. This includes simple links and more targeted or specific sharing and connectivity, for example, a "Pin It" link (sharing to Pinterest) or Facebook share for a specific project on your site. You can also add to your site's content by linking in things like a Twitter feed. There are lots of ways to share work and drive web traffic to and from various online "places."

I really wanted to embrace social media. I wanted people to be able to tweet, pin, and Facebook my images easily … To this effect there is a pop-out toolbox wherever you are in the site that allows you to download (branded PDF), email, and share (tweet, Facebook, Pinterest) my images. I've also included links to my profile pages for social media in the contact section and included Instagram connectivity on my blog.

— Nick Hall, Photographer

Test Your Site

It's recommended that you ask several people to try out your site before you launch it. Watch carefully as they try and get around. What are they looking for? Are they having difficulty knowing where to go and/or how to get there? Ask questions and document the feedback.

Test your site out on different operating systems, multiple devices, various browsers and the most likely levels of connectivity. Are there visual design, layout, functional, or performance differences? Is the site downloading quickly? If someone has to wait or if the experience isn't seamless a potential employer or client may very well get frustrated and move on. Does the work read and hold up well in terms of size and quality? Are transitions smooth? With online content, you need to weigh quality, quantity, structure, and types of content against a number of variables.

Representing You

In general, referencing an "outdated" trend or technology can make you seem "outdated" as well. Since the photographic and design fields rely so heavily on the use of current technology and aesthetic sensibilities, looking outdated can really have a negative effect. But there's no hard and fast rule. There's often debate within the web industry itself about what is and should be "in" at any given time. Sometimes "outdated" references can even appear cool and "retro."

Technology and user interface design trends should often be paid more attention to than aesthetic ones. If your site doesn't work well on mobile phones and has images optimized for 800 × 600 desktop screen resolution then you're in trouble. If your website uses Flash (and has separate versions for mobile/tablet) or it's got some skeuomorphism going on, then it might be just fine. With your portfolio site, it should be more about what works to represent you, your personality, your work, your expertise and less about following a trend just because it's what everybody else is doing.

Staying Current

So, how do you stay current? Check out what the industry leading technology/social brands are doing; frequently visit online, industry-leading sites; read up on industry articles; talk with people, especially those in the web design/development fields and find out what they think. Check out the list on this page for some good online resources that will help keep you current. Get informed and make informed decisions. It's a good idea to be aware of current design trends and their influences. It's even better to make a great looking and functioning website that represents *you*.

Resources

http://thefwa.com/

http://awwwards.com/blog/

http://smashingmagazine.com/

http://computerarts.co.uk/

http://cssdesignawards.com

http://pdnonline.com

http://asmp.org/

http://aiga.org

http://designtaxi.com/

http://creativereview.co.uk/

http://adweek.com/

http://wired.com/

http://ui-patterns.com/

http://uxmag.com/

Video

To integrate video into your website you will need to compress the video and limit its file size. This can be done with a number of web codecs (compression schemes). Of course, you will trade video quality for file size. HTML5 has a number of standards for video formats and compression. Video can be utilized as a background or as an interactive object within the site's design (see opposite page). For interactive and motion-based project work, video is an important online delivery method.

External players can also be embedded into your webpages— Vimeo and YouTube are two popular platforms.

MATHIAS STERNER, *HTTP://MATHIASSTERNER.COM/,* London, UK.

Designed by: Yours, *http://weareyours.com*

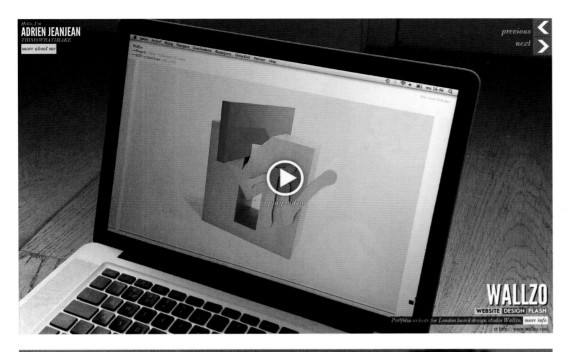

With my portfolio site I was looking for a way to show my work on various devices. The answer was making demonstration videos where you see the work being interacted with. My work is all about motion and interaction so using stills really doesn't make much sense. The advantage of making demonstration videos is it allows you to highlight the most relevant elements.

— Adrien Jeanjean, Creative Technologist

ADRIEN JEANJEAN, *HTTP://ADRIENJEANJEAN. COM/,* Amsterdam.

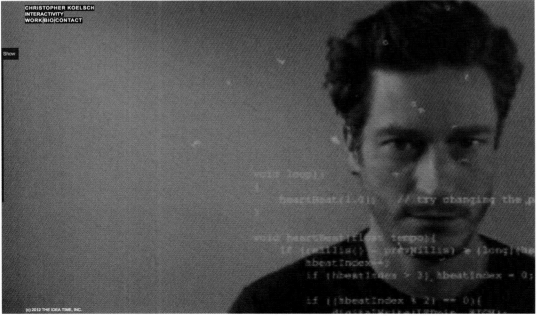

Christopher and Adrien's sites are both hard-coded. Christopher used some jQuery along with HTML5.

CHRISTOPHER KOELSCH, *HTTP://CHRISTOPHER KOELSCH.COM/,* New York, NY.

iPad Portfolio

A number of professionals, especially photographers and digital designers are utilizing a tablet device, such as an iPad for portfolio presentations. With high quality (even "retina" display) resolution and motion capabilities it can be a great addition to your portfolio package, especially for an in-person meeting/interview. There are a number of applications that you can easily use to create and format a portfolio presentation for tablet devices. Some even have built-in editing tools. All take advantage of native user interface capabilities, such as "swiping." In addition, look for one that allows you to personalize the beginning of the presentation with your logo; allows you to curate galleries and customize the layout; and has options to connect to the Internet to download images from a source like DropBox and email images directly from the presentation. Most of these apps are pretty inexpensive. Some options are FolioBook Photo Portfolio, Portfolio for iPad, Keynote, and Flexfolios. For information and reviews on the most current top options, look through online industry resources and industry magazines. In addition, all industry recognized web-publishing solutions for the development of your online portfolio include tablet device portfolio options. iPad portfolios can work on their own (as is or in its own slipcase) or integrated into the construction of a portfolio book.

Scott [Mullenberg] designed my iPad case to complement my existing portfolio book and slipcase that he had previously created for me. I take both my book and the iPad now to my in-person meetings and portfolio showings. I find that my iPad is the perfect place to showcase more recent work, or works-in-progress, as well as examples of my images in use. I've gotten a lot of great reactions to the case as well.

— Brian Fitzgerald, **Photographer**

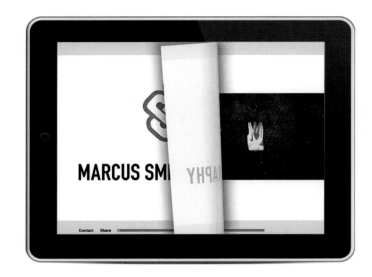

MARCUS SMITH, HTTP://MARCUSSMITHPHOTO. COM/, Chicago, IL.

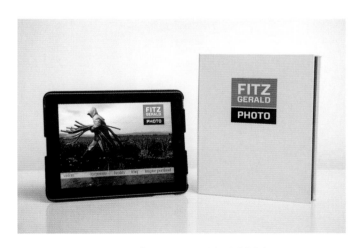

BRIAN FITZGERALD/FITZGERALD PHOTO, WWW.FITZGERALDPHOTO.COM, Portland, ME.

Increasingly, content will be viewed on the go, with internet access by mobile devices (phones and tablets) predicted to surpass desktops in the near future.[1] Most professionals in the creative industries will still view a portfolio site on a desktop, as a nice big screen is clearly the optimum choice for viewing photographic and design work. However, there will be circumstances that will necessitate someone viewing it on their mobile phone. So, if you're thinking about redesigning your online portfolio, blog, or are about to create your first website, there are a couple of options you need to consider—each with their respective pros and cons. Being aware of these options can help make your online presence more effective, less costly and easier to update and manage.

Creating Multiple Versions

One way to make sure content looks good and functions well across devices is to create multiple versions of the same site. A web designer and developer create multiple versions of a website—each tailored for a specific device. Then, a simple media query script checks the type of device requesting the website and serves up the appropriate version with considerations to technology, type and image size, layout, and navigational scheme. While it makes it more difficult to maintain and update content for varied versions, this option works fine. You get to take advantage of the native capabilities of mobile and tablet devices, like transitions and gestures, while avoiding incompatibility issues like Flash. This can be a more expensive and time-consuming route though as three completely different "sites" are often built.

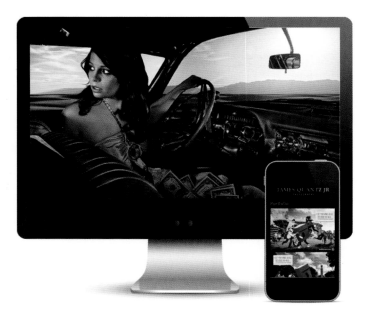

James Quantz's desktop site is developed in Flash. He has separate versions for mobile and tablet devices.

JAMES QUANTZ, JR PHOTOGRAPHY *HTTP://QUANTZ PHOTO.COM/,* Columbia, SC.

Responsive Design

Perhaps you've heard the buzz about responsive design—and it's buzzing for good reason. A responsive design can *kill three birds with one stone* giving your website a more cohesive presence across multiple devices. It makes maintaining your portfolio easier and quicker, and has become the industry standard to ensure your content looks good and functions well no matter when or how a user is viewing it. It's "responsive" in the sense that the layout, navigation, images, and functionality automatically adapt to the size of the device it's being viewed on—a desktop browser versus tablet or mobile. The site is built once and the CSS contains media queries and display rules for different devices and native UI considerations.

First off, your responsive design's layout needs to adapt to a resizing browser window and a device's viewport. A fluid grid enables a site to scale more dynamically. It means thinking less in terms of pixels and more in terms of percentages, proportions, and break points. For example, a responsive grid takes a 3-column layout on desktop and adapts it to just one column on a 320-pixel wide mobile device. There are a number of online tools and templates available to help you utilize a responsive grid system.

Handling navigation across desktop, tablet, and mobile is a critical part of responsive design: There are a number of popular and practical navigational patterns that you can reference. For example, responsive navigation can adapt a horizontal row of buttons at the top of the desktop screen to one with less space between them on a tablet device or a drop-down menu on mobile. The idea is to create navigation that doesn't get hidden or squished down to a point that the links are oddly broken up or even unreadable.

In responsive design, images should be fluid, changing scale to fit the device. Images can even be full-screen, altering width to account for screen resolution. In addition, larger scale images can be used for desktop and swapped out for smaller versions on mobile so image quality stays high and download speeds are optimized. Similarly, type size and line length should scale appropriately depending on device.

Many out-of-the-box web solutions, such as WordPress, PhotoShelter and Squarespace offer responsive design templates or themes to choose from. In addition there are a number of boilerplates and frameworks (Skeleton, Bootstrap, Zurb) that make developing responsive, mobile-friendly sites much easier (see *www. noplasticsleeves.com* for additional resources).

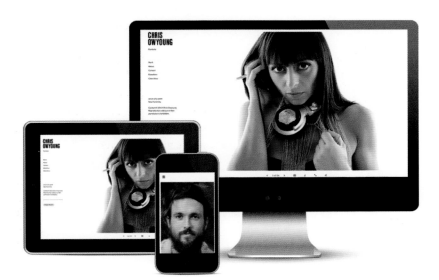

Chris Owyoung's portfolio website provides quick easy access to each section of his site and slideshows of his work through the use of navigation and keyboard arrows. The site is responsive—content, images, and navigation conform to the size of the browser/device. Chris is using PhotoShelter's Beam platform.

CHRIS OWYOUNG, WWW.CHRISOWYOUNG.COM, NYC.

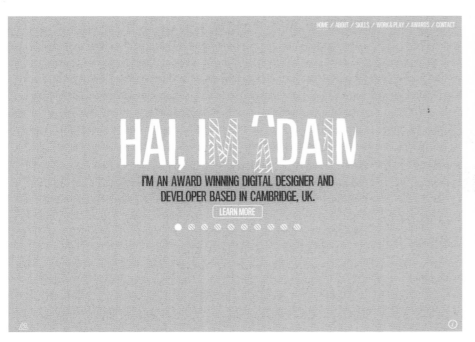

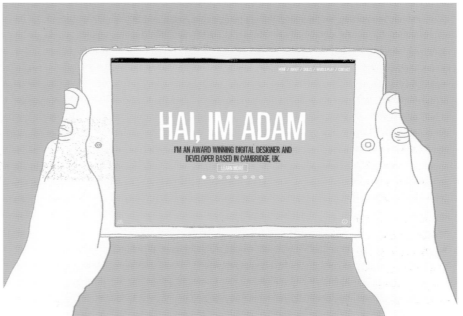

As the growth of the mobile and tablet space accelerates, it's becoming increasingly important for sites (especially Web Apps) to be able to target multiple platforms at once. A key aspect in the thinking behind my site was the target audience; the technologically savvy, the creative thinkers, the people looking for inspiration, and creative agencies. I wanted to be able to resonate with, as well as demonstrate to these individuals, to show the things you can achieve on the web with modern technologies for a mainstream audience, to collaborate with them, as well as to showcase my own ability.

— Adam Hartwig, Designer

ADAM HARTWIG, HTTP://ADAMHARTWIG.CO.UK/, UK.

Navigation

When it comes to navigation, focus on your user goals and the site's "ease of use." For a portfolio site, primary navigation should be limited to a few main sections of content (mainly galleries of work) and allow someone quick, easy access to what you have to offer—clearly labeled and consistently applied throughout the site. Think about internal navigational links to sections of your site and external links to blogs and social media connections.

When determining the navigation and functionality of your website you need to start by considering you website's overall site architecture. The architecture of your site describes three things.

1. The kind of content you are including in the site and how much of it there will be. Consider scalability of the site and content areas that may be added in the future.

2. How your content is organized and prioritized—subdivided and grouped into particular sections or webpages.

3. How these sections are linked together—if you're in one area of the site, how do you get to another?

As a rule of thumb, always default to the simplest architecture and make sure to include navigation to all the primary sections of your website (called global navigation) no matter where someone is within your site. This should include all major groupings of your portfolio work, your contact info, social media links, and a blog if you have one. Secondary navigation, such as subcategories within a larger overarching category can remain available only within that one particular section. Secondary navigation can be useful if you feel the need to break a section down further into smaller groupings. However, be sure to have enough work within each subcategory to support doing so.

Defining Categories & Labels

The manner in which you organize content will directly impact the structure and labeling of your navigation. It's important, especially for a portfolio site, to be clear about what content is included and how someone can get to it. To do this you should **organize** and **prioritize** content into main sections—grouping similar content into overarching logical sections. You should have already done something similar when organizing your portfolio book.

Determining how to name sections of your website and subsequent navigation will tell your target audience a lot about you right up front. It will define the context with which someone will understand the depth and breadth of your talents and experience in one glance. This may take some thought, as it's not necessarily easy to capture your bodies of work with only a handful of keywords. Think about not only the similarities and differences between the information itself, but also the different kinds of content you have: there's a fundamental difference between a section that includes mainly text describing your talents and experiences (like an "About Me" section) versus a section that includes mainly images describing your talents and experiences (like a "Portfolio" section).

Start with logical groupings of your work—defined by form/genre, medium, industry, style, chronology, and/or subject matter. You may stick to one type of organizational scheme or mix it up a little bit. For example you could include main navigation to "portraiture" and "documentary" (form) as well as "recent work" (chronology). You may even find more offbeat and creative ways to describe each section of your site. Figuring out what's best for you means figuring out what works best with your user's needs, overall portfolio concept and means by which you want to contextualize your work.

And don't forget, one of the great things about the web is that it is malleable—easily changed and updated as your work and/or sensibilities change. So, consider a design layout and technical means by which you (or your web designer) can easily edit labels and add or delete navigational items.

Once someone does access a portfolio section on your website they should immediately see examples of that type of work—either as thumbnails, a sequence gallery of larger images, or a scrolling page of examples. Also, project descriptions can be informative, but shouldn't get in the way of viewing images.

Curated Galleries

Be selective. While you can and should include more work on your portfolio site (and blog) than your portfolio book, you should still focus on your strongest work—both in terms of quality, demonstration of particular strengths, and level to which it's for a high-profile client. Try to look like an expert in a particular area—with a body of work that complements that notion. You need to appear credible—with the knowledge and skills necessary for a particular job. So remember that old adage—you're only as good as your weakest link.

Consider how long someone will stay on your site, which is probably only a couple of minutes. So show your best first. Balance demonstrating that you have enough experience (by showing lots of stuff) with how well those works will reflect upon you (limited to your best). As with your portfolio book, curate the work in each section of your site thinking about the sequence and how it will flow together with a rhythm that complements each individual piece as well as the overall body of work.

Add new work over time, bolstering your online portfolio as you gain experience and skills. It's fairly easy to add projects on a regular basis. Don't let your online portfolio appear stagnant—doing so will make you look like you're not a professional who's current and working. This is even more important with your blog (as previously discussed). On the flip side, you can remove work if it no longer reflects your interests or if it's no longer in line with current industry expectations.

If you have two completely different areas of your business—say wedding photography and editorial photography—consider two different portfolio websites. Since the audience and industry for these areas differ considerably, having these two bodies of work together in one site could muddle your message about who you are and what you do. Looking like a "jack of all trades" may miss the mark with your intended audience—someone who is most likely looking for a specific skill set and the experience to back it up. So, position yourself as an expert or specialist by focusing your message so that you are someone who can be easily identified and remembered. With that said, if you feel like there's some crossover or related work, feel free to include it.

Number of Examples

Each separately categorized (or subcategorized) gallery should have *at least* 7 examples in it (maybe less if you're a student). A healthy number for a gallery section of photographic images is around 15–25. For designers, a ballpark is 7–15 "projects" per section (which may include multiple images as part of one project). Ask yourself, what do I gain by including this image or project? Remember, you'll lose folks with endless clicking or monotonous scrolling.

These estimates may be much lower for a student who only has a handful of examples to show. It's better to show a few strong project examples than to water it down by adding in weak ones. Demonstrate that you have a critical eye—especially in regards to your own work. In general, designers should show range—especially if you're newer to the industry. You want to show type skills, layout, brand, web design, image manipulation and any "skill" that may add value to your potential employment—illustration, video, animation, etc. If you don't have the work to back it up, list these as part of your skillset somewhere on your site like in the "about me" section and/or your resume.

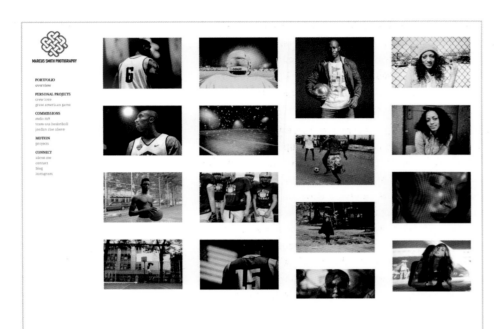

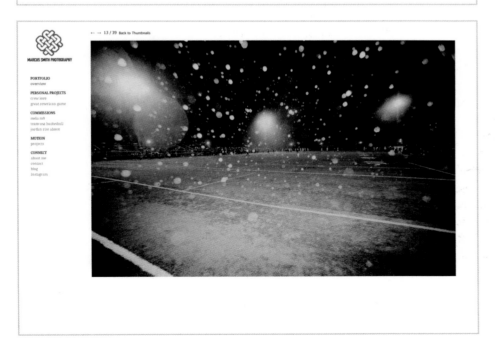

For gallery slideshows, consider adding a subtle "counter" that lets someone know how many are in the sequence and what number it's on. You may also give someone the option to see thumbnails—a great way to see a summary or overview of the body of work as well as the larger images.

Stay true to the original format of the work as much as possible. If you designed a printed book, show us not only spreads from the book, but also a photograph of its final form. If you have video, animation, or motion photography projects—include those as video. If you've designed and developed an app or website—give us a URL to go visit it.

Keep It Fresh

Since web technology and expectations evolve and change so frequently, it's a good idea to at least "refresh" your site design every two years. You may even need to go so far as to consider a complete overhaul.

Make sure to add new work to your portfolio site every few months or as significant projects occur. Less curated work, one-offs or experimental stuff can all go up on your blog—which should at least be updated once every week. A portfolio website and blog that aren't updated and maintained will give the impression that you're not working or are an amateur that doesn't take what you do seriously. Or even worse, you could appear to be someone who others don't want to hire. If you don't have the client work to show, then do some personal work or volunteer your time and do non-profit stuff. These can often make for great projects to include in a portfolio—both online and in your book.

Case Studies (Mainly for Designers)

Demonstrating the strategy, brainstorming, and various stages of a project can go a long way to communicating your ability to work through a design problem. This may not be appropriate for every project, but there may be a few key projects that you want to highlight. Show sketches, wireframes, alternative versions and write out the problem, solution, and results. How and why did it solve the problem?

MARCUS SMITH, HTTP://MARCUSSMITHPHOTO.COM/, Chicago, IL.

For client work, it's acceptable to ask for a recommendation and include a quote in the case study.

Layout & Content Tips

- Include brief explanations about project work, your role when applicable.

- Think about the kinds of content that will be included "above the fold"—what someone can see before scrolling.

- Include your contact information—make sure it's clear to the user how to get in touch with you. Contact info is: Location, phone, email, URL, Twitter, LinkedIn, etc. Don't use online forms for email—everyone hates them, just provide your email address.

- For students—include a link to a resume or CV that will look good when it's printed out—like a downloadable pdf.

- Keep your portfolio up to date—that's one of the inherent benefits to an online portfolio—keep it fresh!

Overview on Blogs

For photographers and designers who work for themselves, a blog is a must. If leveraged, it can be a great asset to your marketing efforts. A blog allows you to show another side of yourself—one that is more casual and open as opposed to the polite and more formal version that is your portfolio website. Both sides can work well together to communicate a complete picture of who you are and your capabilities. A blog provides a quick and easy way to show more, discuss your process and show off your personality. As such, it's a great way for a client, art director, or anyone else to get to know you a little better.

Blogs are fairly easy to set up, use, and update. All blogging platforms include built-in content management systems that allow you to easily manage content as well as the blog's layout and structure.

You have the option of choosing an "internal" blog that is literally integrated into your portfolio site—accessed through primary navigation that takes you to a section of the portfolio site dedicated to the blog. In this case, the top header and primary navigation typically remain constant. An internal structure is often what you get through web publishing services like Squarespace or Behance ProSite. These services offer the choice of built-in blog templates along with more portfolio focused layout options.

Another option is to use a blogging platform like WordPress or zBlogger, in which case, depending on how you set it up, your blog could be "internal" or "external." If you use a blogging platform not only for your blog, but also for your portfolio site, then you can integrate the two together whereby the blog is essentially a section of your site. Or you can set it up so that your website and blog are separate entities with different URLs (they should still be linked together however). In this case, the URL for the blog is often the same as the URL for the portfolio site with the word "blog" added either before or after the primary address. If your blog is external, make sure to add branding elements similar to those on your portfolio website—like logo and such.

Either way, to set up a blog using WordPress or Blogger, you'll want to pick a blog theme or template with a layout that works well for seeing imagery and posting lots of content on a regular basis. (Using a blog platform for your portfolio site as well is discussed later in this chapter.) There are countless free blog themes to choose from (do a Google search for "best free blog themes") or you can check out a site like themeforest.com for lots of cheap themes to purchase.

Next, start creating some content! Your blog should be a place where you allow someone to peak behind the curtains. Show process shots, include photo feeds, personal projects, experiments, "behind the scenes" images/video, and other such stuff. Pat yourself on the back and mention new projects, awards, and participation in events or gallery shows. Use your social media tools like Twitter and Facebook to make announcements and share what you're up to, driving traffic to your blog and portfolio site. The expectation is that a blog is current and active. So if it's not, you could give the impression that you aren't either.

WordPress is chock full of plugins to help design, share, promote, and otherwise make your blog simple to use and snazzy to look at. I'd recommend this platform to anyone who enjoys both customization and writing. For those who find posting a gaggle of photos preferable to writing prose, I'd highly recommend Tumblr. It's a snap to post photo upon photo—and then have those pictures shared across the web. Effortless is a word Tumblr uses to describe itself, and I certainly agree.

— Maria Luci, Wonderful Machine

Blog vs. Portfolio Site

Typically, the work featured on your website is curated, categorized, formatted, and displayed within a particular gallery structure. It's often static for a period of time. And that's great and appropriate for your online portfolio. But sometimes, you just want to show something you've made recently that's not necessarily part of an overarching "gallery" of work. Maybe you'd even like to talk about it and provide a little more info about the work, the process and/or yourself. A blog provides a quick and easy way to do that. It's an opportunity to show yourself, talk about your work, and have a conversation. You can post stuff when you want, in lots of different formats and sizes and talk about it or not. It's active, casual, and organic, allowing for others to comment and provide feedback too. It's a great way for a client, art director, or anyone else to get to know a little more about you—what makes you tick, what you're passionate about and what's going on inside your head.

Tips for Leveraging Your Blog

- Keep it Fresh. The expectation for a blog is that it's current and active. So if it's it not, it could give the impression that you aren't either.

- Be Yourself, But ... You should feel free to be yourself on your blog and show some personality, but keep your target audience and ultimate goals in mind. That may limit your ability to speak as freely as you may want to.

- Give Us More. This should be a place to take a peek behind the curtain. Show people more about what you do and how you do it. This could include process shots, personal projects, "behind the scenes" images or video, and other random tidbits. The more quality content you put up on a regular basis, the more people will visit.

- Quality Gets You Noticed. It would be nice if your work or blog posts go "viral"—meaning they get shared around by others which in turn increases your visibility and audience. To that end, you may consider becoming an "expert," giving advice about this or that and being a resource for others who will in turn follow you more regularly and "share" your content via their blog, tweets or other social media outlets.

- Be a Show Off. Show off your new work, recent promo, or just that shot you took or thing you designed and love. Mention if you're in a show, won an award, or participated in some event. Go ahead, talk about yourself, it's ok.

- Connect It All Together. Obviously, connect your blog to your portfolio site and vice versa. Make sure there's a way to contact you from your blog. Connect to your social channels, like Tumblr, Facebook, Twitter, YouTube, etc. Connect to any community portfolio platforms where you have your work up like Behance, Carbonmade, Dribble, Workbook, etc. A nice feature is to have your blog autofeed your Twitter posts.

- Optimize. Use SEO (search engine optimization) guidelines to make your content more "searchable" through the use of key words and links. You can also use analytics to track where your audience is coming from and what types of blog posts are more popular.

- Brand It. Your blog should be branded and look connected to your portfolio website.

- Get Started. If you're new to all of this it's pretty easy to get going. There are lots of resources online to help.

*Read more about blogging in Step 7: Promotional Materials

The title of Reena Newman's blog plays off of her brand concept as a food photographer (her portfolio book has a red and white checkered tablecloth cover).

Photographer Josh Letchworth shows behind the scenes video from a recent photo shoot.

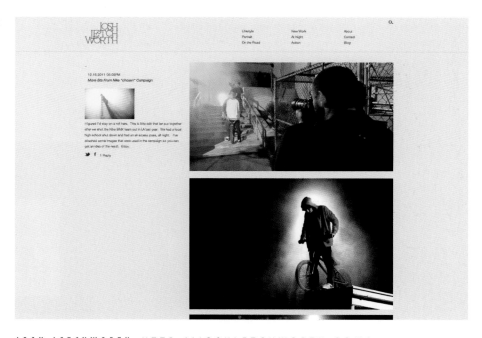

REENA NEWMAN, *HTTP://BLOG.REENANEWMAN.COM/,*
Toronto, Canada.

JOSH LETCHWORTH, *HTTP://JOSHLETCHWORTH.COM/,*
Florida.

Targeting your Audience

Your blog is a *marketing tool*, built around the interests of your audience and designed to extend your visibility. Consider who you are speaking to and as such the content needs to be relevant. If you are a designer who works in print frequently, this should be a building point. If you specialize in web and UX, then you should speak to current thoughts and issues. As a commercial and editorial photographer you should consider the visual style and approach that your target audience might find of interest. All of this, however, doesn't rule out bringing in some broader related content—just remember to whom you are speaking.

Evan Kafka's blog features a number of different kinds of content ranging from editorial and advertising assignments to stock and personal work. In some cases images that might not be placed in his portfolio, are posted here allowing for prospective resale as well as increasing the likelihood that they will show up on searches. He tries to post weekly or bi-weekly. He recently changed the blog to this grid format that displays multiple posts as thumbnails in chronological order with the dates of the post included. The thumbnails are large, allowing one to get a good view of the image. The grid format allows him to show different kinds of work so that a potential visitor might see the range of images that he produces, rather than the single most recent post, which may not be of interest. Further, he has found that visitors don't necessarily scroll through the blog to older posts, so this format enables them to quickly see a broad range of work and click on what is of interest.

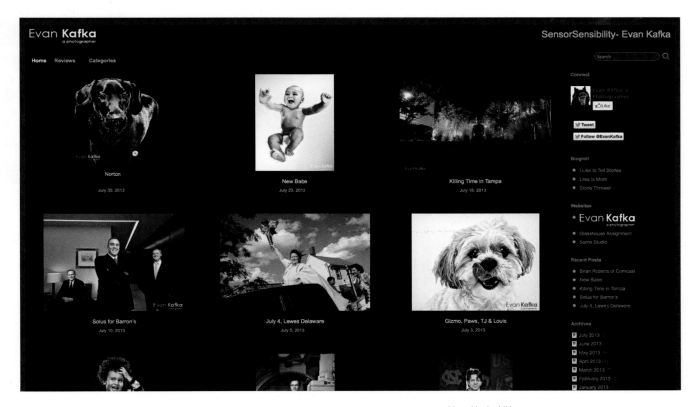

EVAN KAFKA, *HTTP://EVANKAFKA.COM/SENSORSENSIBILITY/*, New York, NY.

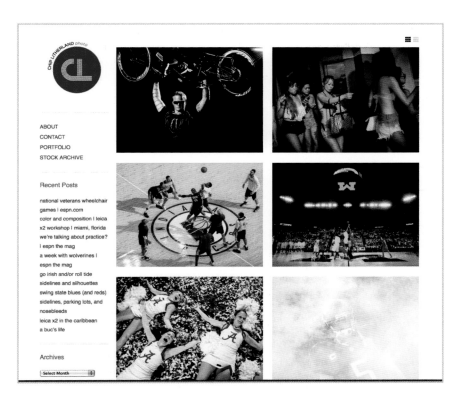

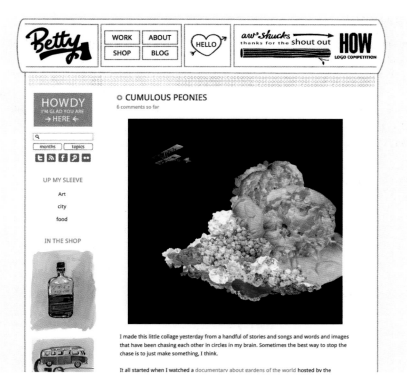

CHIP LITHERLAND, HTTP://CHIPLITHERLAND.COM/ BLOG/, Sarasota, FL.

BETTY HATCHETT, HTTP://BETTYHATCHETTDESIGN. COM/BLOG/, Cincinnati, OH.

Chip Litherland's blog features singular dynamic imagery that shows his love of color, narrative, and strong photographic seeing. His blog allows him to feature groups of images that show the full range of what he captured on a particular assignment. In other cases, side projects or other images of interest get presented. He often provides some contextualizing information to give the viewer some insight into what he was up to and what he was responding to when he made the imagery. These small narrative components give us insight into his interests, his process, and his sense of humor.

Betty Hatchett is an independent designer and illustrator. Her blog is a section of her online portfolio and employs the same format as well as look and feel. The blog represents a range of musings on design work, side projects, and imagery. The sum total of the posts reveals a lot about her as a creative individual.

I've had clients mention that they appreciate getting to read about the concepts and process behind my work. I think it helps build an initial trust that they will be heard and their priorities will be incorporated into their design. That they won't just get something that's trendy, but something thoughtful, custom fit for their business.

— Betty Hatchett, Designer

Unique Cases

There are blogs which function to extend a brand through more than just images and updates on activities. Blogs such as these are unique cases where working professionals have established themselves as a "brand" to follow on the basis of their reviews, information, insights as well as their work. Zack Arias, David Airey, Jessica Hische, and Chase Jarvis are good examples. These blogs are the work of energetic, industrious individuals and part of their success is a result of the incredible amount of information, advice, and ideas they pack into their blog. However, it should be noted that these blogs while successful, are largely targeted at their own community, rather than those who hire them. From a professional practice point of view these blogs have a very large following and ultimately, they extend the presence and brand of their creators.

ZACK ARIAS, *HTTP://ZARIAS.TUMBLR.COM/*, Atlanta, GA.

JESSICA HISCHE, *HTTP://JESSICAHISCHE.IS/THINKING THOUGHTS*, San Francisco, CA.

Online Portfolio Directories

There is a whole host of online portfolio directories and community sharing websites that serve as a means for people to post, collaborate, and share work. Many of these are searchable by geographic location and expertise. Some encourage the community to like, follow, or comment. Others are more focused on providing a means for buyers and art directors to find talent and search for someone they'd like to hire—whether full-time or for a specific job. Some directories and photo-sharing sites require a fee (flat fee or fee for membership) in order to be listed and others offer free accounts. Some also offer website creation services whereby for a fee you can build and publish your own portfolio site (with its own unique URL) utilizing the company's portfolio building templates and content management system. This topic is discussed in more detail later in this chapter under "Web Publishing Services."

There are a number of online portfolio directories for creatives to promote their work in hopes of being seen and hired. Most are searchable by category and key word and require a fee for members to include a portfolio of their work. Some examples are Workbook, PDN PhotoServe, Coroflot, FoundFolios, CreativeHotlist and Picture-Book. In addition, there are industry associations/organizations with online portfolio directories for members only. Some examples are AIGA Member Portfolios, FindAPhotographer.org (for ASMP Members) and the Association of Illustrators website.

There are online portfolio directories that focus on community and photo sharing. Along with being searchable, these sites allow the community to give feedback via such devices as "voting," like buttons, and comments. Some examples are 500px, Dribble, Behance and Flickr. Some websites, such as Behance, also allow you to create your own subdirectory and subsequent URL to link directly to your "page" on their site.

Another way to be seen, especially as an industry leader, is to submit projects to industry recognized award websites, blogs, and web portals. If your work is accepted and featured, you'll be recognized within your own community as the best of the best. Some examples are the FWA, Awwwards and noplasticsleeves.com.

Portfolio site [directories] offer buyers the convenience of viewing a large number of artists' imagery gathered together in a single site. Some sites curate the artists and/or the work they'll feature to a greater or lesser extent. Others allow anyone to post any images. While everyone has a story about someone being plucked from the crowd and landing a great job, for most professionals, the more tightly curated the site, the more likely it is to lead to high value stock sales or assignments.

If possible, talk to your clients—or prospective clients—about how they find photographers. Find out which portfolio sites they prefer and why. Use that information to figure out the best mix of marketing tools for your business. Remember, everything you do—including which portfolio sites you choose to participate in—will affect how your brand is perceived. You're better off participating in fewer vehicles that really fit, than diluting your brand by putting your work in the wrong ones.

— Judy Herrmann, Photographer & Consultant

Social Media

Taken advantage of, social media can be a great addition in marketing yourself and your business. In broad context, some social media outlets include Twitter, Instagram, Vine, YouTube, Vimeo, Tumblr, Facebook, LinkedIn, Google+, Github, Flickr and Pinterest. With any of these, the key is to network and increase your number of "followers" who will ultimately land on your portfolio site and blog—ideally potential clients or vocal advocates for you and what you do.

*Read more about online portfolio directories, photo sharing sites and social media in Step 7.

If you don't yet have a portfolio site or are thinking about a redesign there are a few options to consider. You could of course hire a web expert to create your site for you. In many ways this is the easiest route to take, but it can be costly. Another less costly option is to use an out-of-the-box solution and customize it a bit (either on your own or with help). If you're a design student or professional with an interest in working in the interactive fields, then it's in your best interest to design and build your own site—either from scratch or by utilizing an out-of-the-box solution and then customizing it.

Out-of-the-Box Solutions (For Photographers & Designers)

Blog Publishing Solutions

An inexpensive option is to do it all (or most of it) yourself. While this may sound daunting, it's not that bad. Especially if you use a blog publishing platform like WordPress and utilize a portfolio "theme" (which will include both portfolio and blog style templates) as the basis for the design and functionality of your website. WordPress has an online content management system so you can easily add, update, and make changes to the site and its content. You can also manage both your portfolio and blog together as sections of the same site or through separate addresses.

To start, select a blogging platform and then a theme. A theme includes design, layout, navigational, and functional features for your website (you start off with a very generic shell). There are lots of themes to choose from for portfolio and creative websites. Most themes allow you to easily customize brand components such as logo, color palette, and typeface through an online style editor. New themes offer customizable page layout options for portfolio and blog "webpages" as well as built-in links to all major social networks. In addition, you'll have options for web features like a search, an RSS feed, image sliders and turning comments on or off. Check out the "creative" themes available on a site like themeforest.com to get started. Different themes have different layouts and features,

so think about what will work best for you. Make sure to choose one that has mobile/tablet options—many are even responsive. Themes are pretty cheap and some are even free—so if you end up not liking one you can easily change to another.

One caveat—keep in mind that a portfolio site should look like a *portfolio* site with a structured and curated set of "galleries." It should not look like a traditional blog with posts, comments, and a less considered presentation. So when dealing with such tools, make sure to choose a theme that will allow you to have a professional looking portfolio site. Have a separate "blog" section or site for more informal content.

If you go down this route, you'll need to purchase hosting space and a domain name on your own. It's recommended that you purchase both through the same hosting company—it makes the set up a lot less painful. There are easy "one-click" installs for WordPress with all major hosting companies and lots of documentation out there on how to set things up. While the whole process can seem daunting at first, don't let that stop you. It's fairly inexpensive and can produce some great results. So, roll up your sleeves and have fun. While there is a learning curve, once you get going it's quite easy to make galleries, menus and add images, video and other types of content with the click of a button. You probably know someone who already has a blog so get some help if you need it.

With a little code know-how (especially CSS) it's possible to go under the hood of your theme and make further modifications to the look and structure of the site. For example, sometimes your logo doesn't quite fit right in the header and a little extra room is needed. If coding isn't your thing, then work with or hire someone. Most web designers and/or developers are pretty adept at using blog platforms and themes. For a minimal amount of money you could hire someone to set things up for you, customize it, and then show you the ropes once things are in place.

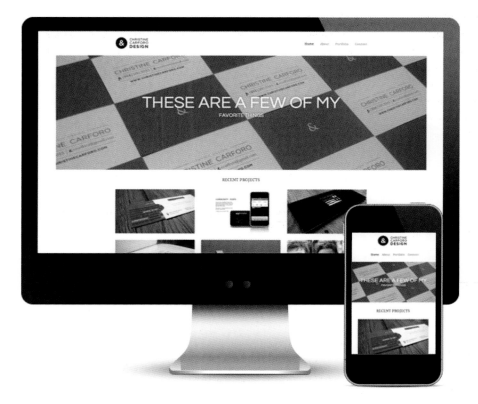

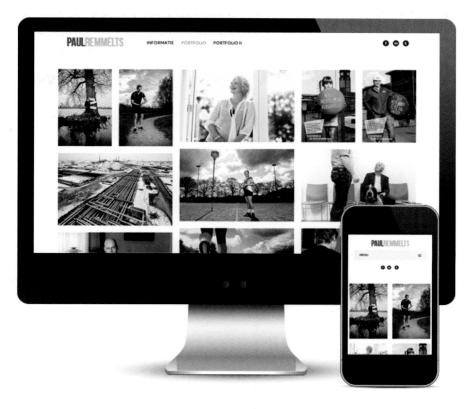

CHRISTINE CARFORO DESIGN, HTTP://CHRISTINE CARFORO.COM/DESIGN/, Boston, MA.

PAUL REMMELTS, HTTP://PAULREMMELTS.NL/ PORTFOLIO-5/, Netherlands.

I wanted a responsive site that would make my brand universal; available to all users on any device. I translated my organization and attention to detail to the site by picking a template that was visibly based off of a grid. My goal was to create a site that conveyed my personality and professionalism to potential clients.

— Christine Carforo, Designer

I'm using a WordPress theme because it's not that hard to change some features in WordPress or CSS, and it's fast to put some new work in my portfolio. It's responsive and loads up quickly, so people don't have to wait too long to see my work showing up.

— Paul Remmelts, Photographer

Web Publishing Services

Another way to go is with an out-of-the-box web publishing service like Squarespace, 22 Slides, Cargo Collective or Behance ProSite. These companies offer website building tools, templates, and hosting services as part of their solutions. They allow you to easily customize brand components such as logo, color palette, and fonts all through online style editors. In addition, many offer customizable page layout options for portfolios and blogs. Most solutions include features such as slideshow galleries, SEO (search engine optimization), integration of social links, social sharing, video integration, and RSS syndication. Almost all include screen and mobile options as part of their design templates, some of which are responsive. Plus, with a built-in content management system, it's a cinch to make changes and add new content. Very little knowledge of code is required, although the more you know the more you can customize the look and presentation of your site and its content.

Image top right:
For my website, I chose 22 Slides. It is an intuitive HTML template site that is also very customizable. It is very easy to use and looks great on all media platforms.

— Adam Jones, Photographer

Image bottom right:
I use Squarespace's service because it offers me the tools I need; a portfolio, a blog, and e-commerce that work across all platforms all in one easy-to-use interface.

— Darren Booth, Illustrator

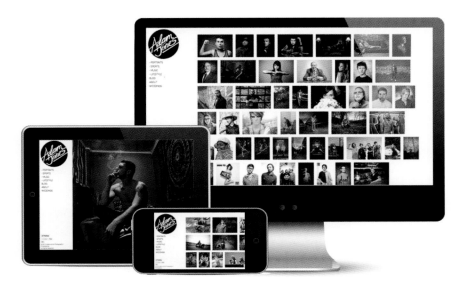

ADAM JONES, HTTP://ADAMJJONES.COM, West Chester, PA.

Logo designed by Kevin Fenton

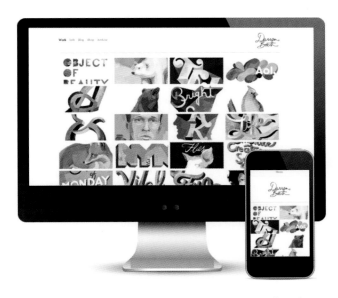

DARREN BOOTH, HTTP://DARRENBOOTH.COM, Canada.

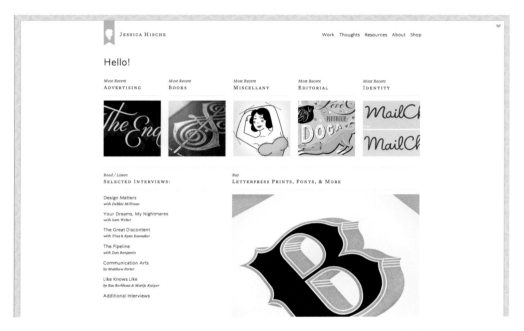

JESSICA HISCHE, HTTP://JESSICAHISCHE.IS/AWESOME, San Francisco, CA.

Creating Your Own Site (Designers)

Let's face it, designing and building your own customized site isn't easy. It takes a lot of knowledge and a specialized skill set to design and build an effective online portfolio. But by doing so, you give yourself the freedom to create your own unique vision for your site—with a design, functionality, and interactivity that's customized to you and your goals. You will also prove that you have the goods to work in an industry that few people are qualified for—making yourself all that more marketable! So, if this is your thing—go for it.

One of the best ways to learn is by doing. So, play around with stuff. Maybe you'll like trying out CSS3 animations, web typography, scalable vector graphics (SVGs), or get into responsive design. As you go, try to have fun with it. There's a lot out there, so remember—you don't have to learn everything all at once. It's best of course to create something that can stick around for a while (considering all the time and effort that goes into it). But one of the great things about websites is that you can completely redo them whenever you feel the need. And get some help if you need it! Buy your web developer friend a beer while you pick his/her brain. Maybe trade some design work for some development help. Complete an online course or tutorial in web design and development. There are lots of resources out there so take advantage. Check out our website for the most up to date resources.

Designing and building my own website over and over again has been one of the main ways I've been able to teach myself HTML markup, CSS, PHP, and a bit of jQuery. I tend to revamp my site every year or so and this latest iteration is definitely my favorite!

— Jessica Hische, Illustrator & Designer

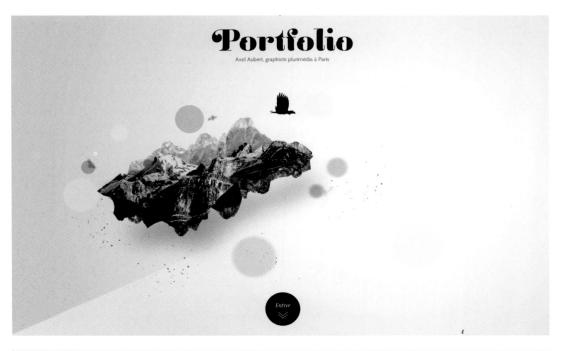

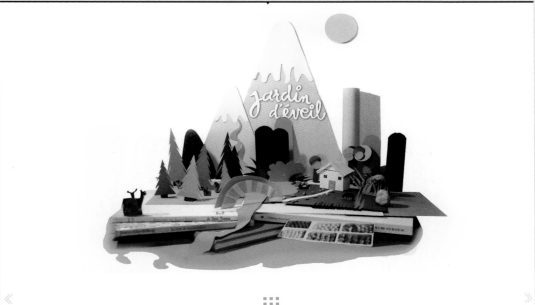

I designed and developed the site in html5 with some JavaScript plugins. I'm a dreamer who loves nature, including the mountains, which is a place of escape and inspiration for me.

— Axel Aubert, Designer

AXEL AUBERT, *HTTP://AXEL-AUBERT.FR/,* France, Student Portfolio

Research

You can't design in a vacuum. Take the time to research online portfolios. There are many sites out there that include directories of the latest and greatest. You should know what the possibilities are.

You may also need to research how to create certain types of content that you want to include in your online portfolio. Hopefully you've taken a web course or taught yourself the basics. There are a number of great resources out there that can help you learn how to develop online content. Just because you might not currently know how to do something doesn't mean you can't learn. For the most up to date list of sites and resources to check out visit our site at *www.noplasticsleeves.com*.

The website was developed as a visual introduction to my professional profile; the design was entirely my own, and a developer helped me with the programming.

— Andreia Carqueija, Designer

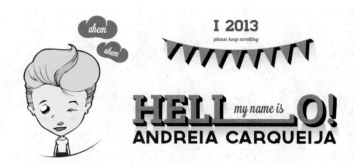

ANDREIA CARQUEIJA, HTTP://ANDREIACARQUEIJA.COM/, London, UK.

Some online portfolio collections are available at:

http://thefwa.com/

http://designcharts.com/

http://moluv.com/

http://websitedesignawards.com/

http://awwwards.com/

http://cssdesignawards.com

Some online resources are:

http://lynda.com/

http://computerarts.co.uk/

http://tutorialmagazine.com/

http://w3schools.com/

http://teamtreehouse.com/

http://smashingmagazine.com/

http://css-tricks.com/

www.codeacademy.com

http://tympanus.net/codrops/

www.bentobox.io/

Work with a Pro (Photographers)

So, if you've got the funds to invest in your business, working with a professional web designer/developer is the ideal situation. This is a legitimate investment in your business and with the complexities involved with online portfolios it makes sense to work with someone who does this for a living. A customized website allows you to have a website that is unique to your needs both in terms of design and functionality. If you decide to go down this path, make sure up front that the person you hire is aware of current web design and development trends. Ask questions and take a good look at the work they've done lately across device and browser. Be up front with what your needs are and the level of involvement you wish to have. To find a pro, look at the portfolio sites of others, select your favorites and then get in touch and ask who they worked with.

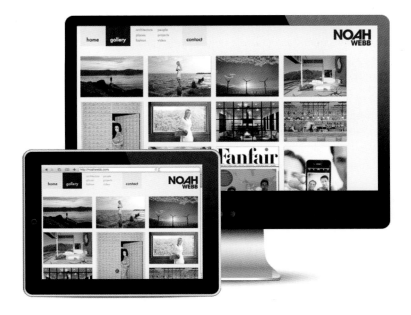

We aimed with this redesign to create an experience for the user that would allow them to take in a broad overview of the work without having to click small thumbnails. The content management system, based on a custom WordPress installation, allows Noah to curate his galleries and the front-end of the site employs scalable grid displays (aka 'Masonry') that wrap to the device or browser size. Large, full-screen images, rich elements, subtle transitions, visual effects, and beautiful design was the ultimate goal. We utilize resources such as Typekit to make use of dynamic typography and modern CSS3 methods to create effects like the 3-D 'card flip' you'll see in modern browsers like Chrome, Safari, and on mobile browsers based on Webkit (iPhones, iPads, and Android, for example).

— Benjamin Borowski, Typeoneerror Studios

THE WALL STREET JOURNAL / PALM SPRINGS

NOAH WEBB, *HTTP://NOAHWEBB.COM/,* Los Angeles, CA.

Driving Traffic & SEO

The best way to drive traffic to your portfolio site and blog is to build a community through social networking, get your site linked from other reputable sites, and of course publish quality content that your community will want to share. In addition, use features like Facebook likes, Twitter shares, and "Pin It" (Pinterest) buttons on your website to get people to share your work and posts.

Utilize SEO (search engine optimization) guidelines to make your website friendly for search engines. This means adding text to your site and including important key words that define who you are and what you do. Include ALT tag text to your images including Category, Location, and Name. Most blog platforms are already set up to be SEO compliant so writing content and adding key words to each post is another great way to drive traffic to your site and have yourself indexed higher in search engines. In addition, links back and forth from other websites will help do this too. Be aware that Flash websites can be problematic for search engines to index. If you have a Flash site, include meta tags and other HTML text so your site is searchable.

Use analytics software via your web hosting service or Google Analytics (which is free) to track the traffic on your site. There's a lot of data that you can collect to inform you about your site and its visitors.

How to Get Your Site Live

If you're not using a web publishing service, you (or the person you hire) will need to do the following.

1. Purchase a domain name

2. Purchase server space (site hosting)

3. Use ftp software to upload your site and push it "live"

It's recommended that you purchase your domain name through the same site that will be hosting your website—it makes the set up a lot less painful. While the whole process can seem difficult, don't let that stop you —it's fairly inexpensive and really advantageous to have your own site. If your grandmother can do it, so can you.

CREATE

your own visual style... let it be unique *for yourself and yet*
identifiable *for others.*

ORSON WELLES
Actor/Director

PROMOTIONAL MATERIALS

PROMOTIONAL MATERIALS

As has always been the case, you need to reach your target audience in order to get hired. How you reach that audience, and where to reach that audience has changed significantly. Self-promotion encompasses a much broader set of options than ever before for individuals who are independent design and photography professionals. As we have stated, self-promotion materials and resources are really a part of *the entire portfolio package*. Your portfolio is only effective if it is visible. To reach your audience and to create visibility, you need employ a range of resources.

A Multi-Faceted Approach

As someone in the creative industries, self-promotion by definition is the use of a variety of approaches, all of which must be consistent in reinforcing the brand and visual identity you have developed. This would include hard copy promotional pieces, electronic promotional (e-promos), photo-sharing sites, and social media channels. These are all used to develop interest in your work and bring viewers to your online portfolio and blog. You are trying to build audience, and bring that audience to your portfolio. It is important to recognize that as you develop an audience through social media and promotional pieces, not every connection will produce a client. These relationships are still of value as building a community of followers extends the reach of what you do, leading to visibility within your target market.

What follows will be a discussion of developing specific promotional pieces that capitalize on taking a creative approach to connect with your target market and establish an audience for your work. We will then discuss online resources—social media, photo sharing communities—that can be used together to maintain your visibility, keep your audience up to date and represent you in the most effective manner. Finally, we will look at other methods available to you to support marketing efforts. The goal is to use all of these in combination to create a regular and consistent message about who you are and what you do, to bring interest to your body of work.

What Should You Be Doing?

How many social media channels should you use and how often should you be sending out promotional works? To some extent much of what you do should be determined by current industry practices, what you can manage, and what you can afford. Professional affiliations, some of which are listed in the later part of this chapter are often the best way to keep up with what is being employed within your industry and what is expected. If you are a student embarking on your career, start by looking at your industry's expectations. Following that, don't over commit; a few well maintained elements that comprise a portfolio and marketing plan are much more effective than irregular use of multiple points of social media and inconsistent marketing.

THE BIGGEST FACTORS, IN MY OPINION,

are consistency in marketing message . . .

IT IS THE HARDEST THING TO DO IN THE WORLD ... BUT IT IS ESSENTIAL

JAMES WORRELL

At the time of this writing with respect to online resources, what will be discussed are the most prevalent approaches being used; however, social media and online culture are, by their very nature, rapidly changing and evolving. How they can be utilized is the essential point. As these trends change, memberships to professional organizations (ASMP, PPA, AIGA, Graphic Artist's Guild) can help you stay on top of the most effective and prevalent resources.

JESSICA HISCHE, PROMOTIONAL MATERIAL, San Francisco, CA.

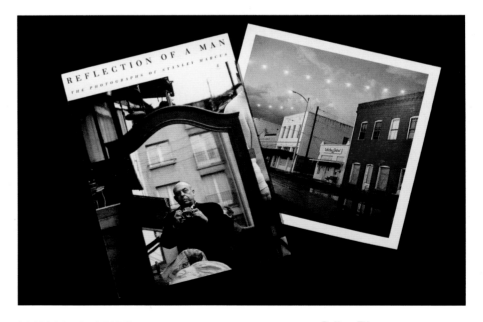

ALLISON V. SMITH, PROMOTIONAL MATERIAL, Dallas, TX.

Developing promotional works is key to finding and connecting with your target audience. As part of your marketing efforts, they will be supported and reinforced by your online presence. There is no fixed formula for what you do and there are differing opinions about which are the best approaches. They are, however, a necessity and can be leveraged to best reflect who you are and what you are capable of doing.

Traditionally self-promotional pieces are focused works that are built around a central idea and show a "snapshot" of your creativity and ability. They are designed to pique the interest of a prospective client who would hopefully want to know more having seen the promo. That is a hard thing to do though, as most creatives in the industry have seen just about everything under the sun. The most effective promo pieces then are developed around a specific and entertaining concept, form, or theme making them stand out and be memorable. They should reflect the kind of work you wish to do, or a dimension of your abilities. They can be a single piece or a series of interrelated pieces. These can range from inexpensive, do it yourself productions that are easy to reproduce (e.g. postcards and e-promos) to more elaborate works. They should, however, be well crafted and well thought out. They need to be on point and focused, as your intended viewer has very little time to waste on muddy concepts or shoddily produced work.

Printed Works

There is a quite a range to what one can produce in printed form and there is a great deal of flexibility as well. A simple two-sided postcard is an affordable way to present a work. Taken further, a printed piece can take many forms: stapled pamphlets, pop-up cards, magazines, or tabloid newspapers. In all cases at minimum they should enable you to feature your work by creating a context which supports its presentation through clean design, thoughtful concept, or unique materials.

Because these are seen outside the context of your portfolio you have the opportunity to do something a little different and this can be leveraged. When developing an idea for a promo, take advantage of what is easily available to you. Use holidays and seasonal activities to build promo concepts. Looking for content? Promote your side projects, exhibitions, and lectures. Shoot small works specifically for a promotional. Create narrative works, or one-off series that explore a subject. The goal is to get viewers to your work, and to do so you have to get their attention.

Promos That Reinforce Your Brand

You can take a variety of approaches, but a good starting point is to be consistent with the other components of your portfolio which incorporate your visual identity. By using a well-developed concept and thoughtful execution, Matt Dutile's (opposite, left) travel ticket promo is a striking example of a promotional piece where his images are seen in the context of a relevant and effective concept that is fun and well designed. Incorporating the iconography of air and rail tickets as well as envelopes which reference maps, all contribute to reinforcing Matt's focus as a travel photographer. Continuity between his online portfolio and his blog is maintained through consistent use of his logo.

As a recent graduate in design, Katherine Smith (opposite, right) created a promotional that has some attitude, humor, and a clear brand identity. Her identity as an independent designer, *Hire the Redhead*, is established through a slightly tongue-in-cheek copy (referring to herself in the third person) which is then reinforced through a simple visual, the red hair silhouette. It is clear, attention getting, and fun. This effectively establishes her brand and gives the recipient a sense of her character as well.

Reena Newman (p. 187) takes things one step further in sending messages about her brand and area of specialization with an unusual package. As a food photographer, she created a set of 4 caramels and a small visual booklet on making bacon candy, which came wrapped in butcher's paper complete with a food packaging label. The iconography of the packaging is playful, and the promo is unusual, which draws some attention when sitting in a pile of 2-D works. Though moving beyond the 2-D card is useful, what is more significant is how the promo represents her work effectively through a thoughtful, on-target concept. While her logo is less prominent in this work, it does appear on the label maintaining continuity with the other components of her portfolio.

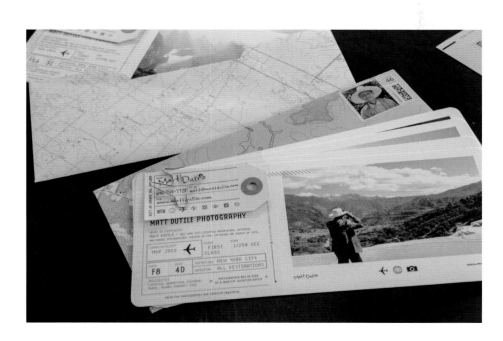

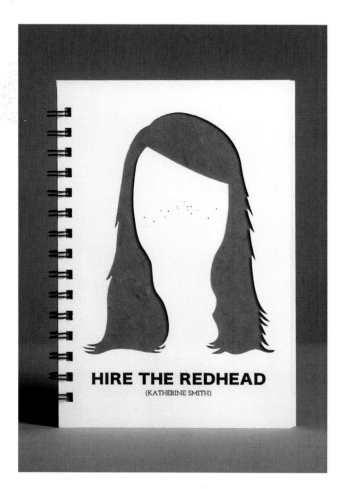

MATT DUTILE, PROMOTIONAL MATERIALS, New York, NY.

KATHERINE SMITH, PROMOTIONAL MATERIALS, Brandon, MS.

Q&A: Interview with Reena Newman, Photographer

Reena Newman is a photographer based in Toronto, Canada, specializing in food and still life photography.

While some photographers have clean, minimal promos and portfolios, and "let the work speak for itself", you clearly have taken an approach where the promo and the portfolio presentation reflect and define the work within. What led to your taking this approach? Were you responding to portfolios and presentations that you had seen?

I wanted to do something different that would get me noticed. Art Directors have dozens of portfolios on their desks and I see my book as a way of introducing my personality and myself to them before they even get to the work itself. I think of commercial photography as part of a bigger package. We're not just creating pretty pictures. The images along with other materials are conveying a message to the consumer. I wanted to take a similar approach with my portfolio. The images inside are just part of what sells my brand and me. I wanted the package to convey a sense of my personality.

Some photographers establish their "brand" through subject matter, or type of photographic work they make, others through visual character, or feel. Your portfolio and promotional materials seem to be a bit of both. How did you arrive at concept for the portfolio?

My portfolio really started with the gingham fabric. I like the idea of presenting my work like the food I shoot (e.g. the bacon promo was wrapped in butcher's paper). The fabric I chose reminded me of a classic picnic blanket. I thought that presenting a food portfolio wrapped in such an iconic pattern would be a great way to pique people's curiosity and then tie into my work when they opened the book. I originally toyed with the idea of having custom picnic baskets made to hold the book, but it turned out to be too unwieldy and complicated. I wanted to convey a fun food-centric vibe, but I still needed it to be in a practical package.

What are the associations and qualities that you want to suggest when a potential client receives your promo, or looks at your portfolio?

I really want people to smile when they receive my portfolio or promos. The goal with any of my packages is to convey a sense of playfulness. I want to give them a quick sense of my personality while showcasing my photography and my ability to consider all aspects of a project.

What were some of the visual, design and material choices that you made in making the promo in order for it to have the right visual references as well as reflect your work and who you are?

The Bacon Promo was a very involved package. I wanted to really play up the dichotomy of the meaty bacon and sweet caramel by referencing both in my materials and packaging. The caramels themselves sit in a classic candy box which in turn is wrapped in butcher's paper and completed with a sticker designed to mimic a price tag. I felt that it was important to source the real materials and not just allude to them. The actual promo book was meant as a play on the legend that you find (included) in a chocolate box that tells you what each chocolate is.

For someone who is trying to establish their business what do you see has been the benefit of having materials with a distinct look and feel and very specific subject matter?

I found that doing something unique, that supports my work and doesn't distract from it, really helped me get noticed. By focusing my branding on food, I've been able carve myself a bit of a niche. I can and do shoot other things, but having a cohesive and concise message has been very effective for me. Having packaging that helps support the product is key.

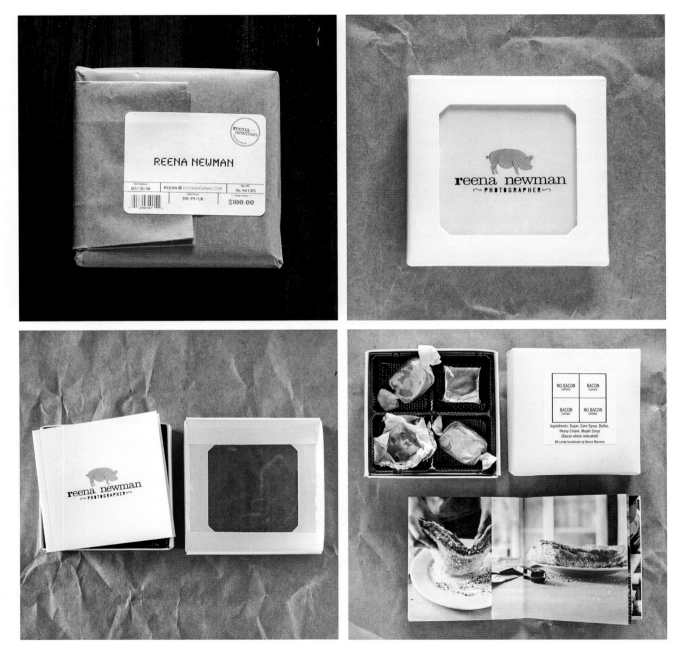

REENA NEWMAN, PROMOTIONAL MATERIALS, Toronto, Canada.

Promos That Are Attention Getting

Sometimes the most effective pieces are those that move beyond standard presentations even though they might not be quite as consistent with other visual elements in your portfolio. While Danny Cohen's brand identity may not be fully reflected in this pop-up postcard piece, the promo is very effective. It leaps beyond the standard postcard, is a lot of fun, and shows great execution. Because these are handmade it also reflects a high degree of commitment and energy suggesting: *I'll go the extra mile, and produce something for you that really pops.*

I started out by making a list of all the agencies across Australia. Then, I would look up campaigns which I felt aligned to my particular style and made a list of the creatives involved ... I had an idea that people find it hard to resist opening hand written envelopes ... having each card individualized with the creative's name on the front cover ... This added a personal touch which I find most mail-outs lack.

— Danny Cohen, Photographer

MacKenzie Cherban establishes her brand identity through a type driven promotional that uses a playful form. Nine laser engraved wooden blocks reinforce her brand identity by integrating her type treatment and suggest a sense of play in a well-executed form. When laid out the blocks send 4 messages including: "Hire Me" and "MacKenzie". Making something other than a printed card does help to get your work to stand out, but a good concept and thoughtful integration with your brand is what will make the promo effective.

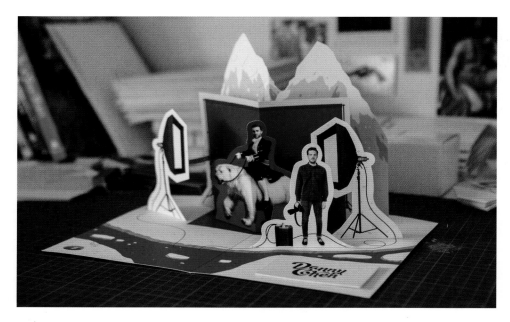

DANNY COHEN, PROMOTIONAL, Melbourne, Australia.

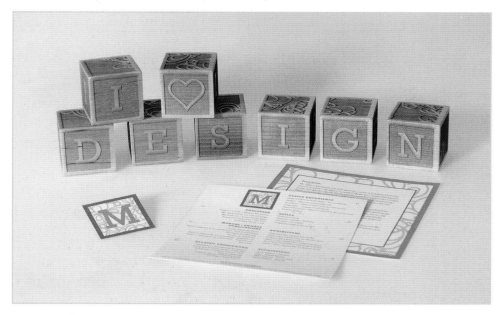

MACKENZIE CHERBAN, PROMOTIONAL, Pittsburgh, PA.

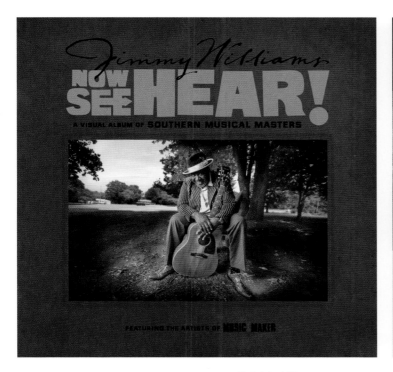

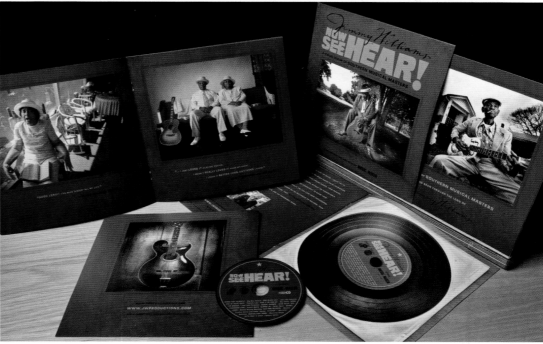

JIMMY WILLIAMS, PROMOTIONAL, Raleigh, NC.

Jimmy Williams' promotional represents a more significant commitment both in terms of production and cost, but it is a fine example of a well executed concept that leaps beyond the standard promotional piece. He conceived doing a series of portraits of older musicians who represent traditional southern music. This project enabled him to promote his environmental portraiture as well as contribute to efforts to support their careers. While the images are strong examples of his work, the promotional presents the portraits to the viewer through thoughtful design and packaging. The piece is presented as a 16-page booklet, with an audio-visual CD in a vintage record jacket, referencing vinyl LPs of an earlier era. The iconography of vinyl records provides a tie in to musicians of an earlier era and is

a clever concept for packaging a CD album. Even the title is a play on words, the declaration, "Now see, hear!" As an audio-visual work, this is exactly what the viewer will do when they open it. A web version of the album was also produced as an e-promo.

As for the response, it was terrific. Yes, the subjects were all musicians but the content promoted is really my strong suit—environmental portraits that tell a story. This promo received an enormous amount of attention from agencies (my target audience), the press, and contests. So this was really the gift that kept giving by putting my work in front of many more eyes than my original mailing.

— Jimmy Williams, Photographer

NICOLAS FELTON, PROMOTIONAL, New York, NY.

JEANIE CHONG, JIBERIS PROMOTIONAL, Los Angeles, CA.

Personal Projects

It isn't necessarily to your advantage to simply send materials that only reflect the kind of work your clients might hire you for. Projects that reflect personal interests or side-trips if you will, allow you to leverage what drives you as a creative, and show your commitment to your craft, and your diversity and range. Presenting these to existing clients might allow you to expand your opportunities with them. Further, you may pique the interest of a new audience through works that may not fit into your existing portfolio.

As a student, Jeanie Chong developed a typeface based on the North African Daariah sculptures. Lacking a written alphabet, she created *Jiberis* for the tribe. This promotion kit (left) ostensibly functions as a way to describe *Jiberis*, yet as a whole it presents a complex system of visual language, presented in a well-designed, newsprint form. This piece showcases the range of skills she possesses as a designer, from conceptual development through production.

Nicolas Felton has produced the "Feltron Annual Report" since 2005 (opposite page). In each year, he has tracked a variety of statistics about his personal life, presenting them in complex and elegant arrays. They are wonderful demonstrations of information design, and within them you find unique indices which characterize an individual's life and experiences. As an offshoot of these, he has co-founded a personal data tracking website, Daytum.com, where individuals can track and develop and download reports about any aspect of their life.

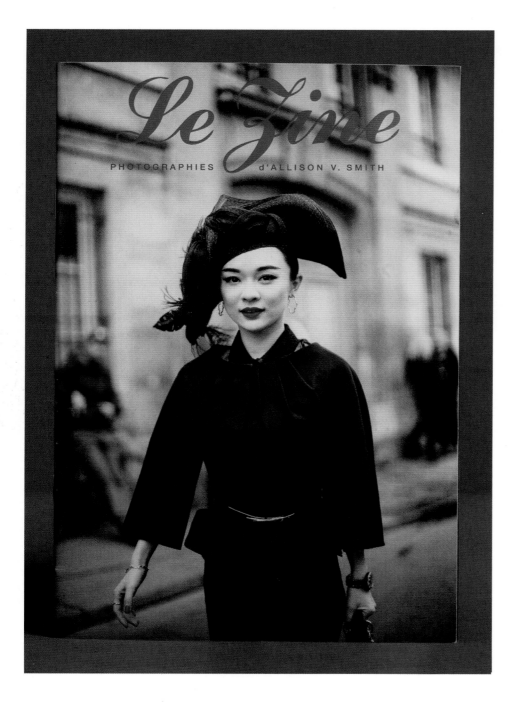

Josh Kohanek's Painted Desert series (opposite right) is a body of work taken in Montana that grew out of his interest to shoot in that environment. Unconstrained by the requirements of an assignment, he was able to present a series of images that have a particular look and feel. Further, in their presentation he is able to suggest something about his working process as described on his website: "On the backside of each image is a story pertaining to how the picture was made. Each instance evolved in its own distinct way ... I wanted to give the audience a sense of what it was like to be present in that very moment."[1]

Nate Luke's Musky Old School promo (opposite left) is another personally driven project. He was motivated by the idea of bringing Wisconsin and fishing to his audience. The well-designed piece combines the imagery and iconography of a backwoods fishing trip. Through the promo, Nate is able to showcase his ability to conceive and develop a narrative with attention to a particular subject and visual character. He also produced video to accompany the promo which is viewable online.

Allison V. Smith (left) has now produced 7 different "Zines" to date. Some are based in an imaging device, such as a Lomo camera, or the iPhone, and some are driven by content. These all represent work that is an outcome of the desire to make photographs. While not strictly promotional pieces, they serve as a great example of a small, simply constructed form that offers an opportunity to share another dimension of your vision and creativity. A simple stapled pamphlet that you could produce by hand or have printed commercially can be a great mailer or leave-behind.

ALLISON V. SMITH, ZINE NO. 7, Dallas, TX.

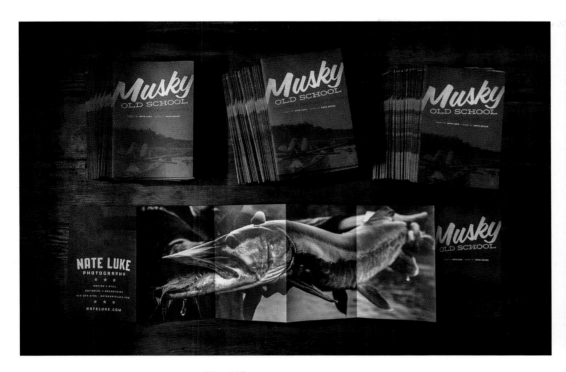

NATE LUKE, PROMOTIONAL, Nixa, MO.

JOSH KOHANEK, PROMOTIONAL, Minneapolis, MN.

Other Approaches: Creating a "Context" for Your Work

For a person just entering the market, trying to get seen, get opportunities, and establish your credibility can be a challenge. For example, side projects such as charitable and pro bono work create visibility and credibility for your work and networking opportunities. However, taken further, a self-initiated side project can create an opportunity tailored to the work you wish to do and directly related to your goals and interests. These differ from personal projects in that they are directly related to the market in which you wish to be hired. In short, if you aren't getting the work you want to do, and you can't demonstrate what you are capable of, create the context yourself.

Lisa Czech is young photographer whose passion has been the regional music scene in her hometown. While there is always an endless stream of new bands and live shows to be photographed, the market for publication and use of these images is small and the opportunities are few. Lacking a context for the imagery she had been producing, she collaborated with designers and writers and created an online and print-on-demand editorial publication, *Amplified*. Filled with writing and reviews, the magazine provides an effective context to showcase her work and has the potential to create opportunities, by building an audience and potentially attracting clients. This publication takes advantage of using low-cost online distribution such as a PDF. Print-on-demand allows hard copies to be produced as needed. Further, the online version is bolstered by a blog site and social media, which allows them to keep the publication's audience engaged in between its quarterly releases.

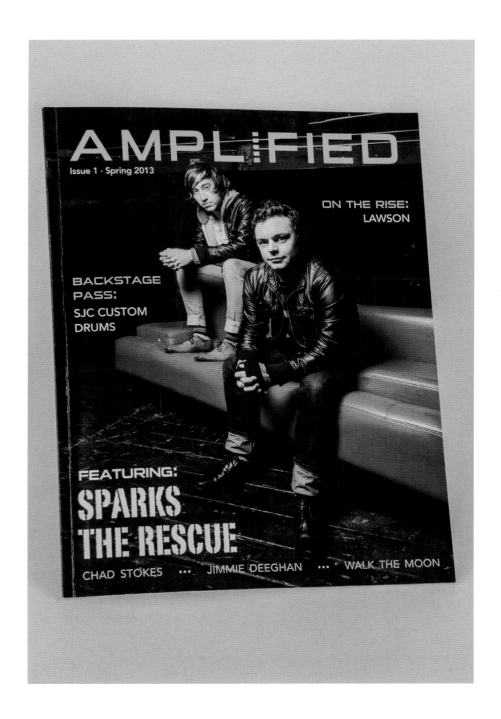

LISA CZECH, EDITORIAL PUBLICATION, Boston, MA.

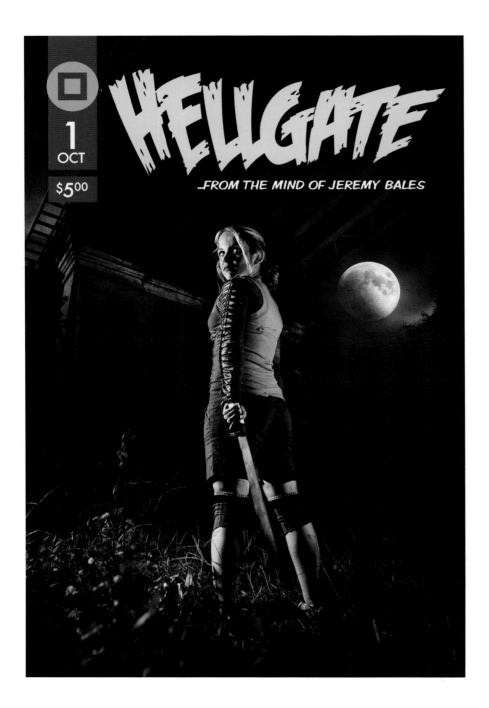

Jeremy Bales' promo highlights his concept-driven production skills. His photo comic book, *Hellgate*, is a methodically conceived, narrative comic that creates a wonderful vehicle for his imagery. It has the look and feel of a classic horror comic with 21st century photographic production. The interior pages employ the frame structure of a classic comic book and the book has a narrative progression. Using actors, costumers, designers, and a copywriter, it underscores his ability to work with multiple artists collaboratively.

Response to *Hellgate* has been very positive. Surprisingly, it led to work with a women's fashion magazine. It turns out the editor was once a fan of graphic novels. The project has also opened some doors for me at advertising agencies to show my work and meet other creatives.

— Jeremy Bales, Photographer

JEREMY BALES, PROMOTIONAL, New York, NY.

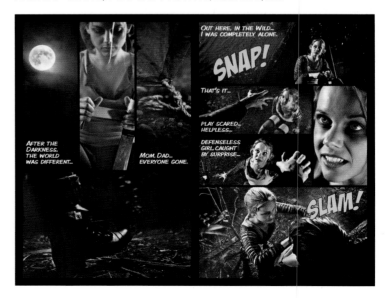

E-Promos and Digital Downloads

Electronic promotional pieces present an opportunity to quickly connect with your existing audience and develop new followers. While not a substitute for hard copy pieces, they are easy to produce and can be used as another component to maintain visibility and a connection to your target audience. In some cases they can be more effective if they announce or point to new work to be viewed online, a personal project, or commission. In the form of an email, they should be concise and to the point. Motion-based works are often easily presented through electronic promotion as links in the body of the promo can quickly bring your viewer to specific works to be viewed.

Kristopher Grunert (opposite, left) has taken a different approach to electronic promotional. Rather than bringing the promo to his clients, his clients come to him for a downloadable, image-based calendar. He has offered the calendar since 2009, as a download that requires registering with his blog. Through this he is able to track traffic to his site and develop an email database. To date the calendar has had over 10,000 downloads, growing the audience for his work and developing significant client connections. The calendar promotes regular following of his work as in its current form it is offered monthly.

James Worrell (opposite, right) uses the e-promo format effectively with a concise approach that only requires a single image. "From concept to production" features his initial sketch of an idea for an image presented side-by-side with the finished work. For a still life photographer, this promo works well given the limited space of an email as in short-order it offers a glance into his work and process.

Mailings: Electronic vs. Hard Copy

This is a question that will produce very different responses depending on whom you speak with. While electronic postcards or image samples are cost effective and easy to employ, they are not necessarily a replacement for printed mailers for the very same reasons that printed mailers are not an end unto themselves either. Electronic forms in some cases can be supplements to initial contacts, and are more likely

to be viewed when you are known to the recipient. On the other hand, some find hard copy promo a refreshing change in the balance of the screen-based material they have to review. In both cases you will find someone who would rather not receive what you send, or doesn't have time to review it on the particular day on which it arrives.

What to do? Pay attention to whom you are sending your promotional materials. Research your audience and your market. Refer to the information in the later part of the chapter on professional organizations and networks and resources for finding your audience. With any type of promotional piece, if you have done your homework, you have a better chance of being seen. Should you employ both? Yes, but as with everything, scale your efforts in relation to what you can afford to produce and support. Further, if you have existing clients and audience, leverage social media to alert those connected to you that you are sending out new promotional works, mailers, or e-promos. This can be a backstop against getting lost in the shuffle. Further, by employing both electronic and hard copy forms, you are covering your bases and this can help to mitigate the problem that arises when your recipients, unknown to you, have different preferences.

Online Resources: Using Social Media and Sharing Sites

Social media represents another component of self-promotion, in that it serves as a way to create interest and drive traffic to your blog and online portfolio. Further it can be used to attract and continue to build audience, thereby increasing your visibility. If promotional pieces are a form of targeted outreach, social media platforms function to support and sustain that outreach. Your ability to alert your audience to ongoing projects, new works, and professional activities is enhanced by using social media channels such as Facebook, LinkedIn, Google+, Twitter, Instagram, and Pinterest. Which social media platforms should you be using? As mentioned earlier in this step, the expectations and practices vary by discipline. In addition, you need to consider how the different platforms vary in terms of the population of users. In all cases, you should be sure that your blog and portfolio sites employ sharing and following via social media channels.

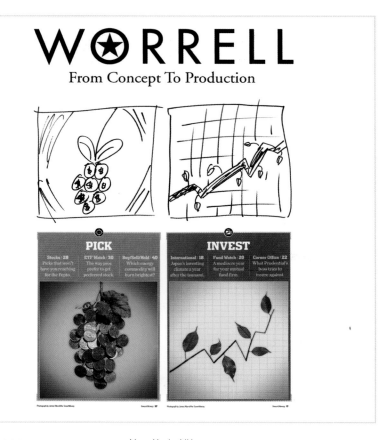

KRISTOPHER GRUNERY, ELECTRONIC PROMOTIONAL, Saskatchewan, Canada.

JAMES WORRELL, E-PROMO, New York, NY.

Facebook, LinkedIn and Google+

Of these three social media platforms, Facebook is without question, at this writing, the largest network and broadest in its population. The value of Facebook is that it enables you to support any of your activities by posting and those who follow or "like" you will receive updates through the newsfeed. The caveat is that you don't have much control over the length of time it appears on your audience's newsfeed. As Facebook has evolved they have begun to focus on supporting businesses and they provide means to direct your activities to the newsfeed of those who friend and follow you, but for a fee. Google+, similarly to Facebook, allows you to build audience and a network of friends or followers, but this can be structured and tailored to interests. As such it may help build more audience and visibility among fellow professionals rather than clients. The value of LinkedIn is that it is more professionally oriented and "connections", as they are called, are built on professional relationships. Finally, Twitter, with its character-limited platform, can act as a driver to your blog and online resources. Its value, as with all of the social media, is to extend your visibility and build audience.

Photo Sharing Sites

Photo sharing sites are generally of more interest to photographers as they are driven by posting and sharing imagery. As with a blog, the photo sharing sites are freed from the constraints of your more formal portfolio so you can feature another side of your image making. They can serve as a place for "one-offs" or side projects that don't necessarily fit into a more formally organized body of work, or commissioned pieces. They invite regular posting that can present you as an active image maker, without the demands of putting together bodies of work, or finished projects and commissions. While bodies of work can be presented, the other value of posting images to these sites is the opportunity for building audience. There many cases (as with Instagram) where individuals foster an audience solely on the basis of their hosted imagery. The intent, however, is to link to your blogs and portfolios, which all of these sites enable, and ultimately foster interest in your larger body of work. There are different variations on these sites which include Instagram, Flickr, and Tumblr.

Pinterest

Pinterest is worth mentioning as a unique hybrid that is suited to a number of different kinds of users who aren't necessarily producing photographic imagery. It allows for posting and sharing a variety of material from original imagery and artwork, to blog posts and rich media. The users can essentially compile an electronic collection that can be tailored to different categories of interests and ideas. These can be shared, followed, reposted, and linked. As with photo sharing sites, the use of a sharing site can add to your online presence which contributes to building your audience.

Attracting attention in a saturated market

REQUIRES A CONCERTED EFFORT ACROSS MULTIPLE FRONTS . . .

TO DRAW ATTENTION TO YOUR WORK, *EXPRESS YOUR PERSONALITY* AND

COMMUNICATE THE FULL VALUE OF WHAT YOU BRING TO THE TABLE

— JUDY HERRMAN, PHOTOGRAPHER

Instagram

Instagram is unique in that it is not simply a photo sharing community, it is also tied to an imaging device and software. As a device for imaging, Instagram's looser, out-of-the-box quality has attracted many photographers. As it is well documented, this imaging approach has led to major publications commissioning photographers to do Instagram-based projects. This has subsequently drawn many photo editors, art directors, and buyers to Instagram as a source of ideas and new image-makers. Much of the significance of Instagram beyond the imagery itself is that as an online photo sharing site, it leverages the power of social media. As such, it has the potential for any user to generate a following and this has made it one of the most active sites for imagery. The visibility created through Instagram has brought opportunity to many photographers, and in some cases jump started careers.

I feel all of it [social media] has merit. In particular, I enjoy Instagram as it is so visually based. But I post work on Instagram, Facebook, and Twitter constantly … On my company page we'll post the Ad work and behind the scenes PR photos. In either case I try to be careful to only post work that has some visual strength. Instagram and Facebook seem to get the most notice. I do think that all of it combined has led me to new jobs with existing clients. I can tell they follow my work and sometimes will comment as well. Even if they don't comment it is a passive way to have my name and imagery in front of my audience.

— Jimmy Williams, Photographer

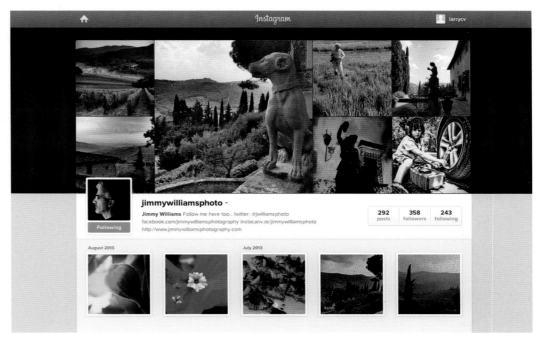

JIMMY WILLIAMS, INSTAGRAM PAGE, Raleigh, NC.

Protecting Your Copyright

One of the largest pitfalls of social media is copyright infringement. The more visible your work is online, the more likely it can be used without license. Further, the act of reposting can blur the lines of use quite quickly. There is no magic bullet here, but watermarking your work is a fundamental basic step. While many photographers include copyright information in the image's metadata, as of this writing there is evidence that many social media sites strip this information out of the file when it is posted.

The other culprits here are the terms of service (TOS) agreements of all these sites. This is a moving target, and they change quite frequently. The watchword here is buyer beware. You should recognize what kind of agreement you are entering into when placing your work on a social media site in particular. Industry organizations such as ASMP have been very active in providing information and best practices as new issues emerge and it is recommended to check regularly to see how this is being managed, or if there are problems with new TOS language.

Putting It All Together: James Worrell

As previously described, self-promotion and its varied components are all part of the comprehensive portfolio package. Brand consistency, a consistent visual identity, and active communications and updates, are an expectation for successfully reaching your target audience and maintaining your client base. James Worrell is a New York based photographer who, in addition to his online portfolio, has an active blog, sends out e-promos and hard copy pieces, and employs Facebook as well.

James' blog, entitled *less is more*, is distinguished from his online portfolio and serves as a dynamic complement to it and features recent works, promos, and side projects. His e-promos, as described, have featured work and show process in a simple direct way: initial sketches and finished work. The hard copy promo, a printed calendar, while more significant than a card or mailer, allows him to create a promo that presents multiple images and has some functionality, which is an incentive for the recipient to keep it. Facebook is used to notify his audience of blog posts as well as current activities. Of note, he frequently features previews of promos and e-promos as well. While this may seem redundant, it is very useful as it exposes new visitors to the promo pieces and for recipients who did not open his email the blog posting can serve as a backup.

We have to consistently get our name, images, message out there just enough to be noticed but not too often as to be unsubscribed.

— James Worrell, Photographer[2]

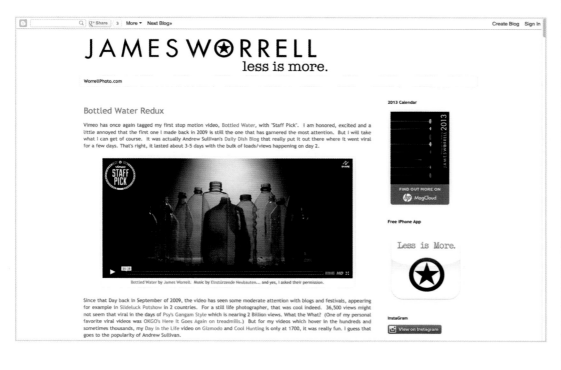

JAMES WORRELL
less is more.

WorrellPhoto.com

Bottled Water Redux

Vimeo has once again tagged my first stop motion video, Bottled Water, with "Staff Pick". I am honored, excited and a little annoyed that the first one I made back in 2009 is still the one that has garnered the most attention. But I will take what I can get of course. It was actually Andrew Sullivan's Daily Dish Blog that really put it out there where it went viral for a few days. That's right, it lasted about 3-5 days with the bulk of loads/views happening on day 2.

Bottled Water by James Worrell. Music by Einstürzende Neubauten... and yes, I asked their permission.

Since that Day back in September of 2009, the video has seen some moderate attention with blogs and festivals, appearing for example in Slideluck Potshow in 2 countries. For a still life photographer, that was cool indeed. 36,500 views might not seem that viral in the days of Psy's Gangam Style which is nearing 2 Billion views. What the What? (One of my personal favorite viral videos was OKGO's Here It Goes Again on treadmills.) But for my videos which hover in the hundreds and sometimes thousands, my Day in the Life video on Gizmodo and Cool Hunting is only at 1700, it was really fun. I guess that goes to the popularity of Andrew Sullivan.

2013 Calendar

FIND OUT MORE ON
hp MagCloud

Free iPhone App

Less is More.

InstaGram
View on Instagram

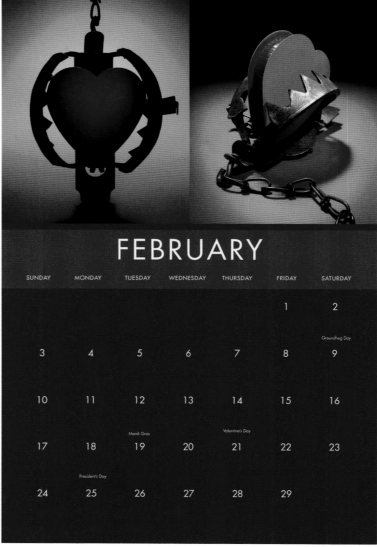

JAMES WORRELL, PROMOTIONAL CALENDAR, blog (*www.lessismoreworrell.net/*), New York, NY.

Audience and Networking

While this is just a brief overview, and each platform presents differences, all of these are valuable as tools to direct your clients and potential clients to your blog, online portfolio, and generally keep you on their radar. In all cases, you should always separate your personal social media from your professional social media. Further, when doing this you should maintain a consistent brand and visual identity throughout all of your social media channels. As mentioned before, beyond its value in cultivating clients, social media is significant in fostering a community of peers in your discipline. It is important to remember that maintaining a network of peers in your industry can yield important opportunities. As is the case with social media, one person within your following who responds to your work, can enable you to connect to a larger audience and that extends your visibility.

Managing Social Media

There are many ways to aggregate your output to social media channels. Some independent companies offer online services for managing multiple social networks. Often blogging and web hosting platforms have built in tools for distributing content to all of the social media platforms you employ and these should allow you to stop posting and messaging. Check with your particular blogging platform to see what options you may have.

Rather than generating content for Facebook and Twitter, I use them as a way to get (my audience) to follow my blog.

— Evan Kafka

Making All the Pieces Work Together

When you are using blogs, Twitter feeds, and specific promos, there is a momentum that you want to take advantage of. In all cases if you are reaching out to individuals then you need to be ready. If you have new work in a portfolio, it should be good to go. If you are just starting out, you want to have everything in place—web, book, and a plan for using your online resources. As mentioned previously, having a calendar in place to organize what you may deliver and when can help you manage all of these moving parts. Here are a few essentials:

- Be ready. When you get a response through any of your online resources, or promos, you need to be able to respond and send work, and *follow-up*.

- Have a plan (and budget) for any printed pieces. Two a year is a good number if you can manage this.

- Be consistent. While the number of blog posts and mailings may vary, what you should do is be consistent and maintain an active presence.

- Seek out fruitful collaborations. We function in a networked, community based culture. Find opportunities where you can leverage your skills and strengths with others.

- Start small with respect to any of the above. If you blog, you don't have to write volumes. If you post images, create a reasonable goal for yourself.

Professional Organizations and Networks

While it goes without saying that relationships in your professional community are essential, they can also be extremely useful in extending yourself, your services, and your product, and for some, your brand. ASMP (American Society of Media Photographers), PPA (Professional Photographers of America), and AIGA (the professional organization for designers) are three examples of large organizations that provide resources both nationally and regionally. In addition to keeping up on emerging issues such as copyright and pricing, meeting individuals in the working community eventually can pay off in terms of marketing. While they are often your peers who are competing for similar clients, general networking can provide leads and ideas for self-promotion. At minimum, feedback and sharing experiences with other creatives is always of value. Finally, your membership to a professional association can add to your credibility as an invested professional who is established, or working toward establishing a long-term career.

Organizations and publications of your particular client's industry can also be useful for tracking trends, and identifying potential clients. It is also possible to access industry or association databases (if you are a member) to identify potential clients to target.

Competitions as Marketing Tools

Competitions and contests should be considered another valuable component of building audience and drawing attention to your work. While contests in some sense can be validating and are good resume builders, more significantly they offer great bang for the buck as targeted marketing tools. These contests are resources for professionals seeking new talent. Inclusion in a contest or annual is an extremely valuable way for you to distinguish yourself in an oversaturated market. There are numerous industry-specific contests and annuals that are from publications and organizations such as Graphis, How Magazine, Communication Arts, PDN, SPD, Adobe Achievement Awards, The Type Directors Club, AIGA, AAF ADDY Awards, London International Awards, the FWA, AWW Award, the CSS Design Awards, etc. You should look to industry, your industry publications and organizations for contests and juries that are specific to your interest or specialization.

Contests and juries create visibility, and further, they create credibility by having your work vetted by jurors who frequently are known industry professionals. Having your work selected can raise your profile in the eyes of potential clients, and they are extremely valuable in extending your work and your visual identity.

Marketing Tactics for Designers

Since most designers are looking to secure a full-time salaried position and not a contract or freelance job, the designer's approach to marketing may be a little different from that of most photographers. A salaried position often represents a significant commitment on the part of an agency or creative shop, more so than just a single job. It's a fairly serious investment on their part, especially considering benefits and the dedication of space and computer resources. Because of this, your promotional materials need to communicate a sense of who you are, your attitudes and personality, and what it would be like to work with you on a day-to-day basis. They also need to entice someone into wanting to know more and driving them toward your portfolio.

For designers, target specific companies or areas of the design discipline with promotional pieces that will resonate with a particular kind of company or client. Make pieces that are about more than just the "wow factor." Make work that is thoughtful, relevant, and will engage someone on an intellectual and emotional level—big ideas that are well executed will win people over. Highlight your amazing expertise or talent in a particular area. Think about unique approaches, forms, and concepts that will entertain and make a memorable impact. Employ blogs and social media to reinforce a message about your interests and ongoing activities professionally and creatively.

Tip: Common sense, do your homework.

While it may seem obvious, indiscriminate marketing, particularly email blasts, are not the most efficient or effective way to get on someone's radar. Sure, electronic systems make it easy and inexpensive to send out hundreds of emails, but you would do better to research to whom you are sending promotional pieces and what you should be sending them. Beyond the type of image you are sending out, you should consider the quality, level of production, and content. That doesn't mean you should rule out showing some range, but if you are too far off the mark, you may be wasting your time and might close out further opportunities with a particular individual, because they will have ruled out your work in relation to their needs.

Resources for Finding Your Audience

While online resources can bring attention to your work, one still must pursue potential clients directly. LinkedIn can be a very useful resource for establishing connections, that can then be included on your mailing list. When working on direct mailings, electronic mailings, or sending out packages to targeted clients, it is important to have up-to-date information regarding art buyers, editors, creative directors, and designers. There are numerous services available that provide access to information regarding the individuals you wish to target. Most of these services have subscription-based fee structures. For someone just entering the market, these costs can seem prohibitive, but in the long run they can save a great deal of time and energy when looking to build a client base. These databases are updated regularly and provide specific information and contacts. Two of the largest are Adbase and Agency Access. Beyond this, basic legwork can go a long way. Reviewing contests and industry publications can identify art buyers and editors who are producing work relative to your interests.

It should be noted that even with subscriber services, you do not want to send out indiscriminate blasts of emails. Art buyers, photo editors, designers, and creative directors receive hundreds of these on a regular basis from photographers. Be thoughtful about who you reach out to. Don't expect a quick return on your email investment either. It is often the case that a very small percentage of these are opened; however, it still needs to be done.

Photographer Representatives (Reps and Agencies)

Representation can help you access a greater number of clients by functioning as an agent for you and your work. A representative is paid by commission and acts an agent for established photographers connecting them with art directors and buyers. A new model of representation for emerging photographers is an agency or collective that charges a fixed fee for their services rather than a standard commission. An example of this is Wonderful Machine. They also help to extend the visibility of the photographers in their roster, provide support with bids and contracts, and act as another component in building an audience. As with reps, the photographer continues to be responsible for marketing, portfolios, contests, and the like. In both cases, photographers who are affiliated must already have established themselves in the industry and are now looking to expand or extend their client base.

Creative Placement Agencies and Reps for Designers

If you're having a difficult time getting connected and finding employment, hooking up with a creative placement agency, creative rep, or creative recruiter can be beneficial. They work to match creative talent with companies in their network. This can be true for short-term freelance work and full-time salary positions. Often, placement agencies are even aware of positions that are not being advertised publicly and can open up a number of possibilities for you. Occasionally, placement agencies organize events, such as resume workshops, "meet and greets," or interview fairs. They work with a person to secure a position and often offer advice about your portfolio, resume, interviewing style, etc. If you do find employment through a placement agency, they will work with you and the client to negotiate salary, benefits, and contract concerns. Make sure you are aware upfront how the agency or rep is being paid—typically the client pays

for the service. Check out local agencies and reps first—they are often better connected with the local creative shops and talent.

What Happens When It Works?

Self-promotion is an ongoing process or, better put, a never-ending process. Once you've got someone's attention, submitted a portfolio, or even been hired, the communication has just begun. In fact, it is even more important to continue to stay in contact and keep past and potential clients aware of your presence and your work. You need to stay on their radar. What do you do once you have established contact, perhaps even had your portfolio requested by a buyer or editor? Follow-up and continued contacts are very important.

If an art buyer, potential employer, or editor makes an initial contact with you and requests and views your portfolio, common courtesy is a good starting point. Follow up with a visual thank you or leave-behind. Then in the weeks and, more likely, months that follow, it is necessary to send mailers and updates on your work, commissions, and new ideas, to keep you in their sights. Make sure they are aware of your blog and other social media that you employ. Invite them to subscribe to any RSS feeds or sites on which to follow you. If you make significant updates to your website, information should be sent out. If you update your portfolio, request to send it out again to give the client a fresh view.

Get Listed

While the fact is that direct contact and showing your work is ultimately going to connect you to potential clients, you still can benefit from professional listings. PDN's PhotoServe is a searchable listing for photographers. While it isn't likely that a busy photo editor or art buyer will have time to search for a photographer, these listings can be useful by demonstrating you are active and working and engaged in the profession. Professional associations such as ASMP have membership listings and periodically these can result in referrals. There are still paid listings and publications such as *The Black Book*, but they represent a significant investment. Some great websites for designers to get listed include Communication Arts (*http://creativehotlist.com*) and AIGA's "jobs and community" at *www.aiga.org*. Both allow you to post examples of your work and are searchable by field and location.

as the world
kerns

abcdefghijklmnopqrstuvwxyz
ABCDEFGHIJKLMNOPQRSTUVWXYZ
0123456789(){}[],.:;"''?!<>/|
@#$%^&*-+=©®¢€

HOLLY BOBULA, STUDENT PROMOTIONAL BOOK,
Madison, WI.

triumfont

abcdefghijklmnopqrstuvwxyz
ABCDEFGHIJKLMNOPQRSTUVWXYZ
0123456789(){}[],.:;"''?!<>/|
@#$%^&*-+=©®¢Đ

Showings and Exhibitions

As mentioned previously, the great benefit of blogs and other online resources is that they allow you to have a forum for work that is outside the formal constraints of your online portfolio and hard copy portfolio. Inclusion of personal work and side projects can be extremely beneficial. While exhibitions of noncommissioned work, personal projects, or inclusion in juries may not appear to be relevant to your client's needs, they are another way to show your range and commitment to your work, as well as how active you are as a creative. Announcements of exhibitions and inclusion in juries can be directed to specific clients with whom you have had previous contact. Yet, these can be placed more broadly in the context of your blog and other social media.

Q&A: Interview with Judy Herrmann

Judy is a past president of ASMP, and contributor to the ASMP Strictly Business blog and editorial, and a corporate and advertising photographer.

As a past president of ASMP, and in your current role in developing webinars for ASMP, you have been actively involved in addressing marketing and promotion for photographers. What do you see as necessary for an effective portfolio and marketing package for photographers working today?

First and foremost, you need to carefully edit and sequence your work to present a cohesive vision that will give your prospective clients confidence that they can predict what they're likely to get if they hire you. Next, every aspect of the marketing pieces—whether online or print—needs to support that vision. Equally important is vetting your prospect list to make sure that the people you're spending time and money promoting yourself to have a real need for the kind of work you do. Keep in mind that great work is not enough—your promotional materials need to communicate the value you bring to the table above and beyond the imagery you create!

With respect to promos, what do you feel makes for a successful self-promotion piece or campaign?

Ultimately, success comes from getting the right work in front of the right people at the right time. Some would argue that means getting a lot of work in front of a lot of people a lot of times but not only does that get expensive, but presenting the wrong work to the right prospects will do more harm than good. In a market where options are plentiful and attention is scarce, it's more efficient and effective to put more energy into identifying the right people and then help them discover you through a strategic campaign that will help them understand who you are as a person as well as an artist.

I think it's important to understand that it's very rare for any one promotional effort or piece to get dramatic results. Attracting attention in a saturated market requires a concerted effort across multiple fronts that may include writing (articles, blog posts, books, etc.), pursuing personal projects, in person networking and relationship building, generating press coverage, intelligent use of social media, participation in portfolio aggregation sites and/or any other tool you can think of to draw attention to your work, express your personality, and communicate the full value of what you bring to the table.

What do you feel is needed, to have an effective "digital presence" in the marketplace? Where do blogging, photo sharing, and social media communications fit in?

To a certain extent the answer depends on who your audience is and what your goals are. In general, though, I think blogging and social media provide fantastic opportunities to communicate the value you offer above and beyond your images. They are also fantastic prospecting and relationship building tools. With social media in particular, how you respond to other people's content can matter as much (or more) than the content you yourself generate. When it comes to posting your images, though, a word of caution. Before uploading imagery to social media platforms, make sure you fully understand the rights you may be giving up and the liabilities you may be taking on. The ASMP provides guidance on the intelligent use of social media for creators at *www.asmp.org/socialmedia.*

How often should photographers be creating promotional materials, in relation to regular updates online?

Again, it really depends on your audience and goals. I do think that the fast-moving nature of social media has trained all of us—creators and clients—to expect an endless stream of fresh work, so there is greater pressure to get more new work out there more often.

A number of the clients and consultants I've been speaking with have observed that photographers are sending far fewer print pieces so the ones that do show up have a better chance of being seen. At the same time, the quality and sophistication of the print pieces that are being sent has escalated so if you decide to go that route, it's important to invest in a high quality piece with strong attention to detail that will hold its own.

The website and portfolio are the foundations which promos and social media support. What makes a website effective for a photographer?

Like all promotional materials, your website should show off your work, your personality, and the value you offer your clients. Large images, simple navigation, and a clean design that doesn't compete with your work are paramount. I often recommend that photographers spend an hour pretending they have to find the perfect photographer to hire for a specific job. It doesn't matter what the job is but you should take a moment to get a picture in your mind of exactly what you're looking for. Then, go to one of the portfolio aggregation sites and just start clicking through to different photographers' websites.
Ask yourself things like:

- Does their branding (color, typography, logo, etc.) reinforce or work against their imagery?

- Can you tell which gallery you should look at first for the job you have in mind?

- How many images do you have to see before you feel like you could predict what you'd get if you were to hire this photographer?

- How does the way they've edited and sequenced their work affect your perception of their skills and professionalism?

- How easy is it to find their contact information?

- How much can you tell about what it would be like to actually work with each photographer?

How should a printed portfolio work in relation to a website or online presence? What should be featured in this presentation?

Your print portfolio is an opportunity to showcase your creativity and attention to detail. The images themselves should be tightly edited—people might be willing to click-click-click through 50 images on a website but a 50-page book will feel much more daunting. I would view your print portfolio as the place you define the essence of who you are and what you do.

I've heard mixed opinions on overlap between the imagery shown on your website and in your print book. Some argue that overlap helps remind the viewer why they called in your book and see the detail that's often lost on smaller screens. Others want to see new fresh work and will view overlap as a sign that you don't have enough to show. Personally, I think a little overlap (10 percent or even 20 percent) is ok but I would not recommend a print book that mirrors your website.

Q&A: Interview with Bryn Mooth, former Editor, *HOW* Magazine

Bryn isn't a graphic designer, and only occasionally pretends to be one. Nonetheless, she's keen on classical typography, and she's a sucker for letterpress printing. Bryn's involvement with *HOW* magazine spans nearly 20 years, both as a staff editor and contributing writer. During that time, she has written about design and the business of design, organized and judged countless design competitions, and spoken at various professional events, including *HOW's* Design Conference, In-HOWse and Mind Your Own Business Conference, and AIGA chapter events.

As someone who has reviewed so many outstanding portfolios and self-promotional pieces, what distinguishes the very best?

Originality and personality are so important for self-promo pieces and portfolios. As a potential client or employer, I'd want to get a sense not only of the designer's talents, but also of what it would be like to work with her. And it's key to be able to show your thinking. For portfolios, that means including sketches that led to a finished project. For self-promo pieces, that means including case studies of how your work met a client's objective. And of course, the overall design of the piece or portfolio should reflect the designer's personality, originality, and thinking.

How important do you feel a portfolio book and/or online portfolio is in securing a job in the creative industries?

Both are crucial. Prospective employers or clients need to see samples of your work online before they even consider bringing you in for a meeting. And then a portfolio that showcases your work during that meeting is essential.

In the last few years, have you noticed any trends or differences in the types of pieces submitted to HOW's Promotion Design competition?

We're seeing more and more work that has a handmade element: perhaps a promo piece that's hand-bound, or customized for the recipient. Digital printing is, for the most part, so good that designers can print small-run pieces in their own studios. Handmade touches convey personality and uniqueness.

Do you have any advice for a student or young professional currently working on their portfolio and/or promotional materials?

What you say about your portfolio is just as important as what you put in it. Be prepared to walk a client or employer through one or two projects from start to finish, detailing your thinking, your problem-solving, your creative process, and your collaborative skills. A portfolio is only a jumping-off point for conversation.

MARK BURRIER, PROMOTIONAL BOOK, McLean, VA.

The book has a 2-color silkscreen cover and xeroxed insides. I used a printer for the cover and assembled it all myself. When doing small print runs, there's such a cost savings doing it that way.

— Mark Burrier

ANY TOOL YOU USE IS LEGITIMATE. THE KEY TO THE TOOL IS WHETHER IT HAS THE DIMENSIONS TO DEAL WITH WHAT HAVE BECOME YOUR QUESTIONS.

I consider art as a thought form

more than anything else.[1]

ROBERT IRWIN

Artist, ("The State of the Real, Part 1," conversation with Jan Butterfield, Arts 46, no. 10 (June 1972), p. 49)

PROFESSIONAL MATERIALS

Your resume (or CV—curriculum vitae) is a crucial part of your ability to market yourself. It should be approached with as much energy and effort as you would any other aspect of your comprehensive portfolio. A resume presents you with a fundamental and critical information design problem, and will require your best typographic and layout skills. It will be judged as a prime example of your design sensibilities and needs to communicate your educational and work experiences as clearly and concisely as possible. It should also, in a limited fashion, relate back to the look and feel established by your portfolio design. Keep in mind, however, that your resume is a unique visual problem. Don't force it to look exactly like your portfolio book or website, but instead reference your brand identity through color and typographic choices. You will need both a print and digital version of your resume.

Unless you have many years of experience in the industry, best practice is to keep your resume to one page (this is especially true for students and recent graduates). The following is a list, in order, of the standard categories of information that should be included in a resume. Some of the categories listed are optional.

- **Name and contact information**
 - Your name should be noticeable on the page and grouped with your contact information. List the best way to contact you first.
- **Objective** (other terms: mission statement, personal statement). *This is optional*. Some resumes include a brief statement or bullet points addressing the following:
 - The type of position one is seeking.
 - One's strategic skills and/or how one could benefit a potential employer.
 - A personal statement relevant to the industry or one's career.
 - Overall (and typically more generic) career goals or objectives.

It's not necessary to include an objectives category on your resume, and in fact, if it is too generalized, it may not serve you well. Think about whether this type of content could be included in a cover letter and relate more directly to the specific company and job you are applying for.

Nobody is hired because they have kick-ass solutions alone.

PEOPLE WANT TO WORK WITH PEOPLE THEY LIKE.

You are the most important factor.

SEAN ADAMS
Partner, ADAMSMORIOKA

- **Education.** Include:
 - Name of degree received and date of graduation.
 - Educational institution and its location.
 - You can additionally include any honors that you may have graduated with. For those of you who have not yet graduated, include your expected date of graduation. Note that it is the "expected date." If you have more than one degree, it is standard practice to list them in reverse chronological order.
- **Experience.** List your experience in reverse chronological order (start with the most recent). Include:
 - Company or client name
 - Job location (sometimes listed), with city and state
 - Position
 - Brief description of duties
 - Dates of employment

It's common practice to limit the jobs listed on your resume to those applicable to the industry and position that you are applying for. However, an exception could be made for a student with little to no industry experience who has worked a part-time or summer job over a number of years. In which case try to include work experiences that demonstrate leadership skills and a positive work ethic. Additionally, it's completely acceptable for students and recent graduates to include internship and nonprofit work experiences, especially those related to the industry.

- **Awards** (other terms: accolades, acknowledgments). *This is optional.* If you have been recognized by the industry make sure to mention it. This includes:
 - Group or solo shows
 - Features about you or your work in a print or online publication

- **Software skills and capabilities.** *This is optional.* It's typically a good idea, especially for students and recent graduates, to list software and technical capabilities—print, web development, etc. Most entry-level positions require a significant amount of production work. Most employers will want to know that recent graduates can work with the software and processes the company uses right from the get go.

- **Organizations.** *This is optional.* Most potential employers or clients will like to see that you are involved in art, design, or photographic industry organizations. It shows you are engaged, informed, and passionate about your industry. However, don't just list clubs, sports teams, or other organizations that are not relevant to your profession.

- **References.** It's not necessary to list references on your resume, but it may be a good idea (again, especially for recent graduates). Include name, title, company, and contact information (email and phone number) for each person (usually three minimum). If you don't include references on your resume, you should at least include the line: *References available upon request.* Make sure your references know they are your references before they get a call from someone! Ask them ahead of time and give them a heads up if you have recently applied for a position. Additionally, they should be someone who can speak to your character and abilities related to the position you are applying for.

The type treatment for your resume should be clean, clear, and functional—without decorative flair or embellishment. Be careful that you don't overdesign the page. Don't get hung up on logos, decorative typefaces, or decorative shapes and symbols. It's best to avoid a mix and match of too many different typefaces. One practical strategy is to utilize a typographic family with a variety of weights and proportions. This will allow you to maintain visual consistency while still offering variability. Another common practice is to use a sans-serif typeface for titles and a serif typeface for the rest of the copy (serif typefaces are usually easier to read for text blocks). If applicable, use the same or similar typographic system as you used in your interior book design.

A well-designed resume utilizes a *strong typographic hierarchy*. To do so, you will need to create multiple groupings and levels of information.

Not only does a resume include different categories of information (such as education, experience, awards, etc.), but there are also different types of information that belong in each category. The experience category alone includes several subcategories—company name and location, employment dates, job title, and job description—all belonging together, but each also representing a discrete kind of information. Some of this information belongs together on the same line, some on a different line, and some should be more visually prioritized over others. In addition, usually name and contact information stand apart from the other categories of information, either because an aspect of the grouping is more visually prominent (e.g., the name is larger than the rest of the text) and/or because of its placement on the page.

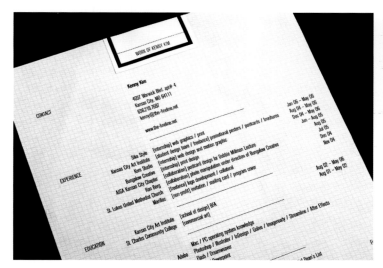

KENNY KIM, STUDENT PROFESSIONAL MATERIALS, Kansas City Art Institute.

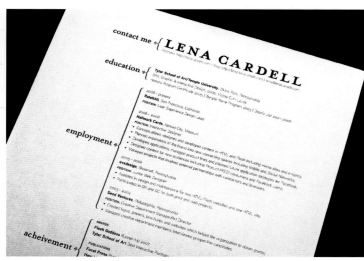

LENA CARDELL, STUDENT PROFESSIONAL MATERIALS, Tyler School of Art.

You can emphasize and prioritize text through multiple techniques:

1. The amount of white or negative space surrounding the type—elements that are isolated on a page typically call more attention to themselves.

2. The simple order in which you compose the information—that is, the reading direction.

3. The use of typographic styles—there are a number of commonly used typographic styles that can be used to emphasize text (bold, italic, accent color, all caps, underline, and size). If you previously developed a color palette as part of your brand identity, the accent color can and should be used effectively to prioritize main categories of information.

4. Visual differentiation—a different typeface or shift in line orientation.

Use these techniques sparingly and strategically to structure information in the document—don't overdo it. Keep in mind that a simple typographic system usually proves to be the most effective. One or two typographic styles and/or compositional techniques should be applied as needed, and consistently in order to prioritize, group, and categorize information.

It's also possible to add variety to the organization and layout of your resume by utilizing vertical type for information like titles, subtitles, or dates. Since this makes the text a bit more difficult to read, use this technique sparingly and limit it to short lines of type. In addition, make sure the reading direction of vertical type starts in the lower left corner and faces up and out.

Keep the type size legible, but not too big (or too small); 9–12 point is usually a pretty safe bet. Make sure that you make adjustments to kerning, leading, and the typographic rag.

Bars, Rules, and Simple Graphical Elements

Bars, rules, or even simple graphical elements like brackets can be used to further emphasize the grouping and separating of information. Basic shapes, such as lines, circles, arrows, or rectangles, can be used at the starting point of a category or line of text in order to call attention to it. These elements can also be used as simple bullet points; however, make sure they are small enough so that they do not become distracting. Flow lines (lines that adhere to the grid itself, indicating its underlying structure) can also be quite helpful in activating or emphasizing subdivisions of space and separating content.

The standard orientation for a resume is vertical, although horizontal layouts are becoming more popular (especially among designers). In general, it's recommended that you keep your paper to the standard size—8½ × 11 inches in the United States and 210 × 297 mm in Europe.

Paper Stock

Material and paper selections are important parts of the print design and photographic process. Make sure you consider their importance when it comes to your resume. Your paper selection will communicate your attention to detail and concern for the total design. Don't just use a standard inkjet paper from an office supply store. Instead, check out a number of paper mills and compare paper selection, quality, and price. Almost all paper companies have samples that they are happy to share. You should avoid "fancy" papers with special linen or parchment finishes and tinted colors. Most will appear unsophisticated and look like they came from a craft store. If you're unsure of a direction, you can always play it safe with a paper that has a whitish or light cream hue, a plain smooth finish, and a slightly heavier weight.

Go to: *www.noplasticsleeves.com* for a listing of resources.

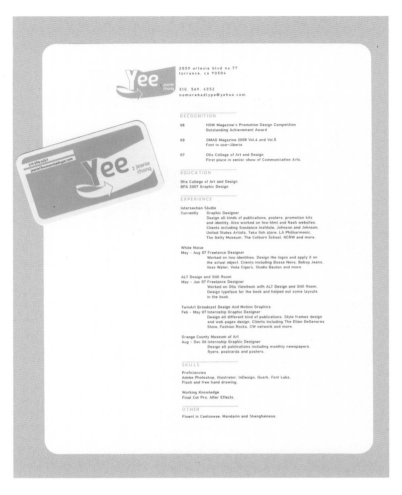

JEANIE CHONG, STUDENT PROFESSIONAL MATERIALS,
Otis College of Art and Design.

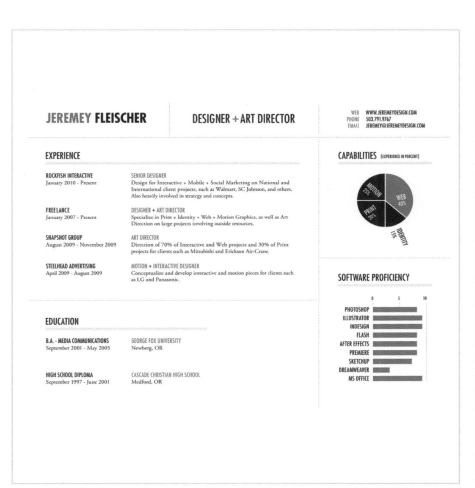

JEREMEY FLEISCHER | DESIGNER + ART DIRECTOR

WEB WWW.JEREMEYDESIGN.COM
PHONE 503.791.9767
EMAIL JEREMEY@JEREMEYDESIGN.COM

EXPERIENCE

ROCKFISH INTERACTIVE
January 2010 - Present

SENIOR DESIGNER
Design for Interactive + Mobile + Social Marketing on National and International client projects, such as Walmart, SC Johnson, and others. Also heavily involved in strategy and concepts.

FREELANCE
January 2007 - Present

DESIGNER + ART DIRECTOR
Specialize in Print + Identity + Web + Motion Graphics, as well as Art Direction on large projects involving outside resources.

SNAPSHOT GROUP
August 2009 - November 2009

ART DIRECTOR
Direction of 70% of Interactive and Web projects and 30% of Print projects for clients such as Mitsubishi and Erickson Air-Crane.

STEELHEAD ADVERTISING
April 2009 - August 2009

MOTION + INTERACTIVE DESIGNER
Conceptualize and develop interactive and motion pieces for clients such as LG and Panasonic.

EDUCATION

B.A. - MEDIA COMMUNICATIONS
September 2001 - May 2005

GEORGE FOX UNIVERSITY
Newberg, OR

HIGH SCHOOL DIPLOMA
September 1997 - June 2001

CASCADE CHRISTIAN HIGH SCHOOL
Medford, OR

CAPABILITIES (EXPERIENCE IN PERCENT)

MOTION 25%
WEB 40%
PRINT 20%
IDENTITY 15%

SOFTWARE PROFICIENCY

	0	5	10
PHOTOSHOP			
ILLUSTRATOR			
INDESIGN			
FLASH			
AFTER EFFECTS			
PREMIERE			
SKETCHUP			
DREAMWEAVER			
MS OFFICE			

JEREMY FLEISCHER, PROFESSIONAL RESUME,
Colorado Springs, CO.

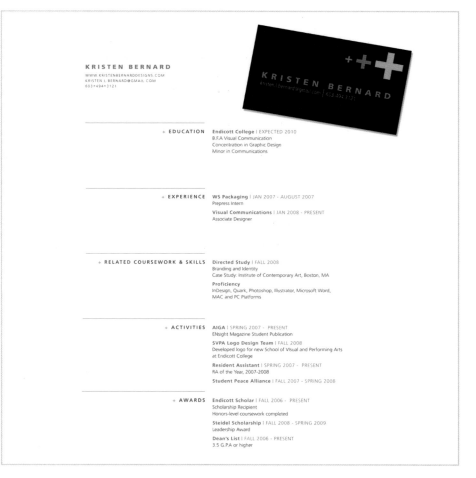

KRISTEN BERNARD
WWW.KRISTENBERNARDDESIGNS.COM
KRISTEN.L.BERNARD@GMAIL.COM
603+494+3121

+ EDUCATION
Endicott College | EXPECTED 2010
B.F.A Visual Communication
Concentration in Graphic Design
Minor in Communications

+ EXPERIENCE
WS Packaging | JAN 2007 - AUGUST 2007
Prepress Intern

Visual Communications | JAN 2008 - PRESENT
Associate Designer

+ RELATED COURSEWORK & SKILLS
Directed Study | FALL 2008
Branding and Identity
Case Study: Institute of Contemporary Art, Boston, MA
Proficiency
InDesign, Quark, Photoshop, Illustrator, Microsoft Word, MAC and PC Platforms

+ ACTIVITIES
AIGA | SPRING 2007 - PRESENT
ENsight Magazine Student Publication
SVPA Logo Design Team | FALL 2008
Developed logo for new School of Visual and Performing Arts at Endicott College
Resident Assistant | SPRING 2007 - PRESENT
RA of the Year, 2007-2008
Student Peace Alliance | FALL 2007 - SPRING 2008

+ AWARDS
Endicott Scholar | FALL 2006 - PRESENT
Scholarship Recipient
Honors-level coursework completed
Steidel Scholarship | FALL 2008 - SPRING 2009
Leadership Award
Dean's List | FALL 2006 - PRESENT
3.5 G.P.A or higher

KRISTIN BERNARD, STUDENT PROFESSIONAL
MATERIALS, Endicott College.

LAYOUT

When designing your resume you should construct a clean, clear, well-organized layout. Utilize a simple grid system to help you do the following:

- Divide the page into equal or proportional columns (and rows if need be). Equal or proportionate units of positive and negative space create a visual rhythm throughout a composition. This pattern can help establish visual balance, harmony, and unity among groups of content and the negative space between and around them.

- Include a healthy margin of white space along the outside of the page.

- Organize and group information by utilizing:
 - *Alignment*—especially along the vertical axes of the grid. Zoom in to make sure that lines of type really are aligned to the same axis. You can utilize both left and right alignment. For multiple lines of text, be sure to pay attention to the typographic rag.
 - *Proximity*—the closer things are to each other the more they are perceived to connect and relate. When separating individual lines of text and groups of content, be sure to use an equal or proportionate increment of space to measure.

It goes without saying that the cover letter should be coordinated with your resume and even the leave-behinds. The paper, typeface, and design aesthetic should all tie together.

A cover letter should be direct and to the point, providing some context or rationale for your contact with the intended audience (e.g., your experience and interest in the available position). State:

- The reason for your writing.
- Who you are and where you are coming from—student, graduate, current employment.
- Your interest in the position/opportunity.
- Your qualifications (briefly) for this particular position.
- What you have attached/enclosed as support materials.
- Your desire to set up an interview/meeting.
- In some cases, how you will follow up (e.g., a phone call, more materials) and whatever might be relevant to the particular process.

Do not:

- Reprise every aspect of your resume.
- Provide a lengthy rationale of why you are the perfect person for the position. This will happen when they interview you.
- Make it any longer than one page—two to three paragraphs should suffice to get your point across.
- Forget to have someone else read it before you send it out.

Think about coordinating the visual look of:

- Business cards
- Envelope
- Thank-you notes

Love this.

Once, we salty and cynical ad people wanted nothing more than to do this for a living. You remind us of ourselves. If we see you love making this stuff, being creative, and never quitting on the pursuit of good ideas, we're more likely to go to the mat for you.

CHRIS WOOSTER
Group Creative Director, T3

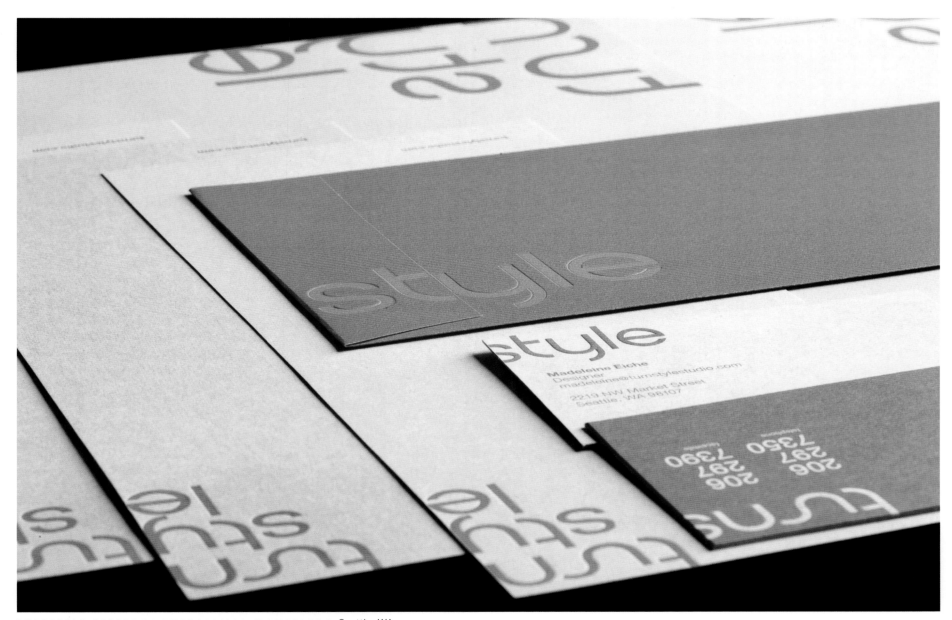

TURNSTYLE STUDIO, PROFESSIONAL MATERIALS, Seattle, WA.

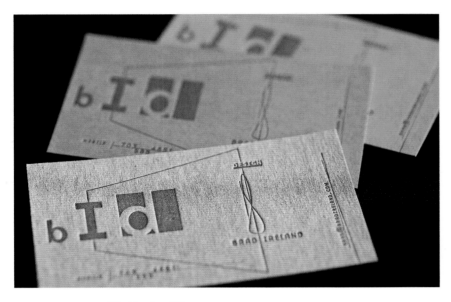

BRAD IRELAND, Washington, DC.

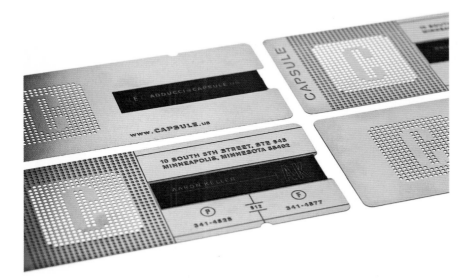

CAPSULE, Minneapolis, MN.

Some tips for business cards:

- Use the standard U.S. business card size (fits in holder) of 3½ × 2 inches.

- Design it in the same brand style as the rest of your comprehensive portfolio package.

- Make it easy to read—consider type size and contrast. Provide a margin around information.

- Make your name the top level of information on your card.

- Additionally, include email, phone number, and the URL to your portfolio website. Make sure your email address is a professional one with an extension that matches your website's URL.

- Keep the design simple (much like your resume). Use typeface and color effectively so the design is clean, clear, and stands out!

- Think about the ink, finish, card stock, and/or material of the card.

- For fast, inexpensive business cards, check out online companies like Moo Cards or *www.psprint.com*.

- A business card must be functional first and foremost—keep that in mind if you are pushing the envelope in terms of form, size, or materials.

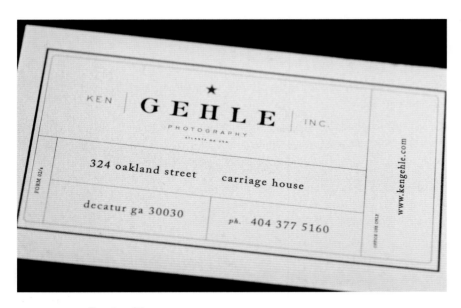

KEN GEHLE, Decatur, GA.

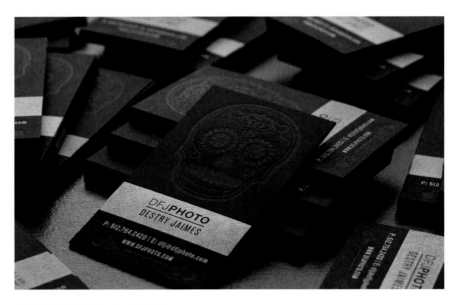

DESTRY JAIMES, Austin, TX.

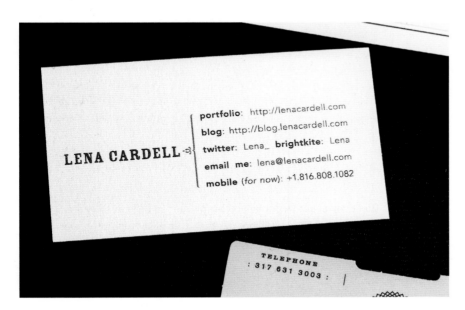

LENA CARDELL, Tyler School of Art.

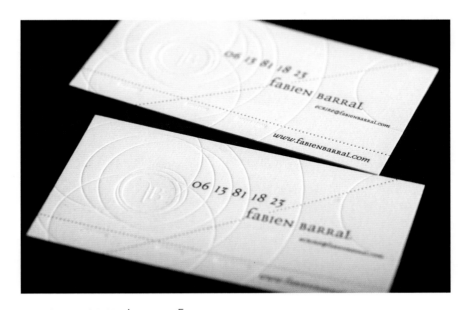

FABIEN BARRAL, Auvergne, France.

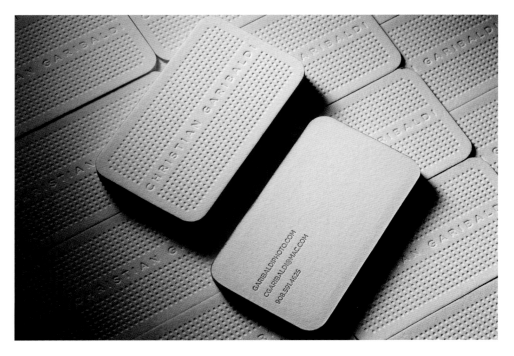

CHRISTIAN GARIBALDI, Bayonne, NJ.

Interviewing

A portfolio is a requirement even to be considered for a position. After that, it's really all about the interview.

<div align="right">

— Jeremie Dunning, Digital Creative Director at
Finish Line, Boulder, CO

</div>

Hopefully, after you've done all this work on your portfolio, you'll land that big interview. Sitting down with someone in person is a golden opportunity to engage someone in a discussion about who you are and what you can do, to essentially prove you are the right fit for the job both professionally and personally. The importance of making a great impression during your interview cannot be underestimated.

Consider that someone has already seen your work and liked it well enough to want to know more. So, bring your book to the interview, but be prepared to discuss more than just the work you've previously done. An interview is just as much about who you are and what you have to offer in the future as it is about what you've done in the past. During the interview, you'll be evaluated on what someone thinks it would be like to work with you—your personality, your enthusiasm for the industry, your passion for your work, your interest in the company you're interviewing with, your knowledge about industry practice, your work ethic and attitude, and much more.

If you are a student, don't be afraid to present yourself as just that. An entry-level position or internship is a learning opportunity; you aren't supposed to know everything. Be confident and show them the energy, drive, and problem-solving skills you have, but don't try to show them something that you aren't. You are better off showing how hard you are willing to work and how capable you are of learning and developing as a creative.

Don't talk about work that you don't have available to show the interviewers. The last thing you want to do is get your interviewers interested in something that they can't see.

Do bring additional work to show. However, don't necessarily show it, as you can overwhelm the interview with too much work. Be prepared to show it if the interviewers ask about something in particular, want to see more work, or if you have a specific point you want to make and need an example.

Be prepared to talk about a work experience or project that you have worked on. Sometimes the best example is a job that didn't work out. What did you take away from that experience? What did you learn? This demonstrates self-awareness and humility.

Some interviewing tips are:

- Take some time to find out about the company or client you are interviewing with. Their website is a good place to start. You need to be able to answer the question "Well, tell me, why do you want to work here?" with specific knowledge about what makes this company or client unique and appealing to you. Find out what they are proud about and get excited about it too. Ask a couple of informed, intelligent questions about the position or company.

- Consider every interview as an opportunity to practice your interviewing skills. Don't be arrogant or pushy during the interview, but try not to lack confidence either. Remember that looking someone in the eyes and smiling can actually go a long way.

- Be prepared to discuss your work—the objective, your process, your solution. Be brief.

- If possible tailor your portfolio to the company or client you're interviewing with. Know what they are looking for and provide it.

- Take a moment to think before you respond to a question. If you don't understand the question, ask for clarification.

- Be polite and professional.

- Dress appropriately. Depending on the place, that may not mean wearing a suit. However, when in doubt, err on the side of dressing more formally than casually.

- It goes without saying: Be on time!

- Bring a few printed copies of your resume.

- Refrain from asking about salary or compensation on the first interview. That's something best reserved for a second interview. When you get to that point, know how much you're worth.

Photography: Contracts and Pricing

Photographers work as independent contractors 95 percent of the time, and as such your contact with potential clients will ultimately result in a bid or proposal for a specific job. The nature of pricing, bidding, and contracts is such that we could devote a whole book to this subject.

Image use and licensing constitute a big part of the bidding and fee structure for a photographer. The compensation for photographing and licensing of images has changed dramatically in the web era. This is in part due to the proliferation of inexpensive stock photography, royalty-free compilations, and expanded uses for images. Businesses in turn are aware that the more uses they can get out of an image without incurring additional fees, the better. You should familiarize yourself with the fees for the particular market you are working in. If you are new to the industry, there are numerous resources for establishing rates and license terms. You can also talk with other professionals to get advice on bidding and fees.

When you talk to a potential client, you do not have to provide an estimate on the spot, and this is generally not the best practice. It is better to do your research than speak prematurely. Further, there is a judgment to be made on how you bid your job. If you are new and trying to break into the industry you might feel you need to underbid to get the work and build some client relationships and even portfolio material. This is generally not the best practice. Underselling yourself is a fast way to getting paid less further down the road. Your best gauge is the client. You may be making a photograph in the same manner, with the same use as an editorial publication. Your client may be a small business or nonprofit, with a smaller audience and ultimately much less budget. This may impact the scale of your license and fee, and again you have to make judgments about how to go about this.

Note: All work should be licensed.

With the exception of family portraits and other kinds of work for private individuals, all of your photographs made on commission should have licensing terms. Even pro bono work should reinforce the understanding to the client that you own the photographs and that the work has terms for its uses. You should define those terms in your contract and invoices.

Pro Bono Work

Should you work for free? You may find that you are approached by a nonprofit agency or a small business that can't afford to pay for the services of a designer or photographer. This is an opportunity to build your portfolio and extend yourself into the world with your work. While your goal is paying jobs, or a salaried position, occasionally doing a job for free can be very beneficial to you as well as the client.

There are many professionals who do pro bono work as a regular part of their professional practice because they believe in offering services to support certain non-profits. They often find that it has been work that they enjoyed and benefited from as well.

Pro bono work can offer you more creative freedom than you might have in a typical project, and for this reason alone it is worth taking on, particularly if you are starting out in the industry. It may lead to a paying job since the work you produce extends your visibility. It can be a portfolio builder and can help you gain some experience. There are no guarantees, but these are worth pursuing. The clients generally cover material costs.

Pricing, Licensing, and Salary Resources

Go to *www.noplasticsleeves.com* for a listing of resources.

Q&A: Interview with Chris Wooster, Group Creative Director, T3, Austin, TX

Do you have any advice for students or recent grads?

Junior people rarely have many questions in interviews, which is a mistake. I know you're anxious and a bit nervous, but consider as one of your questions: "Is there anything you recommend I take out of my portfolio?" Be prepared for some jerk to say "everything," but you'll mostly get some constructive advice from a real creative director, which early in your career is a rare opportunity.

Have a one-sentence pitch for every piece of work, summarizing the target audience, the ad's creative direction (what problem are you trying to solve with this ad), and why you thought it belongs in your book. If you don't have any of this, make it up. But have it. Without it, you've obviously just created something because you thought it was cool, and that's not how the industry works. We make cool stuff, but with a purpose and a mission behind it. Tell me that. If you don't, I'll probably just reconstruct the brief in my head backward from the work, and I may come to the conclusion you didn't solve the brief. You don't want that.

Credit your co-creators. This is a small industry, and word gets around if you're claiming full credit for work a group did. I always applaud people who clearly list their role in the creation of work. You don't need to name names; you can simply list your roles this like: Roles: concept, support copywriting; or Roles: execution, production support (if you weren't in on the concept).

Consider having different flavors of your portfolio. Especially for art directors, sometimes you're going for more "design-intensive" jobs,

sometimes more "traditional/tactical" jobs, and sometimes more "conceptual" jobs. Having different collections of work ready helps you better answer the needs, and avoid showing irrelevant work. This is one way to help "cull" the number of pieces, especially with online portfolios.

Perfect your thank-you email/card. Thank me for a piece of relevant advice. Mention how you'll be thinking about something I said that resonated with you. Don't tell me how perfect a fit you think you'd be—you're biased and I already have my own opinion. But do take the time to make it personal without getting chummy.

Be human. If you're not ferociously curious about the world (and not just advertising), you're not a very interesting human being. Don't interview like a robot. Have questions, observations, opinions. Read things, stay up on current events and culture. More than anything, don't be dull. I promise to give you a chance to make an impression. Make the most of it by being interesting or engaging. Unless you're just batshit crazy, in which case you need to back it down a bit. Heh.

Love this. Once, we salty and cynical ad people wanted nothing more than to do this for a living. You remind us of ourselves. If we see you love making this stuff, being creative, and never quitting on the pursuit of good ideas, we're more likely to go to the mat for you. If you don't really, really love the process of making ads, or improving your book, you're probably chasing the wrong line of work. Even all these years later, I'm still that 13-year-old kid who loved TV ads and wanted to make them for a living. You're next; show me you've got the same nerdy love for this.

Q&A: Interview with Sean Adams, Partner, AdamsMorioka, Beverly Hills, CA

Sean Adams has been recognized by every major competition and publication, including *Step*, *Communication Arts*, Graphis AIGA, Type Directors Club, British Art Director's Club, and New York Art Director's Club. A solo exhibition on AdamsMorioka (Beverly Hills, CA) was held at the San Francisco Museum of Modern Art. Adams has been cited as one of the 40 most important people shaping design internationally in the ID40. Sean is the national president of AIGA, past AIGA national board member, and past president of AIGA Los Angeles. He is a Fellow of the Aspen Design Conference, and AIGA Fellow. He teaches at Art Center College of Design.

How important do you feel an online and print portfolio is in securing a creative position in your industry?

The portfolio is the point of entry. It is like wheels on a car; I expect them to work and be great quality, but I don't buy a car because of them. The baseline of a portfolio must present excellence in craft and concept. After that is proven, 80 percent of the decision to hire a designer is based on personality and presentation.

Do you have any advice for a student currently working on his or her portfolio and/or other promotional materials?

The portfolio is only a prop. It must be flawless, well made, and cared for. Time is short and precious. The interviewer does not care about every typeface choice, or how your first dog inspired a project.

Give one simple explanation for each piece—what the assignment was, and what the best part of the solution is. Keep the explanations to a couple of sentences. If the interviewer wants more information, they'll ask. Nobody needs to go through every piece in detail. I can look at the work in a couple of minutes and understand if someone knows typography, or doesn't.

Most importantly, there are thousands of designers out there with beautiful, well-made work and wonderful portfolios. Nobody is hired because they have kick-ass solutions alone. People want to work with people they like. You are the most important factor. Learn about the company you're visiting. Compliment a recent piece or mention an article on the firm. Flattery always works. I once interviewed a young designer with incredible work, who started the interview with, "You know, your work's not that bad. I thought you were just ripping off the old guys." Not good.

Job Listings and Professional Resources

Go to *www.noplasticsleeves.com* for a listing of resources.

ENDNOTES

Step 2: Branding

1. Alina Wheeler. *Designing Brand Identity: A Complete Guide to Creating, Building, and Maintaining Strong Brands*, p. 1. New York: Wiley, 2006.

2. Scott Bedbury. *A New Brand World: Eight Principles for Achieving Brand Leadership in the Twenty-First Century*, p. 15. New York: Penguin Books, 2003.

3. David Ogilvy. *Ogilvy on Advertising*, 1st Vintage Books edition, p. 14. New York: Vintage, 1985.

4. Doug Menuez. "On Chaos, Fear, Survival and Luck: Longevity is the Answer," *Editorial Photographers,* retrieved on October, 10, 2008; August 1, 2009, from *http://editorialphoto.com/articles/doug_menuez/*.

5. Alina Wheeler. *Designing Brand Identity: A Complete Guide to Creating, Building, and Maintaining Strong Brands*, p. 6. New York: Wiley, 2006.

Step 3A: Cover Design

1. Steven Heller and Seymour Chwast. *Graphic Style: From Victorian to Digital.* New York: Harry N. Abrams, 2001, p. 9.

2. Fernando Lins. "Typography Tips and Advice for Graphic Design Students," *David Airey.com*, retrieved on August 1, 2009, from *http://davidairey.com/typography-tips-and-advice-for-graphic-design-students/*.

Step 4: Interior Page Design and Layout

1. Steven Snell. "Clear and Effective Communication in Web Design," *Smashing Magazine*, retrieved on August 1, 2009, from *http://smashingmagazine.com/2009/02/03/clear-and-effective-communication-in-web-design/*.

2. Ellen Lupton. *Thinking with Type: A Critical Guide for Designers, Writers, Editors, and Students*, p. 67. Princeton, NJ: Princeton Architectural Press, 2004.

3. Keith Smith. *The Structure of the Visual Book*, p. 45, 1st ed. Rochester, NY: Keith Smith Books, 1984.

4. Ibid., p. 16.

5. Ibid., p. 16.

Step 5: Book Construction

1. Keith Smith. *The Structure of the Visual Book*, p. 10, 1st ed. Rochester, NY: Keith Smith Books, 1984.

Step 6: Digital and Online Portfolios

1. Holly Richmond. "The Growth of Mobile Marketing and Tagging," *Microsoft Tag*, retrieved on August 14, 2013, from *http://tag.microsoft.com/community/blog/t/the_growth_of_mobile_marketing_and_tagging.aspx*.

Step 7: Promotional Materials

1. Josh Kohanek."Watching it all Come Together," Josh Kohanek Blog, retrieved on August 15, 2013, *http://joshkohanek.com/blog/2013/3/4/watching-it-all-come-together*

2. James Worrell. "That Email Promo Newsletter Thing we all Do," *James Worrell Less is More*, retrieved on July 25, 2013, *http://lessismoreworrell.net/2013/06/that-email-promo-newsletter-thing-we.html*

Step 8: Professional Materials

1. Robert Irwin (conversation with Jan Butterfield). "The State of the Real, Part 1," *Arts* 46(10) (June 1972): p. 49.

INTERVIEWS

Interviews

Mary Virginia Swanson, Marketing Consultant and Educator, Tucson, AZ, *http://mvswanson.com*, "On Making and Marketing Art"

Richard Grefé, Executive Director, AIGA, New York, NY

Joe Quackenbush, Associate Professor of Design at Massachusetts College of Art and Design, Boston, MA, *http://josephquackenbush.com*

Kristen Bernard, Graphic Design Student, Endicott College, Beverly, MA

Will Bryant, Recent B.F.A. Graduate, Mississippi State University, *http://will-bryant.com*

Christine Pillsbury, VP, Group Director, Creative & UX, BEAM Interactive and Relationship Marketing, Boston, MA, *http://sweettonic.com*

Shauna Haider, Designer & Blogger, Portland, OR, *http://nubbytwiglet.com*

Luke Copping, Photographer, Buffalo, NY, *http://lukecopping.com*

Gail Swanlund, Co-director and Faculty, CalArts, Graphic Design Program, Valencia, CA

Jamie Burwell Mixon, Professor, Mississippi State University, *http://cargocollective.com/jburwellmixon*

Reena Newman, Photographer, Toronto, Canada, *http://reenanewman.com*

Hyun Sun Alex Cho, Creative Director, Ogilvy and Mather, New York, NY, *http://alexcho.carbonmade.com*

Judy Herrmann, Photographer, Herrmann+Starke, *http://hsstudio.com*, herrmann@asmp.org

Bryn Mooth, Editor, *HOW* Magazine, *http://brynmooth.com*

Sean Adams, Partner, AdamsMorioka, Beverly Hills, CA, and National President, AIGA, *www.adamsmorioka.com*

CONTRIBUTORS

Chapter Openers

Sketches provided by the following:

Step 1: Ashley Macleod, Student, Endicott College

Step 2: Danielle Currier, Beverly, MA

Step 3A: Kristina Mansour, Graduate, Endicott College

Step 3B: Jessica Hartigan, Student, Endicott College

Step 4: Ashley Macleod, Student, Endicott College

Step 5: Jessica Hartigan, Student, Endicott College

Step 6: Jessica Hartigan, Student, Endicott College

Step 7: Jessica Hartigan, Student, Endicott College

Step 8: Ashley Macleod, Student, Endicott College

Step 2: Branding

Matthew Barnes, Promotional Materials, Toronto, Ontario, *http://thatsthespot.com*

Will Bryant, Student Portfolio, Mississippi State University, *http://will-bryant.com*

Luke Copping, Portfolio & Promotional Materials, Buffalo, NY, *http://lukecopping.com*

Betty Hatchett, Identity & Website, Cincinnati, Ohio, *http://bettyhatchettdesign.com*

Adam Jones, Portfolio & Identity, West Chester, PA, *www.adamjjones.com*

Rachel Karaca, Student Portfolio, Kansas City, MO, *rachelkaraca@yahoo.com*

Solvita Marriott, Student Portfolio, Tyler School of Art, *www.be.net/solvita*

Reena Newman, Portfolio Book, Toronto, Canada, *www.reenanewman.com*

Dom Romney, Wonderful Machine, Portfolio Book & Identity, Newport, UK, *http://domromney.com*

Noah Webb, Promotional Book, CA, *http://noahwebb.com*

Step 3A: Cover Design

Kristen Bernard, Student Portfolio, Endicott College Graduate

Will Bryant, Student Portfolio, Austin, TX

Filippo Cardella, Portfolio Book, Pisa, Italy, *http://filippo cardella.com*

Ken Gehle, Promotional Book, Decatur, GA, *http://kengehle.com*

George Graves, Student Promotional, Endicott College, *www.gdgraves.com*

Jessica Hische, Student Portfolio, Tyler School of Art, *http://jessicahische.is*

Stephanie Kates, Logo, Endicott College

Denis Kockedykov, Portfolio Book, Moscow, Russian Federation, *http://behance.net/egideydenis*

Christopher J. Lee, Student Portfolio, Pratt Institute, Brooklyn, NY, *http://christopherjhlee.com*

Aisling Mullen, Student Portfolio, Endicott College

Dana Neibert, Portfolio Book, Coronado, CA, *http://dananeibert.com*

Joel Silva, Student Portfolio Booklet, Faculty of Fine Arts at the University of Lisbon, Portugal, *http://behance.net/joelfilip*

Roger Snider, Portfolio Book, Los Angeles, CA, *http://roger snider.com*

Kylie Stanley, Student Promotional Book, Ohio State University, *http://kyliemstanley.com*

Theoretical Universe, Logo, Boston, *http://theoreticaluniverse.com*

Larry Volk, from A Story of Roses, Beverly, MA, *http://larryvolk.com*

Noah Webb, sewn folio, Los Angeles, CA

Step 3B: Materials and Forms

Karyne Bond, die cut aluminum portfolio, Montreal, Canada, *http://karynebond.com*

Hilary Bovay, accordion fold book, Student Project, Cleveland, OH, *http://hilarybovay.com*

Kevin Connolly, Student Portfolio, Endicott College, *http://kevinjamesconnolly.com*

Chris Crisman, post and screw portfolio, Philadelphia, PA, *http://crismanphoto.com*

Rosie Fulton, back-to-back binding, Student Project, Endicott College

Nicole Gobiel, coptic stitched binding, Watertown, MA, *nicolegobiel@gmail.com*

Amy Grigg, coptic stitched binding with laminated photographs, Student Project, Endicott College, *amyjgrigg@gmail.com*

Andrew Johnson, Student Portfolio, Endicott College, *http://aetherpoint.com*

David Le, panoramic image, accordion fold book, Student Project, Endicott College, *le.davidk@gmail.com*

Alaine Montes, Student Portfolio, Endicott College, *http://est1one.carbonmade.com*

Alison Murphy, Student Portfolio, Massachusetts College of Art and Design, *alimurphy@comcast.net*

Dana Neibert, promotional with embossed flap, Coronado, CA, *http://dananeibert.com*

Amanda Nelson, stab bindings, clasp and bone closures, stitching sampler, Charlottesville, VA, *http://amandanelsen.com*

Ben Noel, Student Portfolio, Endicott College, *http://stuartbnoel.wix.com/goesbyben*

Ann Pelikan, Artist's Book, Ipswich, MA, *annepelikan@mac.com*

Benjamin Rasmussen, post and screw promotional book, Denver, CO, *http://benjaminrasmussenphoto.com*

Allison V. Smith, zine #2, Photography Portfolio/Promotional Materials, New York, NY, *http://allisonvsmith.com*

Terry Vine, softcover promotional books with slipcase, Houston, TX, *http://terryvine.com*

Xavier Wallach, post and screw portfolio with tools and materials, Auckland, New Zealand, *http://xavierwallach.com*

Step 4: Layout Design: Interior Page Design

Kristen Bernard, Student Portfolio, Endicott College

Darren Booth, Portfolio Book, Canada, *http://darrenbooth.com*

Luke Copping, Promotional Magazine, Buffalo, NY, *http://lukecopping.com*

Chris Crisman, Portfolio Book, Philadelphia, PA, *http://crismanphoto.com*

Arne Hoel/The World Bank, still photographs, Washington, DC, *www.arnehoel.com*

Jordan Honnette, Student Portfolio, Los Angeles, CA, *http://jhonnette.com*

Gretchen Nash, Student Promotional Book, California Institute of the Arts, *http://gretchenetc.com*

Emily Nathan, Website, New York, *http://emilynathan.com*

Dana Neibert, Promotional Book, Coronado, CA, *http://dananeibert.com*

Larry Volk, SX-70 Series, diptychs and triptychs, Beverly, MA, *http://larryvolk.com*

Winni Wintermeyer, Portfolio Book, San Francisco, CA, *http://3am.net*

Step 6: Online Portfolios & Blogs

Zack Arias, *http://zackarias.com*, Atlanta, GA

Axel Aubert, *http://axel-aubert.fr*, France

Darren Booth, *http://darrenbooth.com*, Canada

Christine Carforo Design, *http://christinecarforo.com/design*, Boston, MA

Andreia Carqueija, *http://andreiacarqueija.com*, London, UK

Luke Copping, *http://lukecopping.com*, Buffalo, NY

Carlos Gómez, Esperanza Covarsí, Pablo Dominguez, *http://veasetambien.com*, Spain

Nick Hall Photography, *http://nickhallphotography.com*, Seattle, WA

Adam Hartwig, *http://adamhartwig.co.uk*, UK

Betty Hatchett, *http://bettyhatchettdesign.com*, Cincinnati, OH

Jessica Hische, *http://jessicahische.is/awesome*, San Francisco, CA

Jordan Honnette, *http://jhonnette.com*, Los Angeles, CA

M.T. Hoogvliet, *http://mthoogvliet.nl*, Rotterdam, Netherlands

Robert Jaso, *http://robertjaso.com*, France

Adrien Jeanjean, *http://adrienjeanjean.com*, Amsterdam

Andrew Johnson, *http://aetherpoint.com*, MA

Adam Jones, *http://adamjjones.com*, West Chester, PA

Evan Kafka, *http://evankafka.com/sensorsensibility*, New York, NY

Christopher Koelsch, *http://christopherkoelsch.com*, New York, NY

Josh Letchworth, *http://joshletchworth.com*, Florida

Chip Litherland, *http://chiplitherland.com*, Sarasota, FL

Reena Newman, Photographer, *http://reenanewman.com*, Toronto, Canada

Chris Owyoung, *http://chrisowyoung.com*, New York, NY

James Quantz, Jr Photography, *http://quantzphoto.com*, Columbia, SC

Paul Remmelts, *http://paulremmelts.nl/portfolio-5*, Netherlands

Mark Sherratt, *http://marksherratt.com*, UK

Marcus Smith, *http://marcussmithphoto.com*, Chicago, IL

Noah Webb, *http://noahwebb.com*, Los Angeles, CA

Justin Windle, *http://soulwire.co.uk*, New York, NY

Step 7: Promotional Materials

Jeremy Bales, Promotional, New York, NY, *http://jeremybales.com*

Holly Bobula, Repartee, Student Promotional, Madison Area Technical College, *http://outlierdesign.com*

Mark Burrier, Promotional Book, McLean, VA, *http://markburrier.com*

MacKenzie Cherban, Promotional, Pittsburgh, PA, *http://mackenzie cherban.com* (photo courtesy of Hannah Bailey – *visionsofalchemy.com*)

Jeanie Chong, Student Promotional, Otis College of Art and Design, Los Angeles, CA, *http://nomorebadtype.com*

Danny Cohen, Promotional, Melbourne, Australia, *http://dannycohen.com*

Lisa Czech, Editorial Publication, Boston, MA, *http://lisaczech.com*

Matt Dutile, Promotional Materials, New York, NY, *http://mattdutile.com*

Nicholas Felton, Promotional Materials, New York, *http://feltron.com*

Kristopher Grunert, Electronic Promotional, Saskatchewan, Canada, *http://grunertimaging.com*

Jessica Hische, Student Promotional, Tyler School of Art, *http://jessicahische.is*

Josh Kohanek, Promotional, Minneapolis, MN, *http://joshkohanek.com*

Nate Luke, Promotional, Nixa, MO, *http://nateluke.com*

Reena Newman, Promotional Materials, Toronto, Canada, *http://reenanewman.com*

Allison V. Smith, Promotional Materials, Zine, Dallas, TX, *http://allisonvsmith.net*

Katherine Smith, Promotional Materials, Brandon, MS, *http://katherinesmithdesign.com*

Jimmy Williams, Promotional and Instagram page, Raleigh, NC, *http://jimmywilliamsphotography.com*

James Worrell, Promotional, Blog Site, e-Promo, *http://jamesworrell.net*

Step 8: Professional Materials

Fabien Barral, Business Card, Auvergne, France, *http://fabienbarral.com*

Kristen Bernard, Student Professional Materials, Endicott College.

Capsule, Business Card, Minneapolis, Creative Principal, Brian Adducci, *http://capsule.us*

Lena Cardell, Student Professional Materials, Tyler School of Art, *http://lenacardell.com*

Jeanie Chong, Student Professional Materials, Otis College of Art and Design, *http://nomorebadtype.com*

Jeremey Fleischer, Professional Resume, Colorado Springs, CO, *http://behance.net/jeremey*

Christian Garibaldi, Business Card, Bayonne, NJ, *http://garibaldiphoto.com*

Ken Gehle, Business Card, Decatur, GA, *http://kengehle.com*

Brad Ireland, Business Card, Washington, DC, *http://bradireland.com*

Destry Jaimes, Business Card, Austin, TX, *http://dfjphoto.com*

Kenny Kim, Student Professional Materials, Kansas City Art Institute, *http://kennykimwastaken.com*

Turnstyle Studio, Professional Materials, Seattle, *http://turnstylestudio.com*

Page numbers in **bold** refer to illustrations.